DATE DUE

Nicholas Wadley

CUBISM

Movements of
Modern Art
General Editor:
Trewin
Copplestone

Hamlyn

NG GROUP LIMITED
ey · Toronto
Hamlyn House, Feltham, Middlesex, England
© Copyright 1970 The Hamlyn Publishing Group
Limited

ISBN 0 600 02634 5

Printed in Hong Kong by
Toppan Printing Company (H.K.) Limited

Contents

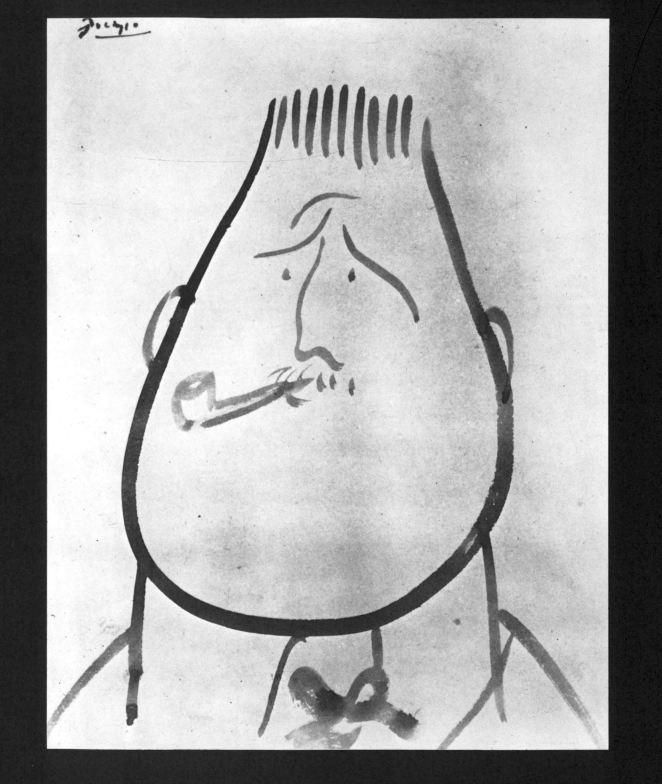

The Movement

Cubism and the modern world

At the start of the 20th century, all faces of European culture seemed infected by a wave of restlessness, discovery and change. It was the era of Marconi and Blériot, Scott and Amundsen, Einstein and Rutherford, Jung and Freud, Schoenberg and Kandinsky. New theoretical standpoints and practical discoveries were providing vast new areas of raw material to be sifted and analysed. It was a matter not simply of extending and refining existing knowledge, but of creating new dimensions of knowledge, thought and experience. Existing social, academic and technical structures were giving way to new specialisations, new professions. Machine-power and electricity were transforming the appearance, the sound and the whole pace of urban life. Concepts of time, distance and communication were being radically and repeatedly modified. It was a time, too, of great political unrest, ranging from extreme forms of optimistic idealism to aggressive materialism and erupting in the second decade in the First World War throughout Europe and the October Revolution in Russia. The history of Cubism belongs intimately to this period, growing out of the extraordinarily dynamic situation and dissolving in the more diffuse context created by the First World War.

Emotionally and intuitively the whole Cubist generation was infected by this atmosphere. Cubist art itself is full of comparable dislocations and disorientations, shattering traditional ideals and processes and creating new technical and theoretical specialisations. Pictorial concepts of space and time were irrevocably altered by Cubism. But beyond such generalised analogies as these, the relationship between Cubist art and the contemporary world becomes elusive. Unlike most other early 20th-century movements (notably those in Germany, Russia and Italy), Cubism was not tied to any moral, social or political ideals. The Cubists were not political revolutionaries. They wrote no manifestoes and their relatively rare statements were anything but inflammatory. Even the typical appearance of a Cubist painting does not immediately generate visions of the heroic modern man in a brave new world. There are some exceptions, of course, in the work of Léger and Delaunay, but for the most part Cubism's expression of its age was more oblique and in a sense more profound.

Picasso wrote later that 'Cubism has kept itself within the limits and limitations of painting, never pretending to go beyond it.' (Writings, p. 128). It was more the *scale* of 20th-century change than any particular changes that the Cubists endorsed, and they applied this scale of radicalism to art. All of the major Cubists shared an excited enthusiasm for things that were new, different, even eccentric. Their associations with members of the Parisian literary avant-garde like

1. *Pablo Picasso*
Caricature of Apollinaire
1905, wash drawing
Institute of Contemporary
Arts, London

Alfred Jarry, Gertrude Stein, Guillaume Apollinaire and Blaise Cendrars; with the naive painter le Douanier Rousseau; with the art of unknown African tribal craftsmen—all of these reveal a deep commitment to change rather than to modernity for its own sake. It is in this sense that the Cubists were most deeply affected by factors external to art. They were aware in varying degrees, of recent technical advances in photography and the cinema for example (see Léger, Writings, p. 130), but for Picasso, Braque and Gris their exploration of relatively traditional forms of popular, commercial and applied arts was equally relevant. The relevance was always determined by a potential application to painting.

Some Cubists enjoyed associations with musicians and architects as well as the writers already mentioned. There was also a degree of popularised discussion at café and studio level about philosophy, mathematics and science, but no deliberate or systematic attempt to absorb these interests into their art. The magical phrase 'the Fourth Dimension' appears in several contemporary articles and there has been discussion in more recent times about parallels between Cubist propositions and the ideas of—among others—Bergson on reality (widely known in Paris at the time) and Einstein on relativity. The presence among the Cubists' friends and neighbours of an amateur mathematician, Maurice Princet—a glamorous supplement to the movement who has become something of a legend—has also received critical attention. On the whole, comparisons between Cubism and such ideas are more valid as retrospective insights into Cubism than as the discovery of specific and genuine catalysts behind the movement.

Some contemporary writers could already see an affinity between the Cubist painters and the spirit of their times. Maurice Raynal, a perceptive early critic of the movement, wrote in 1912:

'Along with a large number of intrepid scientists who have devoted themselves to extraordinary scientific researches, the mere starting points of which have made nonsense of accepted views and vulgar sensibility, the twentieth century has seen the rise of a generation of artists who, possessing an exceptionally wide culture, have tried to renew the pictorial conceptions and styles of the past through their own knowledge in various fields and their affinities with the modern movement.'
(Catalogue, *IIIe Exposition de la Société normande de Peinture Moderne*, Rouen, June—July, 1912) and again in 1913:

'The Cubists, not having the mysticism of the Primitives as a motive for painting, took from their own age a kind of mysticism of logic, of science and reason, and this they have obeyed like the restless spirits and seekers after truth that they are.'
(*Qu'est-ce que...le 'Cubisme'?, Comoedia illustrée,* Paris, December, 1913).

Raynal's observations come as close as any to the elusive romanticism of the Cubist philosophy. Certainly the Cubists were affected by the widely held concept of innovation for its own sake. Certainly they endorsed the widespread ambition to cut through all layers of convention and tradition to a crude but dependable basis of 'truth', 'logic', 'reality' (words which recur endlessly in the writings of and on Cubism). But at the same time they were deeply infected with what could well be called a 'modern mysticism'.

Their total faith in the intuition and in a clear-sighted empiricism that was the peculiar privilege of modern man—writer, scientist, artist, whatever—outweighs any real sense of logic or rationalised system. They seem to have admired the creative idea of science (perhaps because of the exhilarating state of scientific thought and progress at the time) rather than to have had any deep respect for scientific method. As Gleizes and Metzinger say, 'Cubism, which has been accused of being a system, condemns all systems' (*Du Cubisme,* 1913). In a scientific age, Cubism was a very unscientific art. In this spirit they could admire the intellectual integrity of Seurat, but remain intolerant of the scientific dogma of his art. Marcel Duchamp's later obsessional affection for scientific systems, halfdedicated and half-mocking, was an extreme development of this attitude, not unlike the exotic affairs with the church among artists in the 1890s. In Cubism the delicious surrender was at the altar of the real: science probably seemed to symbolise a closer preoccupation with reality than all the artifice of traditional Art.

The Cubists' stated objective was a greater 'reality' in art—a reality that no longer depended on the artificiality of illusionism, that could reach beyond a picture of surface appearances at a particular place and a particular time. In many ways Cubism brought art closer to life and to the facts and inconsistencies of everyday experience than it had ever been before. It is in the changing of attitudes towards reality in art that Cubism's greatest revolution lies.

The movement.
The name 'Cubism' originated from criticisms of the angular volumes in some of Braque's paintings of **2** 1908. His L'Estaque landscapes were rejected by the jury of the 1908 Salon d'Automne and shown instead at the gallery of the young German dealer, Daniel-Henri Kahnweiler, who handled the work of all the leading Cubists. One of the Salon jurors, Matisse, is reputed to have spoken of Braque's *petits cubes* and the critic Louis Vauxcelles used the words *'cubique'* and *'cubiste'* in reviews of 1908 and 1909. As with

2. *Georges Braque* Houses at L'Estaque *detail 1908, oil on canvas 2.75 × 2.5 in. (60 × 59 cm.) Kunstmuseum, Berne (Hermann Rupf Collection)*

Fauvism (also coined by Vauxcelles) and Impressionism, an abusive name stuck. It was accepted by the artists despite its long-term unsuitability. In fact the 1908–9 paintings are the only important Cubist works which one can really describe in terms of 'cubes'.

The important refinements, 'Analytical Cubism' and 'Synthetic Cubism', were first clearly formulated by Juan Gris (Writings p. 129) to distinguish between the early Cubist paintings deriving from the analysis of a motif (*c*. 1909–*c*. 1911) and those which, conversely, started from an abstract arrangement of forms that gradually acquired the attributes of a motif. Other categories have been added: 'High Cubism' or 'Hermetic Cubism' for the later part of the Analytical phase (although Kahnweiler applies 'Hermetic' to the whole period 1909–13); 'Rococo Cubism' (by Alfred Barr) for Picasso's decorative works of 1914–15; 'Epic Cubism' for the panoramic city subjects of Delaunay and others; 'Tubism' for Léger in 1911 (again by Vauxcelles). Gris' distinction between an art of analysis and an art of synthesis is obviously the most meaningful division and has been universally accepted, with only slight discrepancies in dating.

Many events have been seen retrospectively as marking the birth of the Cubist movement. The christening mentioned above; the serious recognition of primitive, notably African art forms; the painting of 35 Picasso's *Demoiselles d'Avignon* 1906–7; the coming together of two artists as temperamentally contrasted as Picasso and Braque in 1907; the restraining disci-

pline of Cézanne's influence on Picasso's violent primitivism between 1907 and 1909—all of these are relevant factors and there are others. But it was a complex of pressures and influences, of events, circumstances and coincidences, some of them reaching a lot further back than 1906 that coalesced in the first crystallisation of Cubism between 1907 and 1909 and in its very rapid subsequent development. The reasoning out of these pressures and influences was undertaken by Picasso and Braque together, each of them capable of further gestures to push their concerted progress into new fields of technical and conceptual realisation. Picasso described their relationship as a 'marriage'; Braque compared them to two mountaineers roped together.

The development of Cubism between 1908 and 1914/15 was both dramatically rapid in its ruthless progress from each proposition to its conclusion and highly elusive in the ambivalent subtlety of some of its transitions. Cubism was not the conscious search for a form to express an idea, so much as a radical exploration of the forms of painting that itself threw up ideas. The opportunist discovery of a device in one painting or one thought could accelerate, rebounding between Picasso, Braque and later Gris, into a concept of lasting importance and influence.

The early phase of Cubism still drew direct inspiration from a wide range of other art. The later phase fed more off itself, its own forms and ideas, and off sources right outside art. This change is almost implicit in the difference between Analytical and Synthetic Cubism.

Analytical Cubism was a revision more than a rejection of traditional and current values in painting. The picture plane was still the surface or the window of an illusion. Although early Cubism virtually abandoned colour, its subtle tonal scale is full of allusions to light and forms in space. Although it abandoned the fixed, single viewpoint, it was still concerned essentially with direct analysis of things seen. Even when by 1911 this analysis was so extreme that the motif was almost indiscernible, the external titles reassure us of the intended representational role of the painting. The technical innovations of Analytical Cubism—its emblemmatic use of symbols, its introduction of lettering and imitation wood-graining—all endorse this representational reference.

Synthetic Cubism, technically and conceptually, was a denial of the European tradition. Technically, the surface was now the furthest point from the spectator, not the nearest. Its new technical means—*collage* (from *coller*, to glue or paste) and *papier collé* (pasted paper)—emphasise this inviolable respect for the surface. They demonstrate too the new attitude to motifs or subjects. Representation of reality was now the final objective rather than the starting-point. Whereas

the Analytical Cubist worked from a specific motif towards its reconstitution in terms of painting; the Synthetic Cubist started with the terms of painting— and from them composed an image which he could justly claim was more real, since it in no sense distorted or imitated something else.

The recognition, pursuit and resolution of these new principles was undertaken primarily by Picasso and Braque, joined around 1911 by Juan Gris. Gris had arrived in Paris from Spain in 1906 and was a neighbour of Picasso in Montmartre almost from his arrival. Rapidly comprehending and assimilating the principles of their early work, he made an important independent contribution to Synthetic Cubism and some of the clearest formulations of Cubist theory. Gris' role really emerged after 1912 and the strength of his lucid artistic personality at the heart of Cubist activity may have contributed as well to the dissolution of Picasso's and Braque's tight-knit personal partnership.

These three formed the nucleus of Cubism, standing somewhat apart from the wider movement that quickly grew up around them. After 1909 Picasso and Braque did not contribute to the annual Salons, in which a Cubist group or section was to become an expected and newsworthy feature. Gris did occasionally show elsewhere, but mostly like them exhibited through his own dealer, Kahnweiler (or occasionally in the smaller gallery of another young German, Wilhelm Uhde).

The other Cubists embrace a wide scale of predis-position, ability and originality. They shared a universal respect for Cézanne, although some of them, like Léger and Delaunay, came to it independently, while others were led there by Picasso and Braque. Some recog-nised in Cubism new principles that could be inter-preted just as flexibly as the canons of traditional art; others, little more than camp-followers, saw Cubism as a more or less geometric style to be accepted un-questioningly.

The gradual assembling of this wider Cubist group crytallised between 1910 and 1911 into a recognisable and conscious association of people with common interests. Throughout its history, the homogeneity of the Cubist movement was promoted by the critical writing of its protagonists (Apollinaire, Allard, Raynal, Hourcade, Mercereau and others), who wanted to identify a positive new spirit among younger French painters, as well as by hostile critics, inclined to wel-come an identifiably subversive new element in order to attack and ridicule it. The future Cubist paint-ers had begun to meet socially as early as 1906 and by 1910 Léger, Delaunay, Gleizes, Metzinger and Le Fauconnier were meeting regularly. They all attended, for example, a weekly gathering of artists and writers at a café called the *Closerie de Lilas*. Sponsored by the literary review *Vers et Prose*, these meetings pro-vided the first contacts between the young Cubists and Apollinaire and the other supporters.

At the 1910 *Salon d'Automne*, paintings by three of them (Gleizes, Metzinger and Le Fauconnier) were hung, apparently quite fortuitously, side by side. This coincidence clarified their need for a more conscious collective identity. The series of statements in articles or books, in which the artists tried to define their common attitude towards the new art, start at this point.

This second group of Cubists grew rapidly. Other painters like Segonzac, la Fresnaye, Lhote, Marcoussis, Laurencin and Marchand were now drawn—if rather superficially in some cases—towards Cubism. They arranged for their paintings to be hung together in two rooms of the 1911 *Salon des Indépendants* and the ensuing storm of abuse in the press put the final public seal on the new movement. The name 'Cubism' immediately assumed common currency, among champions, critics and artists alike. The publicity at-tracted a further wave of adherents. This time they were to be more significant and included two sculp-tors, Archipenko and Duchamp-Villon. The others of importance were Picabia, the Czech Kupka and Duchamp-Villon's two brothers, Jacques Villon and Marcel Duchamp.

In the 1912 *Salon des Indépendants*, *Salon de Juin* (in Rouen) and *Salon d'Automne*, the concerted strength of the movement grew. Public protest reached such a pitch that a demand was made in the French parliament that the national *palais* (the buildings that housed the annual *Salons*) should not be sullied by such 'anti-artistic and anti-national' manifestations. From 1911 there had been regular meetings of a large group which called itself '*La Section d'Or*' and in-cluded the Duchamp brothers, Gleizes, Metzinger, Léger, Le Fauconnier, Gris, de la Fresnaye, Lhote, Picabia, Delaunay, Archipenko, the architect André Mare and the writers and critics Apollinaire, Allard, Salmon and Mercerceau. They met on Sundays at the Duchamps' Puteaux studio and on Mondays at Gleizes's studio at Courbevoie. This group was re-sponsible for a large exhibition held in October, 1912, entitled *La Section d'Or*. This was probably the most comprehensive and retrospective of all the Cubist exhibitions with thirty participants including Gris, Metzinger, Gleizes, Léger, Archipenko, Picabia and the Duchamps.

At this moment, serious divergencies within the larger movement began to take shape. This happened at precisely the moment when Picasso and Braque seemed to be moving apart.

Cubism had started from the work of Picasso and Braque. Their painting and, after his first public ap-pearance in 1912, that of Gris, continued to exert

considerable influence. But the Cubist painting of the larger group which gathered around 1910 and of a number of the 1911–12 recruits interpreted their ideas at second-hand. Within the second group, Gleizes and Metzinger remained fairly close to the formal means and the motifs of Picasso, Braque and Gris. Others like Marcoussis followed them. Léger and Delaunay, who first met around 1907 and whose assessment of Post-Impressionism was largely independent of Picasso and Braque, were concerned with different values from the outset. More volumetric in Léger's case, more colouristic in Delaunay's, their art was a more romantic expression of the modern environment.

Perhaps surprisingly in this context and possibly under the stimulus of Kupka, Delaunay moved in some paintings of 1912 to a point of total abstraction. In tune with the general change from analysis to synthesis, Delaunay abandoned Cubist fragmentation for a flatter structure based on contrasts of colour. Like Léger some two years later, he rapidly retreated from this extreme position. Abstraction as an end in itself was never pursued by Parisian Cubists. In this sense the movement as a whole endorsed Picasso and Braque's ambition to find new means of representation. But however short-lived this tendency, it demonstrates the separatist impulses that were emerging within the Cubist camp. Apollinaire and other writers, pursuing directly analogous concepts in the field of literature, joined Delaunay's circle and the splinter group was given the name 'Orphism' by Apollinaire. Archipenko and Chagall also became associated with it, the former publicly renouncing Cubism in the process. Strictly speaking he was right: Orphism was not a subdivision of Cubism so much as the first example of Parisian Cubism acting as the catalyst for a new and different concept.

The Duchamp brothers quickly became a powerful intellectual force in Cubist circles. All three of them were preoccupied with mathematics and this temporarily interested other Cubists. It was Jacques Villon who had suggested the title of the *Section d'Or* exhibition in 1912 and Maurice Princet, already mentioned as a dilettante mathematician and associate of the Cubists, was a close friend of Marcel Duchamp. The application of a systematic scale of calculation, while it struck certain chords with Gris, was at odds with the mainstream of Cubism. Duchamp was obliged by fellow Cubists to withdraw a painting from the 1912 *Indépendants*, presumably on grounds of this sort. Picabia, a brilliantly inventive eclectic, followed Duchamp into an area of activity (sometimes called 'Pre-Dada') that was clearly alien to Cubism and was to be highly influential outside France.

Cubist sculpture was dominated by the inventive energy of Picasso: many think of him as more sculptor than painter. His career as a sculptor, after a lull during the critical, creative phase of Cubism, reappeared in 1912, when he extended collage into a fertile art of three-dimensional assemblage and construction. The work of the other sculptors either followed in the same direction or tried to reconcile Analytical Cubism's transformation of object-space conventions to the forms and media of traditional sculpture. Transferred from the two-dimensional space of painting to the real, three-dimensional space of sculpture, the principles of Cubism assumed a different, no less revolutionary, meaning. The activity of Picasso, Archipenko and Duchamp-Villon inspired occasional sculptures from other Cubist painters, but the important figures were Laurens and Lipchitz, who joined Cubist circles around 1912–13.

As well as the splintering among French Cubists, the presence or appearance in Paris of beneficiaries of Cubism as different as Mondrian, the Italian Futurists and the American followers of Delaunay must have magnified the bewildering array of divergent tendencies around 1912. The spread of Cubist ideas and of the style across Europe before the First World War was phenomenal. As early as 1910, Gleizes, le Fauconnier and Lhote were exhibited together in Moscow, at the instigation of their supporter Alexandre Mercereau. With similar help and an increasing volume of invitations from artists abroad, the Cubists had by 1914 exhibited their work in Brussels, Amsterdam, Berlin, Dusseldorf, Munich, Cologne, Prague, Budapest, Florence, Barcelona, London, New York and even in Tokyo. In addition a large number of important avant-garde artists from abroad had visited Paris.

The influence of Cubism has acted on many different levels: in some aspects it can be seen to infect almost all subsequent activity, stretching well outside the limits of fine art. Its immediate impact was largely in terms of a ready-made modern idiom that could be adapted to other and specific purposes. The brilliant adaptation of it by the Futurists is a case in point. In stylistic terms, Futurism became an extra agency for spreading the Cubist vocabulary. The longer term influence, which really emerged between the wars and has since reached well into the third quarter of the 20th century, has been a matter of more profound understanding and interpretation. Cubism's attitudes to surface in painting and more universally, to materials, to imagery and to space, have been as relevant to figurative as to non-figurative arts, to constructive as to destructive. The colossal implications of collage, revolutionising basic attitudes to technique and exploding standards of coherence and literacy at every level, is some measure of the heritage which the 20th century is still considering.

The outbreak of war in August, 1914, cut right through the structure of the European avant-garde. The various Cubist cells disintegrated. Several of the artists left the country: Duchamp and Picabia to America, Le Fauconnier to Holland, Delaunay, Laurencin and later Gleizes to Spain. The two Spaniards, Picasso and Gris, stayed in France, so did the Lithuanian Lipchitz. Most of the others enlisted. Apollinaire and Braque were seriously wounded and discharged; Léger, victim of a gas attack at Verdun, was discharged in 1916. Duchamp-Villon contracted typhoid while serving at the front and died in 1918 in a military hospital.

There were serious attempts after the war, led principally by Gleizes to resume the same communal structure; but that particular blend of talents, spirits and circumstances which had fired the pre-war movement in Paris was gone. The last significant exhibition of working Cubists in Paris was in 1920. Nostalgically again titled *La Section d'Or* it centred around Gleizes, Braque, Léger, Marcoussis and Villon. By this time collective activity throughout Europe was fired by rather different philosophies, to some extent created by the war. Cubism, as a movement, was finished.

Biographical notes on the artists

Archipenko, Alexander (1887–)
Born Kiev 30.5.87. 1902 began art studies in Kiev, turning to sculpture 1903. 1905–8 studied in Moscow. 1908 Ecole des Beaux-Arts, Paris. 1910 contact with Cubists. 1912 began teaching in Paris; contributed to *Section d'Or* exhibition, Paris. 1913 Armory Show, New York. Joined *Der Sturm*, Berlin, and exhibited there. Very active as a teacher from 1921 when he opened his own sculpture school in Berlin. 1923 moved to New York. Taught at various centres in America, including Maholy-Nagy's New Bauhaus, 1937. Lives in Woodstock, N.Y.

3 **Braque**, Georges (1882–1963)
Born Argenteuil 13.5.82. Childhood in Le Havre. 1899 apprenticeship as a painter-decorator. 1900 moved to Paris; continued apprenticeship. 1901 military service. 1902–4 studied at Académie Humbert, Paris; met Picabia, Laurencin. 1904 took studio in Montmartre; independent painting began. 1906–7 exhibited Fauve paintings at *Salon d'Automne*. 1907 Cézanne Memorial Exhibition; contract with Kahnweiler for his entire output; met Apollinaire, Picasso, Matisse. 1908 first Cubist landscapes rejected at *Salon d'Automne*, shown at Kahnweiler's gallery; began etching. 1909–14 close partnership with Picasso. 1913 Armory show, New York. 1914 enlisted in army; severely injured 1915; discharged 1916. Returned to Paris where he

continued to live until death. 1923–25 designs for Diaghilev. Several public commissions including a ceiling decoration in the Louvre 1952–3. 1948 awarded Grand Prix, Venice Biennale; published his *Cahier* (Writings 1917–47). Died Paris 31.8.63.

Delaunay, Robert (1885–1941) 6
Born Paris 12.4.85. 1902–4 apprenticed to a theatrical designer. 1904–5 first serious paintings. 1905 met Metzinger; by 1907 knew Léger, le Fauconnier and le Douanier Rousseau. 1907 military service, Laon. 1908 studied the colour theories of Chevreul and Rood. 1908/9 met Picasso. 1910 met Gleizes and other Cubists; married Sonia Terk; friendship with Apollinaire. 1911 *Salon des Indépendants*, Paris; exhibited with *Blaue Reiter* in Munich. 1912 correspondence with Kandinsky, Marc and Macke; visited by Klee who translated his essay *On Light*. 1913 one-man exhibition *Der Sturm* gallery, Berlin; visited Germany; friendship with Cendrars. 1914 left Paris; lived in Spain and Portugal until 1920/21. 1918 met and worked for Diaghilev in Madrid. 1921 returned to Paris. 1922–3 friendship with Surrealist writers. 1936–7 painted plaster reliefs for the Palace of the Air and the Railway Pavilion, Paris World's Fair. Died Montpellier 25.10.41.

Duchamp, Marcel (1887–1968) 5
Born Blainville 28.7.87. Younger brother of Raymond Duchamp-Villon and Jacques Villon. 1902 started painting. 1904 moved to Paris. 1904–5 studied at the Académie Julian. 1905–10 worked as occasional cartoonist for Paris journals. 1905–6 military service. 1906 first serious paintings. 1909–10 joined weekly gatherings of Cubist artists and writers at Puteaux. 1912 visited Munich; clashed with Cubists at the *Salon des Indépendants*, withdrew his *Nude descending a Staircase No. 2* and showed it at the *Section d'Or* exhibition and at Armory Show, New York, 1913; close relationship with Apollinaire and Picabia. 1913 abandoned oil-painting; first ready-made. 1915–18 New York. 1918 Buenos Aires. 1919 onwards divided time between Paris and New York. Contributed to Dada and Surrealist exhibitions and literature in Paris and elsewhere during 20s and 30s. Since the war lived and worked mainly in New York. Died 1968. 110

Duchamp-Villon, Raymond (1876–1918)
Born (Raymond Duchamp) at Damville, near Rouen 5.11.76. 1894–98 medical student, Paris University; abandoned studies through illness. 1899–1900 turned to sculpture during convalescence. *c.*1901 changed name to Duchamp-Villon; settled in Paris. 1902 first work exhibited at the *Salon de la Société Nationale des Beaux Arts*. 1907 moved to Puteaux, where was a neighbour of Jacques Villon and Kupka. 1911

assisted group hanging of Cubists at *Salon d'Automne* (he was Vice-President of the jury). 1911–12 central figure at the regular Sunday meetings of Cubist painters, sculptors and writers at Puteaux. 1912 exhibited at *Section d'Or* exhibition. 1913 Armory Show, New York. 1914 enlisted in medical corps. 1915 transferred to the Front. 1916 contracted typhoid while stationed at Champagne. Died Cannes military hospital 7.10.18.

Gleizes, Albert (1881–1953)
Born Paris 8.12.81. Worked as an industrial designer, turning to painting under the influence of Impressionism. By 1906 knew Mercereau and through him met Le Fauconnier 1909, and Metzinger and Delaunay 1910. 1911 exhibited with Cubists at *Salon des Indépendants*; met Picasso. 1911–12 regular Monday meetings of Cubists at his Courbevoie studio; founder-member of the *Section d'Or* group. 1912 *Du Cubisme* by Gleizes and Metzinger published in Paris. 1914–15 military service. 1915 went to America and later to Spain and Portugal. 1919 returned to Paris. 1939 moved to St Rémy in Provence, where died 29.6.53.

4 Gris, Juan (1887–1927)
Born Madrid 23.3.87., (José Vittoriano Gonzales). 1902–4 studied at Madrid School of Arts and Crafts and worked as a designer. *c.*1902 began working as an illustrator, sold humorous drawings to Madrid newspapers. 1906 moved to Paris; lived in 'Bateau-Lavoir', Montmartre; met Picasso, Apollinaire, Jacob, Salmon; freelance illustrator for Paris journals and newspapers. 1908 met Kahnweiler. 1910 begins serious work—watercolours and drawings. 1911 first **60** oil-paintings. 1912 exhibited *Hommage à Picasso* at *Salon des Indépendants*; also showed at *Section d'Or*; contract with Kahnweiler for entire output. 1914–18 lived mainly in Paris, conditions of great hardship. 1915 friendship with Matisse, who helped him financially. 1916/17 friendship with Lipchitz. 1921 in hospital with pleurisy. 1922–23 designed for Diaghilev. 1924 lectured at Sorbonne on 'The Possibilities of Painting'. 1926–7 rapid decline in health. Died Paris 11.5.27.

Kupka, Frantisek (1871–1957)
Born Opocno, Czechoslovakia 23.9.71. 1887–91 studied at Academy of Fine Arts, Prague. 1891 studied at Vienna Academy where in contact with Vienna *Sezession*. *c.*1895 came to Paris and worked as satirical illustrator for Paris journals. 1905 lived in a studio at Puteaux near the Duchamp brothers. 1906 one-man show in Prague. 1911/12 joined Cubist circles; *c.*1911 first non-figurative paintings. 1912 exhibited at *Section d'Or*. 1914–18 enlisted and

fought in Czech Legion, but invalided out and joined French resistance movement. 1918–39 Professor at Prague Academy of Fine Arts, but continued to spend much time at Puteaux. From the 1930s exhibited with *Abstraction-Création* movement in Paris and contributed to journals. Died at Puteaux 24.6.57.

La Fresnaye, Roger de (1885–1925)
Born Le Mans 11.7.85. 1903–8 studied at the Académie Julian and the Académie Ranson. 1910 first work exhibited at the *Salon des Indépendants* and the *Salon d'Automne*. 1911 friendship with Villon and Gleizes; member of the *Section d'Or* group. 1914–17 army service (as a volunteer). Died 27.11.25.

Laurens, Henri (1885–1954)
Born Paris 18.2.85. Apprenticed to a decorator but turned to sculpture under the influence of Rodin. Early friendship with the poet Pierre Reverdy. 1911 met Braque; joined Cubist circles and the *Section d'Or* group. 1913 his first work exhibited at the *Salon des Indépendants*. Several important public commissions, France and elsewhere; also active as an illustrator. Died Paris 18.5.54.

Le Fauconnier, Henri (1881–1946)
Born Calais, July 1881. 1901 moved to Paris. Admirer of Denis and the Nabis as a student. 1907 met Delaunay; met Gleizes at Mercereau's house. 1910 paintings hung with those of Gleizes and Metzinger at the *Salon d'Automne*; contact with German artists, became member of the *Neue Kunstlervereinigung*, Munich; late in 1910 met Picasso. 1911 contributed to the first large Cubist group at the *Salon des Indépendants*. Member of the *Section d'Or* group. 1914–19 lived in Holland. 1919 returned to Paris where lived and worked until death in January, 1946.

Léger, Fernand (1881–1955) 8
Born Argentan, Normandy, 4.2.81, the son of a farmer. 1897–9 apprenticed to an architect in Caen. 1900–2 draughtsman in an architect's office in Paris. 1902–3 military service, Versailles. 1903 onwards studied in Paris at the Ecole des Arts Décoratifs, Ecole des Beaux-Arts and Académie Julian. 1903–4 earned living in architect's office, retouching photographs; friendship with André Mare. 1907 deeply impressed by Cézanne Memorial Exhibition; close friendship with Delaunay and Cendrars. 1909–10 first Cubist paintings. 1910 met Gleizes at Mercereau's house; saw work of Picasso and Braque at Kahnweiler's gallery; met Picasso and Braque. 1911–12 member of the *Section d'Or* group; 1913 contract with Kahnweiler for entire output. 1914 enlisted in the engineers. 1916 gassed at Verdun. 1920 met Le Corbusier; became involved in Purism.

During 1920s worked as a designer in various ballet productions. 1923—4 film *Le Ballet Mécanique*. Late 1920s association with the *De Stijl* painters. 1940—45 lived in America. 1945 returned to Paris. Produced a number of publicly commissioned works, including mosaics and stained glass. Died 17.8.55.

Lipchitz, Jacques (1891—)
Born at Druskieniki in Lithuania 22.8.91. 1909 moved to Paris, where studied anatomy and carving at the Ecole des Beaux-Arts, Académie Julian and the Louvre. 1912 returned to Russia for military service; friend of Diego Rivera. 1913 met Picasso through

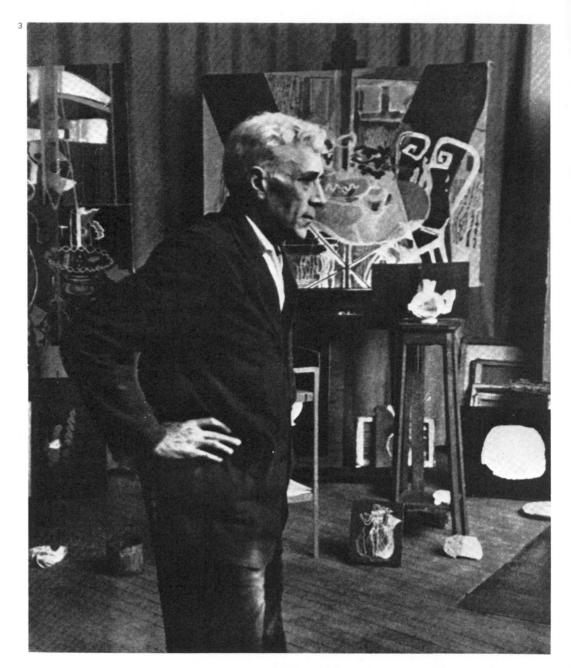

3. *Photograph of Braque in his studio, 4 rue d'Orsel, c. 1911*

4. *Photograph of Gris*

5. *Photograph of Duchamp*

6. *Photograph of Delaunay in his studio in the rue des Grands Augustins, taken in 1924 by Germaine Krull*

7. *Photograph of Picasso in his studio at Bateau-Lavoir, taken in 1908 by Gelett Burgess*

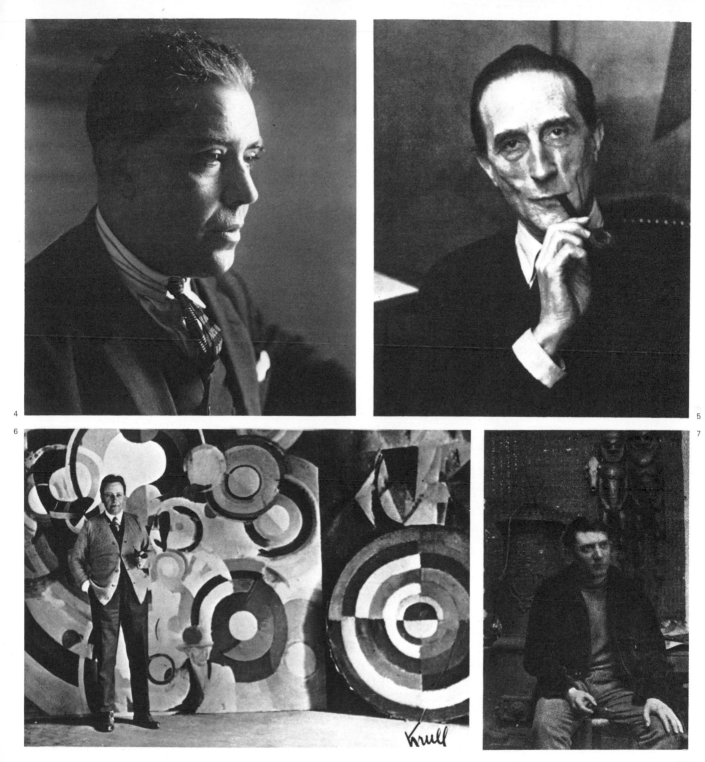

4

5

6

7

Krull

19

20

Rivera; became associated with Cubist painters; first exhibited at the *Salon d'Automne*. 1914 visited Spain. 1916/17 close friendship with Gris. 1918 friendship with Cocteau, Max Jacob, Modigliani. 1922 member of the *Esprit Nouveau* group. 1935 first major exhibition in America. 1941 went to live in New York. Has produced a number of works for architectural environments in Rio de Janeiro, France and the United States. 1945 stayed briefly in Paris, then returned to U.S.A.

Marcoussis, Louis (1883–1941)
Born Warsaw 14.11.83. Studied at Warsaw Academy. 1903 moved to Paris; friendship with Roger de la Fresnaye. 1910 saw and was much impressed by Braque's painting. 1911 met Picasso. 1912 contributed to the *Section d'Or* exhibition. 1914 volunteered for military service, served 1914–18. Died at Cusset, near Vichy, 22.10.41.

Metzinger, Jean (1883–1956)
Born Nantes 24.6.83. 1903 moved to Paris; exhibited at *Salon des Indépendants*. By 1906 knew Delaunay and was active as a writer, publishing poetry in literary reviews. *c.*1910 frequent visitor to Picasso's Montmartre studio; member of Mercereau's circle. 1910 paintings hung with those of Gleizes and Le Fauconnier at the *Salon d'Automne*. 1911 exhibited at the *Salon des Indépendants*. 1912 member of the *Section d'Or* group. Essay *Du Cubisme* by Gleizes and Metzinger published in Paris. 1914 called up at outbreak of war. Died Paris 1956.

Picabia, Francis (1878–1953)
Born Paris 22.1.78. Studied at the Ecole des Beaux-Arts, under Cormon. 1898 on, taught by Pissarro. 1905 first one-man exhibition. 1909/10 friend of the Duchamp brothers; joined Cubist circles. 1911–12 founder-member of the *Section d'Or* group; close relationship with Marcel Duchamp and Apollinaire. 1913 visited New York; represented at the Armory Show. 1914 called up at outbreak of war; posted to New York, where invalided out. From 1915 participated in American avant-garde activities (exhibitions and publications). From 1918 associated with Dada groups throughout Europe. 1920s joined Surrealists. 1940–45 lived in south of France. 1945 returned to Paris. Died December 1953.

Picasso, Pablo Ruiz (1881–)
Born Malaga 25.10.81, the son of a museum curator and art teacher. 1895–7 studied in Madrid and Barcelona; associated with the Bohemian avant-garde in Barcelona. 1900 visited Paris. 1904 settled in Paris at the Bateau-Lavoir, Montmartre. 1904–6 met Jacob, Salmon, Apollinaire, Gertrude Stein, Matisse, Kahn-

weiler. 1907 met Braque. 1908 held banquet in his studio for Le Douanier Rousseau. 1909–14 worked in close association with Braque; lived in Paris, apart from summers in Spain or southern France (sometimes with Braque or Gris). 1917 visited Rome, Naples and Pompeii, designing for Diaghilev's ballet *Parade*. 1918 onwards, lived in Paris with summers in the South. 1919 met Miró. 1920s associated with the Surrealist movement. 1930 bought villa at Boisgeloup and built sculpture studios there; worked with Gonzales. 1936 appointed Director of the Prado at outbreak of Spanish civil war. 1937 exhibited *Guernica* in the Spanish Pavilion at the Paris World's Fair; visited Klee in Switzerland. 1940–5 lived in Paris throughout German occupation. 1945 exhibition of his and Matisse's recent work at Victoria and Albert Museum, London. 1948–51 visits to Poland, England and Italy for World Peace congresses. 1947 settled in south of France, first at Vallauris, where began to make ceramics, then in Cannes, 1955, finally at Vauvenargues in 1958. 1958 mural decoration, UNESCO building, Paris. 1966 many exhibitions throughout the world to celebrate his eighty-fifth birthday.

Villon, Jacques (1875–1963)
Born (Gaston Duchamp) at Damville 31.7.75. Elder brother of Raymond (Duchamp-Villon) and Marcel (Duchamp). 1894 studied at the Atelier Cormon, Paris. 1903 earned living as a graphic artist; exhibited at the *Salon d'Automne*. *c.*1911 association with Cubism; founder-member of the *Section d'Or* group; his weekly evening gatherings at Puteaux were an important focus of the group. 1912 leading part in organising the *Section d'Or* exhibition. 1914–18 army service. 1919 returned to Paris. Worked as a graphic artist in the 1920s, then resumed painting. Died at Puteaux 9.6.63.

Other artists associated with the Cubist movement included:
Marie Laurencin (1885–1956)
André Lhote (1885–)
Auguste Herbin (1882–1960)
Jean Marchand (1883–1940)
André Dunoyer de Segonzac (1884–)

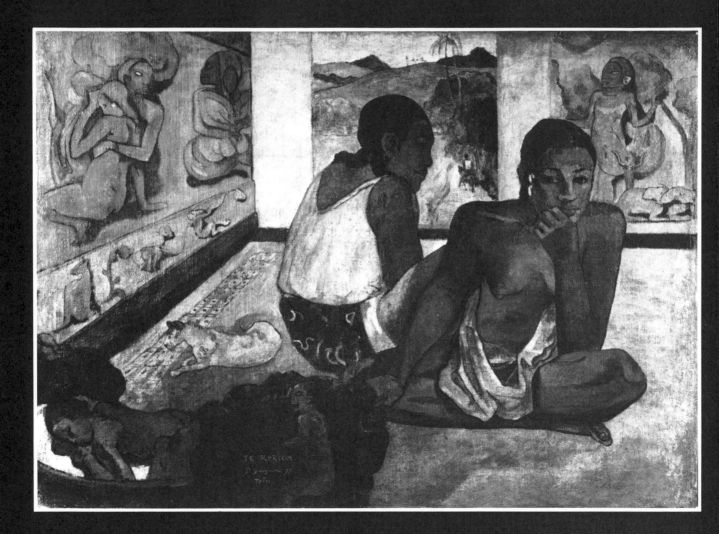

9. *Paul Gauguin*
Te Rerioa
1897, oil on canvas
37.5 × 51.25 in.
(95 × 130 cm.)
Courtauld Institute
Galleries, London

Realism and Symbolism

Cubism's parent-child relationship with earlier art was as ambivalent as that of any revolutionary art movement. It fed freely upon earlier ideas but at the same time wilfully transformed them. In some ways Cubism descends directly from 19th-century art and ideas: without the whole avant-garde French tradition from Courbet and Manet through to Matisse and the Fauves, Cubism is scarcely conceivable. At the same time, in the context of subsequent art, Cubism seems to have abandoned or destroyed enough 19th-century concepts to sever itself from earlier traditions.

The most important theoretical link between Cubism and the 19th century concerns attitudes to subject-matter: the decline in the mid-19th century of allegorical, history or anecdotal painting in favour of what became known as 'Realism'. Courbet, a giant among 19th-century radicals, had organised in 1855 an independent one-man exhibition of his paintings. He called it *'Gustave Courbet, Le Réalisme'*. He is cited more than once in Cubist literature as a father of modern art and it is clearly the stand he made for objectivity in art that was so highly valued. The Cubist painters Gleizes and Metzinger, for instance, begin their essay *Du Cubisme* (1913): 'To evaluate the importance of Cubism, we must go back to Gustave Courbet'. 'This master,' they continue, 'created a yearning for realism which is felt in all modern work . . . it is to him we owe our present joys, so powerful and so subtle.' Gleizes and Metzinger then proceed to analyse subsequent painting in terms of progress within this context. 'Edouard Manet marks a higher stage . . . we call Manet a realist less because he represented everyday events than because he endowed with a radiant reality, many potential qualities enclosed in the most ordinary objects.' After a cursory look at the 'superficial realism' of the Impressionists, they recognise in Cézanne 'a profound reality, growing luminous as it forces the unknowable into retreat.'

This interpretation of their recent heritage in terms of a growing preoccupation with *the real* at the expense of the literary, the symbolic, the picturesque, etc., is valid and predictable. The Cubists' own early obsessions with objective motifs and with new standards of reality in art confirm the historical relationship.

From this point on, however, Gleizes and Metzinger's omissions become more interesting than their inclusions. They draw a straight line from Cézanne to Cubism, as if nothing in between were of any consequence. Sweeping Van Gogh and Gauguin away as Cézanne's 'bad company', they give a brief and critical appraisal of Neo-Impressionism and then ignore Symbolism and Matisse. This, too, is predictable in the sense that the 1890s Symbolist movement in art and

The Heritage

23

literature appeared a complete reversal of the trend towards objective realism. The literary mysticism of Gauguin, Puvis de Chavannes, Moreau or the *Nabis*, the inventive fantasies of Redon and the exotic decoration of *Art Nouveau* all seem to belong to another world. To have acknowledged all this may have weakened the historical continuity that Gleizes and Metzinger were arguing, but deliberately to ignore it was a distortion of history.

Symbolism was in fact by no means irrelevant to Cubism. We know from contemporary sources that Mallarmé featured on Picasso's bookshelf in the early years and that he was worshipped by Gris, a devotee of poetry generally. We know too of the Cubists' contemporary connection with the Symbolist tradition in literature through Apollinaire and Cendrars. The influence of painters associable with Symbolism was not dormant either, as Picasso's highly eclectic early work shows. Redon was held in high regard generally and some of the Pont Aven and *Nabi* painters were teaching in Paris.

Symbolism had revived the importance of the imagination after decades of worship of the eye. It had revived the use of symbols after centuries of naturalistic illusionism. In 1882, Odilon Redon had called one of his lithographs 'The eye like a strange balloon moves towards infinity.' It serves as an epitaph on the grave of 19th-century realism. Reality for the Symbolists lay beyond objective perception: they speak of vision more in terms of the soul, the spirit or the imagination.

For some artists and writers the escape from reality was the escapism of a sensitive and exotic ostrich, escapism for its own sake. For others it was a profound philosophy; a genuine search for a greater and more meaningful reality to be found in spiritual and intuitive experience. Gauguin probably belongs to the first category; Van Gogh clearly was on the painful brink of the second. Whatever the shades of allegiance to Symbolism, the new mood was all-pervading. In the 1890s a serious critic like Félix Fénéon could recognise a Cézanne still-life as 'mystical'. Seurat, in his later work, moved away from the scientific analysis of perception towards an investigation of the symbolic properties of line and colour. The increasingly abstract concepts of media that were evident on all sides and in all the arts provide the most powerful reflection of the drift away from realism. Mallarmé asks for 'a poetry like music'; Van Gogh dreams of 'a music of colours'.

Right at the end of his life, Mallarmé had given an increasing amount of attention to the printed lay-out of his poems. In an introduction to his poem, *Un Coup de Dés* (1897), he had written of the power of '*les blanches*' (the white margins around a printed text) and of the structure of a poem as 'prismatic subdivisions of the Idea', words which could well describe a Cubist painting. His own lay-out for *Un Coup de Dés* was to spread the lines on an informal diagonal, from top left to bottom right, across each pair of pages. In this way the spaces became part of the poem, penetrating and enlightening the word structure. By Apollinaire's time such experiments were more common among the Parisian literary avant-garde and the analogies with Cubist painting were recognised on both sides. The interplay between literary and visual images in Apollinaire's *Calligrammes* finds very close parallels in Picasso's and Gris' collages of 1912–13.

The apparent conflict between Realist and Symbolist standpoints is extreme. The Symbolist thesis that has been defined as 'a denial of reality as nothing but illusion' seems an outright rejection of the tradition of realism so closely championed in *Du Cubisme*. If Cézanne 'forces the unknowable into retreat', much Symbolist activity seems like a deliberate retreat into the unknowable.

Cubism embraced both streams of 19th-century thinking. Gladly inheriting some principles of the Symbolist aesthetic, the Cubists preserved the Symbolist's pure empiricism, free from rationalised illusions, free from dogmatic systems. But they changed the focus of this liberated vision away from the élite world of spiritual experiences back to the Realist's world of day-to-day matter. In effect they examined the most banal levels of reality with all the mystical freedom of a Symbolist poet. They painted quite trivial objects, investing them not with the explicit symbolic meaning of Van Gogh's old boots, but with an imaginative, sometimes magical quality that was realistic in that it took account of the semi-rational nature of human experience. In this paradox lay their future relevance to Surrealism.

So, feeding upon earlier ideas, the Cubists endorsed the honesty and directness of the Realist aesthetic, but abhorred the artificial limitations of its illusionism. They welcomed the liberated mentality of the Symbolist aesthetic, but rejected its self-conscious spirituality and exotic mannerisms.

Cubism's change of focus away from the exotic, exquisite world of the *fin-de-siècle* had already been anticipated around 1903–6 by Matisse and the younger Fauve painters. Their shaggy brushwork and aggressive colour broke with the languorous and rather remote sophistication of turn-of-the-century art. A Matisse beside a Beardsley demonstrates the change of tempo. The most universal expression of a new spirit was perhaps the simplest. This was, in essence, the abandonment of the curve, hallmark of *Art Nouveau* and Symbolism, for the straight line. If

10. *Guillaume Apollinaire*
Je n'oublierai jamais ce voyage nocturne
1914

11. *Aubrey Beardsley*
Lady with the Monkey *detail*
1898
7.85 × 6.65 in.
(20 × 17 cm.)
Collection of the late
R.A. Harari, London

12. *Henri Matisse*
Woman with a Hat
1905, oil on canvas
31.3 × 23.5 in.
(81 × 60 cm.)
Collection of
Mr and Mrs Walter A. Haas,
San Francisco

the raw marks of a Fauve painting lifted art on to a new assertive level of attack, then the straight line was the ultimate new-century statement. This development, already anticipated in some *Art Nouveau* design, (e.g. Mackintosh), was dramatically symbolised in the work of the Viennese architect, Adolf Loos, whose revulsion against decoration expressed itself in a pure, clean, rectangular architecture anticipating the 'modern style'. The affinity between the straight line and the modern world was immediately and widely felt. It contributed to the rapid acceptance and adoption of Cubism by the avant-garde throughout Europe. Cubism, at a superficial level, was an 'art of the straight line'. It was not a geometry based on mathematical calculation but it used geometrical forms in harmony with the poetry of machinery and engineering, concrete, steel, glass and speed, immediately identifiable as a modern language.

Impressionist and Post-Impressionist Techniques

In the field of technical experiment, Courbet—to quote Gleizes and Metzinger once more—'remained a slave

13
14

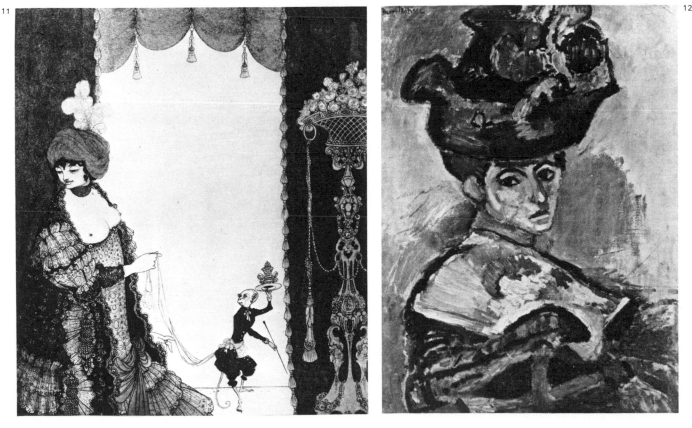

10

11

12

25

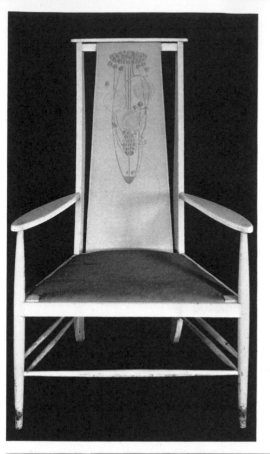

13. *Charles Rennie Mackintosh, chair painted white with linen covered seat, c. 1902, University of Glasgow, Mackintosh Collection*

14. *Adolph Loos, Steiner House, Vienna, 1910*

13

14

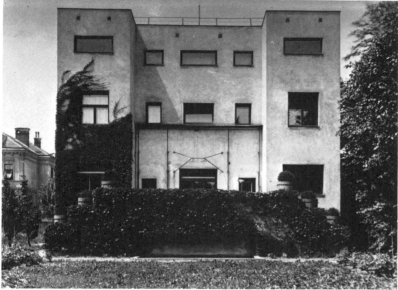

to the worst visual conventions.' Although he painted with a real instinct for the matter of pigment, Courbet had never seriously questioned standing conventions. For his successors, a modification of conventions became a matter of absolute necessity. As the concentration on visual truth increased, so the inadequacy of existing means to cope with this pursuit was revealed. With Impressionism it reached a point of crisis, a crisis resulting in technical revolutions that in no small measure foreshadowed, even precipitated the technical revolutions of Cubism.

It was Manet in the 1860s who first broached the problem of challenging technical conventions. He did not reject perspective and chiaroscuro out of hand, but used them only occasionally and almost casually, as two devices that were available. His restricted palette gave full value to subtle tonal variations and he used his fine scale of tones like colours, not to imitate appearances so much as to create a harmonious complex that could express his prized sensations in front of the motif. But Manet undertook his revolution so quietly and coolly that, while the reactionary establishment was outraged by his insolent disregard of long-standing orders, his avant-garde contemporaries could not appreciate the full extent of what he proposed.

Impressionism limited the objectives of painting to a tight and exclusive visual analysis, but out of this concentration was born the most dramatic revision of technique of the 19th century. Under this revolutionary discipline of fidelity to the eye, the two main constants of traditional art—colour and form—were exploded. The objects represented in their paintings were no longer described by particular colours to identify them, nor by firm contours to define their limits. By its nature, the Impressionist painting was a collection of fragments of perception which assaulted the spectator simultaneously, without any sequence of emphasis. In its form, it appeared as an unfinished, loosely-organised surface covered with freely-executed, often brightly-coloured marks. After the initial shock of this incoherent matter, the marks coalesce, the colours fuse and we are confronted with a vital and shimmering illusion of surface appearances. This last, intense 19th-century homage to illusion was the least significant aspect of Impressionism for the future. Take that away and you are left with a new, fragmentary type of painting that challenged form and colour as constant values; proposed a divisionist structure of small units that laid great emphasis on the picture surface; and broached the idea of simultaneous representation in painting. These were three of the basic preoccupations for the next few decades.

Monet's *Rouen Cathedral* paintings were extraordinary prefigurations of Cubism considering the re-

15,
150

24

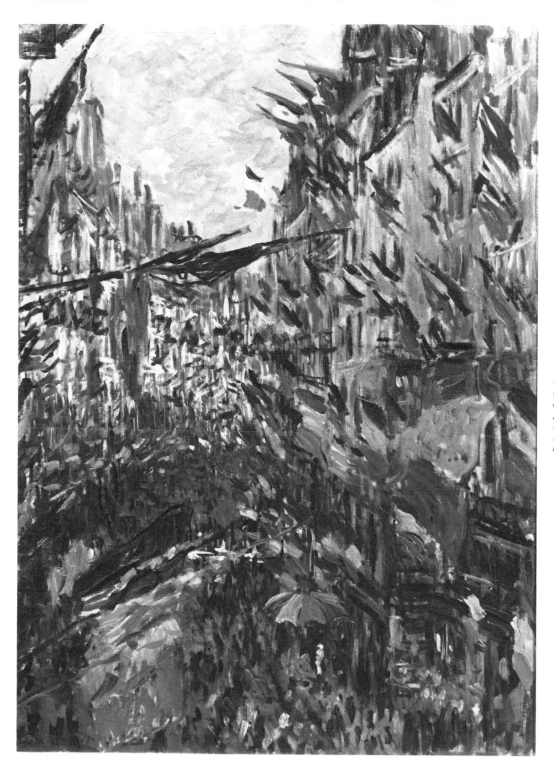

15. *Claude Monet*
Rue Montorgueil decked out
with Flags, *1918*
24.25 × 13 in.
(61 × 33 cm.)
Musée des Beaux-Arts,
Rouen

moteness from Cubism of their objective. The screens of paint almost run off the edges of the canvas. Within this screen there are many inversions of the usual warm-to-cool colour sequences and of the conventional lean-to-fat distribution of paint. Although the picture does describe the building's façade in a way that is more or less legible to us, these relations between the colours and between the bits of physical paint-substance on the canvas combine to offer another sort of architecture, sometimes so much at odds with the literal subject that we cannot immediately recognise it. Dark recesses stand forward like great chunks of crusty, bronze relief and flecks of blue and ginger shadow jump out in front of subdued foreground highlights. Monet's painting was not about objects, but about light; not about things seen, but the nature of seeing.

Impressionism ensured that later painting would be different. The simple fact that it was all right to leave patches of bare canvas showing through a painting— although a trivial incident in the Impressionist context —was of enormous consequence. Once the ground of the painting is left undisguised, the traditional role of the picture plane as a window onto an illusion is compromised and all the marks on that ground assert their own existence.

Neo-Impressionism reduced the Impressionist mark
25 to a small, very regular unit. It became for Seurat a precision instrument by which to separate and document the component hues of each local colour. The effect of his elaborate technique on the surface of the painting was enormous. The insistent uniformity of the marks meant that however powerfully he created volumes and spaces through drawing, tonal variation and perspectival recession, the screen of coloured atoms remained intact. At an optimum viewing distance—and this, of course, is what Seurat demanded— the marks fuse and an optical mixture of the colour takes place. But for later artists, obsessed as they were with the complexities and ambiguities of painting techniques, this was not the point. The way Seurat's technique constantly confronted physical surface with illusionistic depth was potentially as significant for the Cubists as Cézanne's comparable interests. In other respects, too, Seurat anticipates Cubism. His
16 coloured frames, which are both part of the painting's internal harmony and a peripheral decoration of its external form anticipated the Cubists' interest in the painting as a physical object. His unexpected affection for the vulgarity of popular culture and fashions prefigures their own ambition to encompass low art into modern painting.

In practice, the Cubists' attitude to Seurat was mixed. In his book *The Cubist Painters* (1913), Apollinaire prophesied a great future respect for Seurat's

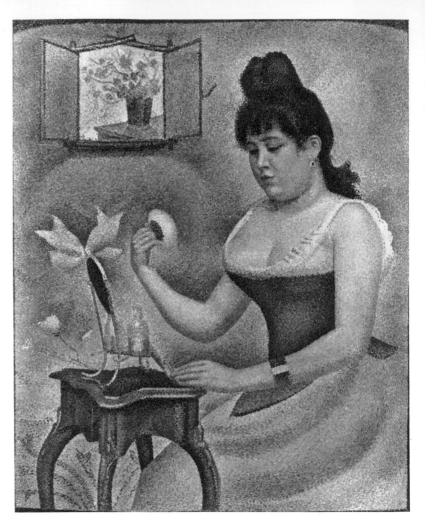

16. *Georges Seurat*
La Poudreuse
1889—90, oil on canvas
37.5 × 31.25 in.
(95 × 79 cm.)
Courtauld Institute Galleries,
London

art and appears to rate him even more highly than Cézanne in his relevance to 'the new art'. Seurat's qualities as an artist were the envy of Gris and an inspiration to Delaunay. But elsewhere he was treated with reserve by the Cubist generation and his scientific discipline seen as an inflexible, even sterile system. Léger expressed a common feeling of the time when he spoke in 1914 of Neo-Impressionism as 'a very small circle, in which there remains nothing of worth' and of Seurat as 'one of the great victims of this mediocre formula'. ('Contemporary Achievements in Painting', *Soirées de Paris*, June, 1914).

The sort of sentiment and ecstatic violence that made Van Gogh so important to Picasso around 1901 were what withheld him from the Cubists' interest at the end of that decade. His intricate colour harmonies and his expressive manipulation of paint on the sur-

face, both loaded with symbolic meaning, were alien to the Parisian traditions that had first converted him to colour. For the Cubists, temporarily relinquishing colour as they did around 1909, Van Gogh's mature art could offer little in the field of technique that was not richly available elsewhere.

28 Technically, Gauguin must have seemed even less relevant, since he rapidly abandoned the subtle complexity of divisionist techniques for a flatter, unequivocal surface organisation. His importance to the Cubist generation lay in the more conceptual character of Symbolism already discussed and in stimulating the European romantic interest in primitive cultures.

Cézanne

No artist has been held responsible for so much paternity of modern painting as Cézanne. For the Cubists his art represented a very positive formulation of post-Impressionist ideas in a much more available way and with a more obvious potential yield than the tighter, more personally realised idioms of Seurat, Van Gogh and Gauguin. The language of his painting was vital and experimental, but not idiosyncratic. After his early romantic pictures and his first transformation at the hands of Impressionism, Cézanne's ambition was to create an art of monumental generalisation without sacrificing that intense devotion to the particular that he had gained from Pissarro, Monet and the others. Cézanne found himself torn between two apparently irreconcilable poles: on the one hand the fragmentary and inconstant nature of the visual perceptions he trusted so passionately, and on the other, these ambitions of his for an art that had constancy and a composite finality. His heroic resolution of this conflict created a permanent art that did not conceal the impermanence of appearances.

Cézanne determined that, contrary to the Impressionist dependence on the eye, painting was a question of the eye and the brain working together to organise visual sensations into a coherent, permanent structure. Like Seurat, he adapted the Impressionist technique of small brushstrokes to an ordered system of more or less uniform marks. These might vary in their size or direction, but were sufficiently regular to give the whole textured surface a certain homogeneity from the outset. The approximation of the brushmarks' shape to the rectangle of the canvas also strengthened the integrity of the structure. Within this basic order there are very complex inter-relationships which, between them, constitute first, a self-sufficient pictorial architecture and second, a representation of particular visual experiences. For Cézanne the motif never lost its importance.

The regularity of the block-like marks in Cézanne's mature style gave dramatic meaning to the occasional

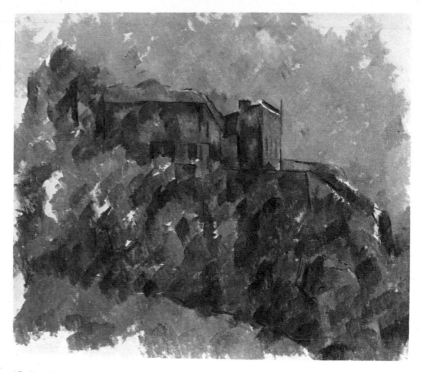

17. *Paul Cézanne*
Le Château Noir
1905–6, oil on canvas
27.5 × 32.5 in.
(69 × 82 cm)
Formerly Collection
Sir Kenneth Clark

irregularity, but for the most part the drama exists in incidents of colour, tone and form. Space-creating devices abound: sequences of colour, sequences of tone and the overlap of planes. Cézanne's statement that 'Nature for men is more a thing of depth than of surface' is as important as his humble discovery that 'painting is not sculpture'. To reconcile these two discoveries Cézanne used painting's surface to master sculpture's depth. Often a single series of marks can both create and defy depth. Sometimes it is more a question of separate sequences working against each other and in the long run it is a question of whole batteries of sequences building, by their total interaction, up to the vast dynamic realisation of the particular motif.

Line became a free agent in this complex, used more sporadically by Cézanne to counteract or intensify the contrasts and analogies of colour and tone. Its original importance as a contour which could adhere to, or be dramatically held away from the colour area it contained, developed in to a much looser approximation to colour 'edges'. Line was outlawed in Cézanne's campaign to build and control space by means of colour modulation alone. In his late works there were only occasional complete coincidences of 17 line and colour edge, at points of crisis or climax, and sometimes even this climax could be achieved by an absence of both line and colour—with a strip of bare

canvas. In some passages of line there seems no clear relationship to neighbouring colour areas at all, in others a 'contour' is composed of a whole sheaf of lines reaching from well inside the form to well outside it. This presentation of several alternative 'edges' simultaneously was one of Cézanne's ways of expressing the impermanence of appearances.

Cézanne defended the value of bare canvas in a painting in preference to any unresolved or ill-considered mark. To cover the canvas was no ambition in itself. In 'unfinished' works—and in Cézanne's mature painting it is difficult for us (and apparently was for him) to presume what 'finished' means—the importance of uncovered canvas during the painting's evolution is clear. The role of the bare patches in some of his greatest late paintings is a vital part of the structure. We need not consider them as empty spaces, or bits missing; we would lose a lot by doing so. The Cubists felt free to interpret them as very positive elements.

For Cézanne this whole flexible apparatus of picture-making was tied to his vision of the motif in particular, and to nature in general. He wrote that:

'the method of painting emerges on contact with nature. It is developed by circumstances. It consists of seeking the expression of what one feels, in organising sensations into a personal aesthetic.'

The degree of commitment to reality, and particularly the Romantic awe of nature were common to most of Cézanne's generation. This was the salient distinction between the late 19th century and the early 20th century. When Matisse first and then Picasso came to grips with the technical achievements of the post-Impressionists, they were not driven by, nor inhibited by any nature-mysticism. When the Cubists took up Cézanne's suggestion of juxtaposing different viewpoints of a given object, it was not amid the heat and frustration of landscape painting but in a relatively cool and detached experiment in reality and art.

'Nature and art being two different things cannot be the same thing' Picasso wrote. 'Through art we express our conception of what Nature is not'. (Statement to Marius de Zayas, 1923).

Parisian painting around 1905–6: Matisse, Braque, Picasso

'Matisse—colour. Picasso—form. Two great signposts pointing towards a great end' was Kandinsky's verdict on Parisian art of the 1900s. Matisse had dominated the first few years of the 20th century, preoccupied more and more exclusively with colour as a vehicle. At the moment when Picasso usurped his leadership of the avant-garde, Picasso himself was reaching a point where colour was of relatively little significance, even an embarrassment to him. Both owed and acknow-ledged a great debt to Cézanne. Although much of Cézanne's working life had been spent in hermit-like seclusion in Provence, by the early 1900s his work was becoming known in Paris. His paintings were regularly shown at Ambroise Vollard's Paris gallery—as many as 150 canvases in 1895; it was here that Matisse purchased a Cézanne *Bathers* in 1899. From 1904 to 1906, the year of his death, Cézanne also showed up to ten paintings at each annual *Salon d'Automne*. The sudden, dramatic recognition of his importance came around 1907. Fifty-six paintings were exhibited in a memorial section of the *Salon d'Automne;* seventy-nine watercolours were on view at the galleries of Bernheim Jeune. In October of the same year the painter, Emile Bernard, a fervent disciple of Cézanne, published his correspondence with Cézanne in the *Mercure de France.*

This revelation did not by itself change the course of art history, but it coincided with a restless change of direction in Picasso's art and with a general slackening of the spectacular initial impetus behind Fauvism. This meant that Cézanne's ideas were exposed at a time when artists were groping for something concrete in the way of formal ideas. Because of the existing situation, the presence of Cézanne weighed very heavily on the direction that French painting, and subsequently most European painting, was to take in the years following 1907. His influence finally broke the ties that still linked the French avant-garde with the decorative and expressive colour symbolism of the last decade.

After a decade of critical and exhaustive trial and experiment with Post-Impressionist ideas, Matisse's

18. *Maurice Denis*
Homage to Cézanne
(showing from left to right
Odilon Redon, Vuillard,
André Mellerio, Vollard,
Maurice Denis, Sérusier,
Ranson, Ker-Xavier Roussel,
Pierre Bonnard,
Marthe Denis)
1900, watercolour on paper
69 × 92.5 in.
(175 × 235 cm.)
Musée d'Art Moderne, Paris

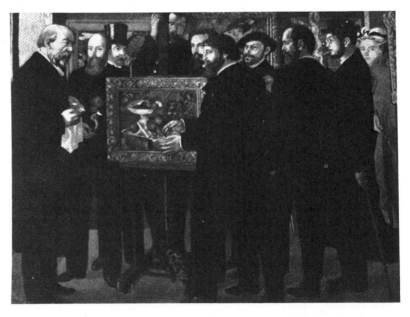

art liberated the role of colour for later European painting. He had gained a profound respect for Cézanne's methods of picture construction; he had drawn what he wanted from Neo-Impressionism, admiring the purity ot its colour marks but disliking its restless surface as well as its final, optical effect of greyness. By 1907 the path he had recognised led to a sort ot painting, serenely untroubled in its flatness, which depended for its construction on colour oppositions alone. It was a very personal assessment of painting's destiny and, in the short term, a lonely path.

The devices which Matisse had used and abandoned in his campaign for the purification and simplification of painting—analytical fragmentation, division or modulation of colour, tonal gradation and bravura brushwork as violent as anything previously known in Europe—were taken up by others, more or less prompt-

ed by his lead. The growth of the Fauve 'movement' between 1903 and 1906 was a testimony to his influence as much as anything else. Out of this rather ragged, aggressive association of very different artists came André Derain, who featured tor a while in the pre-history of the Cubist movement and Georges Braque who became one of its leaders.

As early as 1904, Derain was painting still-lifes, firmly articulated by a Cézannesque sense of structure and by 1906 he had already anticipated the move of his whole generation away from colour painting towards a more severe formality.

Braque's short participation in the Fauve movement was thoroughly consistent with the evolution of Cubism. He saw his Fauve paintings as his 'first creative works', (virtually nothing remains of an earlier date now). For the most part they lack the colouristic au-

19. *André Derain*
Still-Life
1904, oil on canvas
40 × 41 in.
(101 × 106 cm.)
Collection of C. Beron,
Garches

31

dacity of his contemporaries. Paying lip-service at least to the Impressionist tradition of 'paintings of light', the brushmarks with which he defines his landscapes have an immediate sense of pictorial architecture. Not only are they substantial, brick-like units of paint, but they strike up surface correspondences of colour and tone, cutting right across any illusion of atmosphere or space without wholly negating the illusion. These instincts predisposed Braque to re-

20

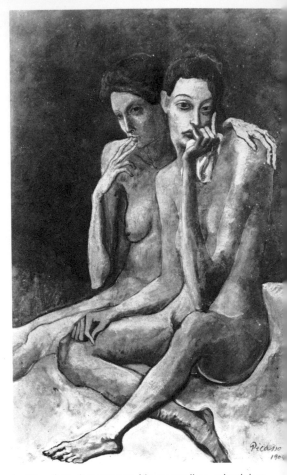

20. *Georges Braque*
L'Estaque, The Jetty
1906, oil on canvas
14.5 × 18.25 in.
(37 × 46.5 cm.)
Musée d'Art Moderne,
Paris

21. *Pablo Picasso*
The Two Friends
gouache on paper
21.5 × 15 in.
(55 × 38 cm.)
Private Collection, Paris

21,31

spond to Cézanne's discipline and to develop a more formal type of painting, even if his discovery of Cézanne had not been followed very soon afterwards by his meeting with Picasso.

1906 was the start of Braque's career. He had been led into Fauvism more by his friendship with two other Le Havre painters, Dufy and Friesz, than by personal quest. His first contact with Picasso in 1907—perhaps collision is the right word—virtually meant a second start. This second start was the beginning of Cubism. Picasso in 1906 was already an established artist, his first one-man exhibition in Paris some five years behind him, his first in Barcelona held at the age of sixteen. The years 1901 to 1906 had seen Picasso still much involved in the mysticism and emotionalism of the *fin-de-siècle*. His deep admiration of Van Gogh and obvious sympathy for the moods of Gauguin, Munch and Beardsley among others, are reflected in the near-suffocating pathos of his 'Blue' and 'Rose Period' paintings. Rich in technical experiment and

facility, they demonstrate his marauding eclecticism. Max Jacob was inspired to suggest that Picasso 'made conscious pastiches of everyone to make sure that he didn't do it unconsciously'. His search for ideas and formal starting-points was uninhibited and far-reaching and almost any available art was vulnerable to his invasion. His early raids on the French and English 1890s and on current and traditional Spanish art, were searches for both techniques and moods. These gave way around 1905–6 to an increasingly stringent concentration on formal values: form to the exclusion of content and of colour. Colour was seldom in itself a significant vehicle for Picasso.

In paintings like the *Portrait of Gertrude Stein* all 22 trace of the earlier emotionalism has gone, from the saturated anguish of the Blue period to the more fragile, bitter-sweet melancholy of the harlequins and acrobats. Colour is reduced to an almost monochrome brown-grey palette and there is the same severity in formal reductions and simplifications. The particular

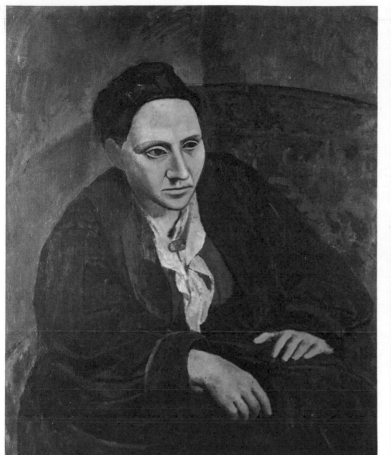

22. *Pablo Picasso*
Portrait of Gertrude Stein,
1906, oil on canvas
39.5 × 32 in.
(100 × 81 cm.)
Metropolitan Museum.
New York

23. *Pablo Picasso*
Two Nudes
1906, oil on canvas
59.75 × 36.75 in.
(182 × 92 cm.)
Museum of Modern Art,
New York
(Gift of G. David Thompson)

sort of formalisation he uses here is directly related to Iberian sculpture, which he is known to have studied in the Louvre at around this time. The head, according to Gertrude Stein, had been completely painted out after many unsatisfactory sittings and was painted in its final version in one day during her absence. That it was Picasso's conception of the head, embodying borrowed stylisations, is typical and crucial. From the start, Picasso's art was not regulated by the discipline of looking. His philosophy may have been educated by the reality around him, but his art was educated above all by other art and by the world of ideas.

Other works of 1906 show the same ruthless concentration on formal values, devoid of sentiment and sensuality. They also begin to show a new interlocking of the total structure. In the *Self-Portrait* the emphatic contour curves of the head and features are picked up by the neck of the vest, the sleeve and the forearm. The drawing of the hand and fingers, so refined and eloquent a part of many early portraits and figure studies,

is heavily economical. The figures of the *Two Nudes* 23 are massively, grotesquely realised as sculptural solids. The feline suppleness of his athletes has been replaced by a sense of energy that is primitive in its urgent simplicity. The background, although rather indefinite, shows its potential as solid when a dramatic diagonal crease above and between the figures breaks forward tangibly enough to be grasped by a colossal hand.

This relationship between the figure and the ground, cancelling out the absolute distinction that traditional painting had maintained between objects and the space around them, was to be a central concern of Cubism. It was implicit in much of the post-Impressionist art discussed earlier, as was the broken, divisionist technique with which Picasso and Braque were to explore it. But an influence from outside European art altogether—primitive African masks and carvings that he probably first saw in the winter of 1906 7 launched Picasso into the Cubist revolution.

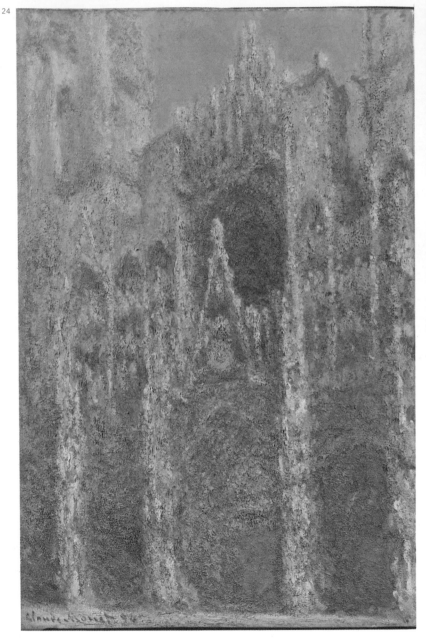

24. *Claude Monet*
Rouen Cathedral: Sunset
1894, oil on canvas
39.5 × 25.75 in.
(100 × 65 cm.)
Museum of Fine Arts,
Boston

25. *Georges Seurat*
Model seated,
study for Les Poseuses
1886—7, oil on board
9.75 × 6.25 in.
(24 × 16 cm.)
Louvre, Paris

26. *Paul Cézanne*
Sous-bois
c. 1895—1900, oil on canvas
31.75 × 25.5 in.
(81 × 65 cm.)
formerly Vollard Collection,
Paris

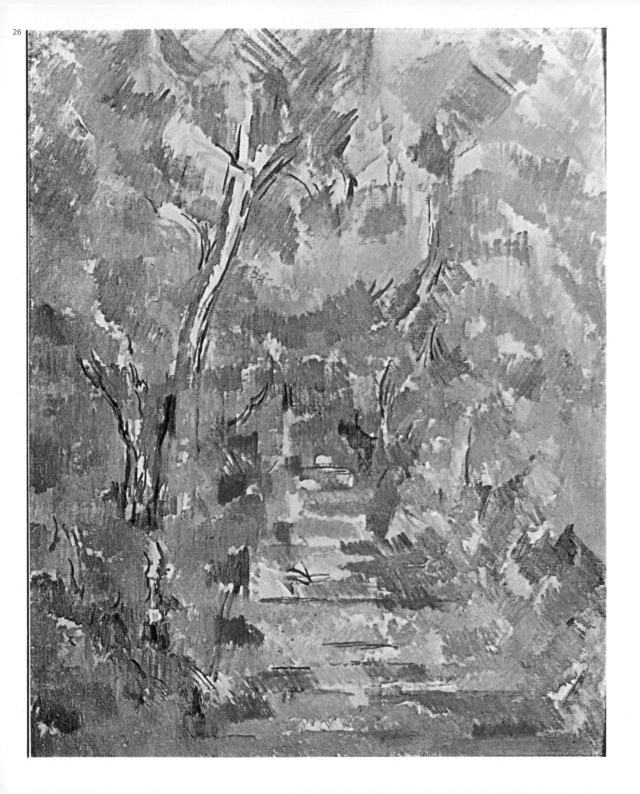

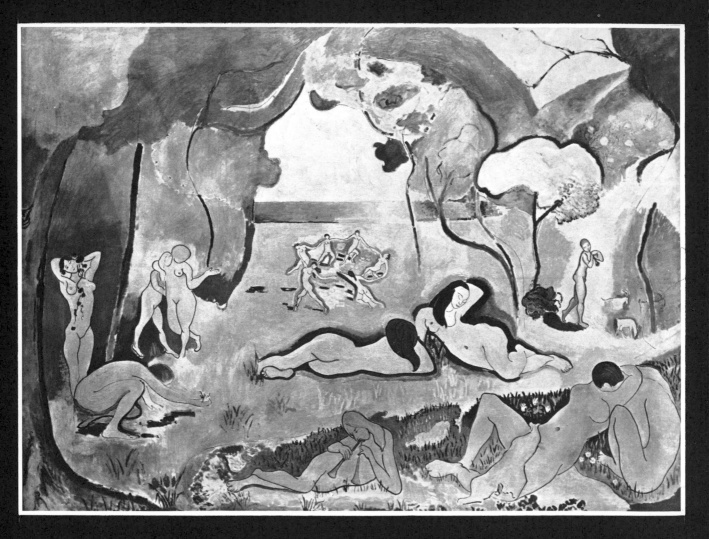

Les Demoiselles d'Avignon

This painting witnessed a major turning-point in Picasso's thinking. His earlier art had already demonstrated his great technical facility and his extraordinary powers of assimilation and formal invention. During

35 the execution of *Les Demoiselles d'Avignon* (1906/7), Picasso acquired a new degree of confidence to distort and invent forms. The critical factor behind this new development was his discovery of African tribal art. His assimilation of the formal freedoms of Negro art, not just stylistically but as a way of thinking, made possible a real break with existing concepts. His art from this point on was more than an extension of existing avant-garde or traditional ideas: he began to see the fundamental processes and principles of art differently.

From the outset, *Les Demoiselles* was obviously a project of particular importance. Roughly eight feet square, it is bigger than almost anything he had tackled earlier. The figures are about life-size. The title (from the rue d'Avignon, a Barcelona street renowned for its brothels) was added later and has no great significance beyond confirming his continued preoccupation with the lower levels of contemporary urban life. But this sort of subject, a large-scale painting of nudes, was almost certainly a conscious reference to tradition: to the whole European tradition of homage to the female nude as well as to its more recent treatment in post-Impressionist circles, most significantly by Cézanne and Matisse. Cézanne's great

36 series of *Bathers* occupies a major place in his late work and must have seemed to Picasso's generation like a standard to compete with. A close correspondence between some of the poses in *Les Demoiselles* and various Cézanne *Bathers* paintings has been recognised for some time.

The relationship to Matisse's painting may have been a more conscious competition, even parody has

27 been suggested. Matisse's *Joie de Vivre* had been exhibited in Paris in 1906, only a few months before Picasso had started work on *Les Demoiselles* and Gertrude Stein's account of the contemporary Parisian scene (in *The Autobiography of Alice B. Toklas*) suggests a competitive and critical awareness between the two artists. The contrast in subject between Matisse's Arcadian idyll and Picasso's contemporary interior emphasises their temperamental opposition. This apart there are remarkable similarities. The pose of the central *Demoiselles*, their arms bent provocatively back behind their heads, echoes traditional details of the *Joie de Vivre*. The starting-point for the *Demoiselles* was even closer to Matisse's next important

32 figure painting, *Le Luxe*, also of 1906–7. The role of the figure in both paintings is relatively passive. In both a highly resolved statement about the means of paint-

27. Henri Matisse
Joie de Vivre
1905–6, oil on canvas
68.5 × 93.75 in.
(174 × 238 cm.)
Barnes Foundation,
Merion, Pennsylvania

Picasso, Braque & Gris 1907-15

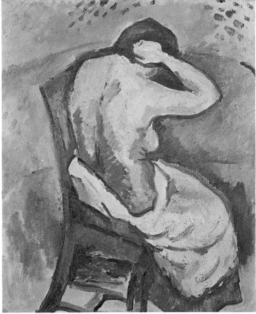

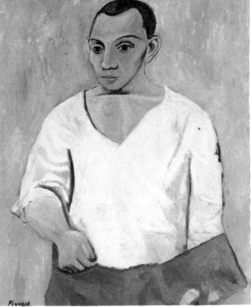

28. *Paul Gauguin*
Maternity
1899, oil on canvas
36.5 × 23.5 in.
(93 × 60 cm.)
Private Collection,
New York

29. *Georges Braque*
Seated Nude
1906–7, oil on canvas
21.75 × 18 in.
(55 × 46 cm.)
Collection of
D.H. Kahnweiler, Paris

30. *Pablo Picasso*
Self-Portrait
1906, oil on canvas
36.5 × 28.75 in.
(93 × 73 cm.)
Philadelphia Museum of Art
(A.E. Gallatin Collection)

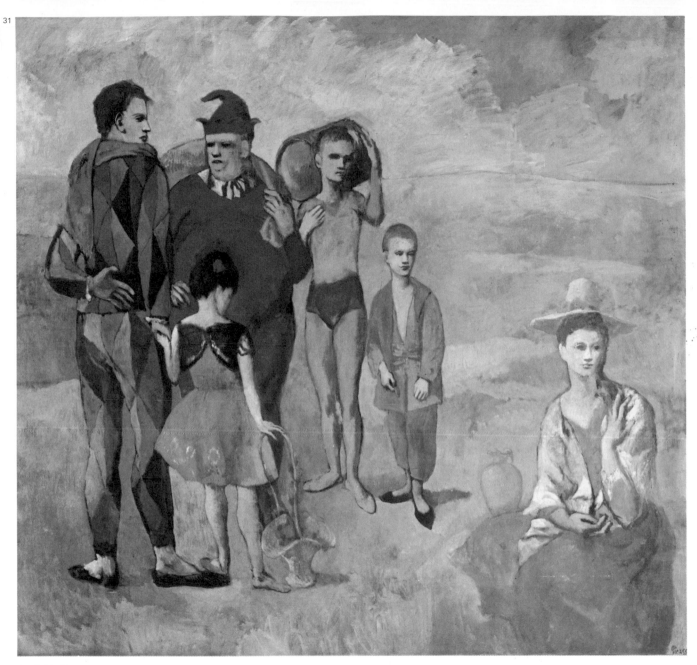

31. *Pablo Picasso*
Family of Saltimbanques
1905, oil on canvas
83.75 × 90.4 in.
(213 × 229 cm.)
Art Institute,
Chicago

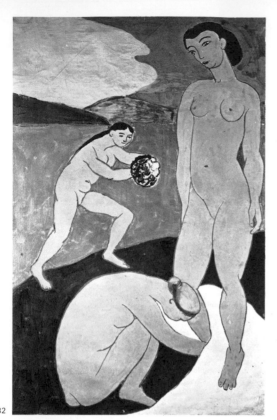

ing seems to have been the first objective. They share a ruthless simplification of drawing, a disdain of chiaroscuro and a dramatic compression of sensations of depth. The comparison is complicated because the *Demoiselles* does not represent just one starting-point, nor one conclusion.

Stylistic discrepancies prove that while it started as a conclusive resolution of Picasso's earlier ideas, the painting's integrity was subsequently shattered by the birth of quite new ideas. In the first phase of the painting, the sculptural and expressive qualities of the 1906 *Two Nudes* were refined. The anatomical dis- **23** tortions were contained in a simple schematic structure reminiscent of Catalan manuscripts. This linear stylisation 'defeminises' the figures. Compared with the wavering, intimate lines with which Matisse drew breasts and hips, Picasso's *Demoiselles* are fixed by impersonal straight lines and regular curves. In the unaltered parts of the painting like the two central nudes, the sophisticated and complete style in which Picasso began the painting is clearly visible. The dynamic tensions of the painting are not created by the complex colour-sequences of post-Impressionism. The colours, like Matisse's, are relatively flat and distinct: finely-tuned pinks and ochres for the figures, blue to white for the drapery and red to brown for the area beyond. It is the jagged linear structure, breaking across these colour-divisions, that knits the composition together. Through the network of drawn lines and sharp edges, the whole complex becomes a space-

32

33

32. *Henri Matisse*
Le Luxe II
1907—8, casein
82.5 × 54.75 in.
(209.5 × 139 cm.)
Royal Museum of Fine Arts
Copenhagen
(Rump Collection)

33. *Pablo Picasso*
Composition study for
Les Demoiselles d'Avignon
1907, pencil and pastel,
18.5 × 24.5 in.
(47 × 62.5 cm.)
Artist's Collection

34. *Pablo Picasso*
Study for
Les Demoiselles d'Avignon
1906—7, oil on canvas

less continuum, leaving little sensation of distinctions between positive forms and negative spaces. The effect is of a heated exchange right across the surface between tense curves and angles.

Some of Picasso's studies for the *Demoiselles* had 33 reflected the fluid linearity of Cézanne's late watercolours, but now there was a much stronger pressure on the surface. It is aggressive and engulfing: the supple curves have become scything arcs, the translucent colours opaque and immutable, as if the whole surface is packed out beyond its capacity with physical objects. In the first stage of the painting, it is this new quality of surface, negating traditional sensations of depth without destroying a sense of volume, that constituted the major revolution of the *Demoiselles* and its chief anticipation of Cubism.

Before it was finished, Picasso's restless invention broke out again. Some of the fine contours are crudely overdrawn, the atonal structure is savaged by coarse areas of Fauvist false shadow and the delicate colour fabric is torn by overpaintings of black, blue, purple, red and green. This violent second phase is concentrated on the two right-hand figures, but neither completely nor consistently so. The alterations take the form of savage, erratic raids on the integrity of the painting's first state. We can reasonably assume that the intervention was prompted by Picasso's discovery of primitive art.

Precisely what led Picasso to this close scrutiny of Negro sculpture—whether he was introduced to it by Matisse or Derain or Vlaminck; whether it was in the Trocadéro museum or a dealer's gallery or a studio or precisely when it happened is uncertain. The importance of the encounter is beyond doubt. So is the fact, despite Picasso's own denial, that the encounter took place at the latest during the execution of *Les Demoiselles d'Avignon*. Several accounts confirm, although again there is some disagreement about the date, that at around this time Picasso started to collect African and Polynesian carvings. What was important about Picasso's attitude to Negro art was that he penetrated the romantic cloud surrounding primitive objects and looked at them for the first time as just another sort of art. He recognised the tribal craftsman as an artist, detached from the 19th-century mystique of the 'noble savage'.

Negro art was not conditioned by European tradi- 39, tions of naturalistic illusion, nor by the technical 131 conventions of European Fine Art. It was concerned not with creating illusions but with making fetishes, totems and ceremonial masks. Picasso did not now abandon the European idea of an art of representation, although many of his paintings and objects bear a strongly ritualistic or fetish-like character. It was more a question of identifying himself with the formal con-

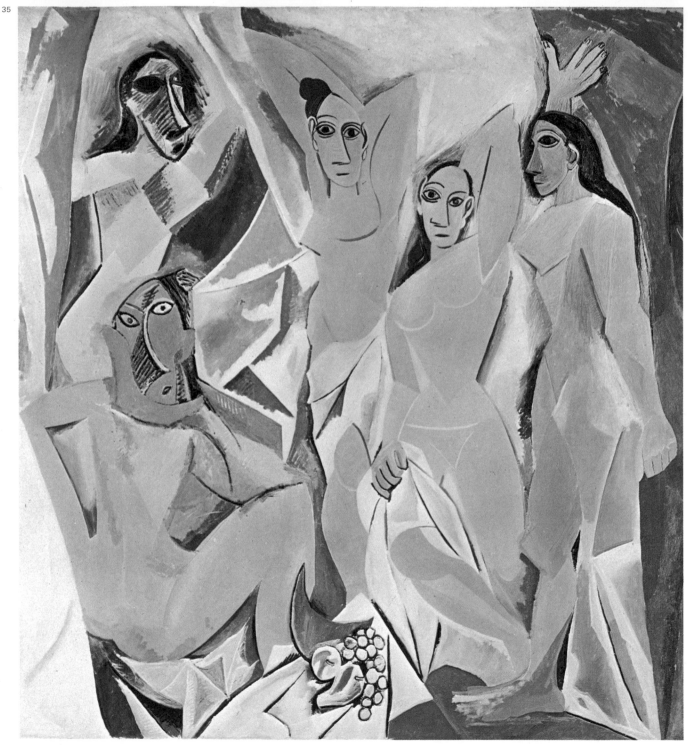

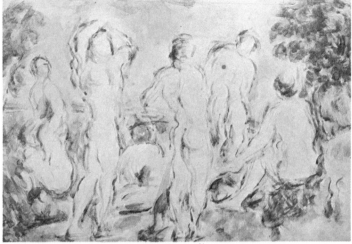

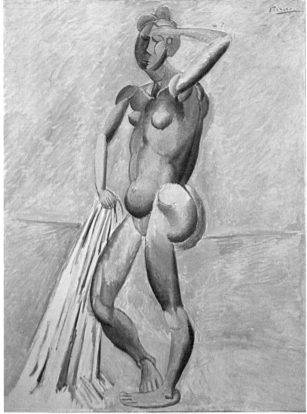

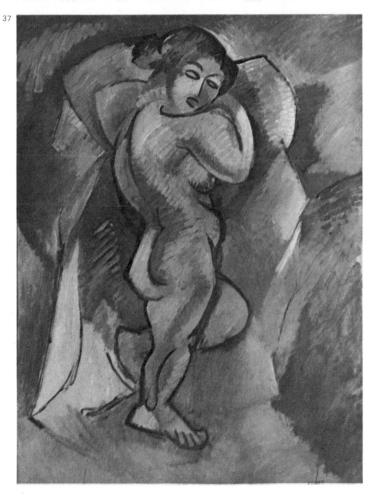

35. *Pablo Picasso*
Les Demoiselles d'Avignon
1907, oil on canvas
96 × 92 in.
(244 × 233.5 cm.)
Museum of Modern Art,
New York (acquired through
the Lillie P. Bliss Bequest)

36. *Paul Cézanne*
Bathers
c. 1895–1900, watercolour
7.25 × 10.5 in.
(18 × 26 cm.)
Collection of
Mr and Mrs Taft Schreiber,
Beverley Hills

37. *Georges Braque*
Grande Nue
1907–8, oil on canvas
55.75 × 40 in.
(141 × 101 cm.)
Collection of
Madame Cuttoli, Paris

38. *Pablo Picasso*
The Bather
1908, oil on canvas
51.25 × 38.25 in.
(130 × 97 cm.)
Private Collection

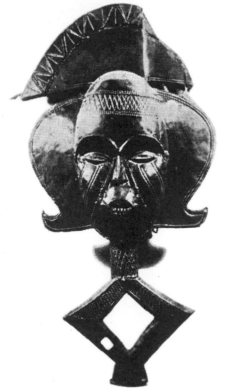

39. *French Congo
ancestral figure, bronze,
British Museum, London*

40. *Pablo Picasso
Dancer
1907, oil on canvas
59 × 39.5 in.
(150 × 100 cm.)
Collection of
Walter P. Chrysler, Jr.,
New York*

cepts of the primitive mentality and applying them to the problems of the modern painter.

The result can be seen in the repainting of the two right-hand figures of the *Demoiselles*. There is a new wilful arbitrariness in colour, in technique and particularly in the distortion and dislocation of the human anatomy, beside which the stylisation of the central figures appears highly naturalistic. The disorientated features and limbs of the squatting figure not only overthrow the traditional European homage to an ideal physical beauty, but also destroy completely the illusion of an object seen from a fixed viewpoint. Cézanne's art had already offered a sort of compromise between naturalistic illusionism and a free pictorial composition, but Picasso could now assert to Leo Stein: 'A head is a matter of eyes, nose, mouth, which can be distributed in any way you like—the head remains a head.' This liberated attitude to imagery underlies all the revolutions of Cubism.

Drawing confidence from the precedent of the tribal artist, Picasso no longer felt any obligation to the European tradition of illusionism. For the moment at least he did not pursue the expressionist potential of this freedom, nor the new freedom of materials that was implicit in tribal masks made from a bizarre as-

41. *Pablo Picasso
Jugs and Lemon
1907, oil on canvas
21.75 × 18 in.
(55.3 × 45.8 cm.)
Collection of Clive Bell,
Sussex*

42. *Georges Braque
Three Nudes
c. 1907, pen and ink
present whereabouts
unknown*

sortment of feathers, wood, cork, string, straw and so on: the importance of these aspects emerged later. Applying himself exclusively to the formal problems of painting in oil on canvas, he could see all art as creation rather than some sort of imitation. *Les Demoiselles d'Avignon* is a dramatic and historic document of this moment of recognition. Side by side we can see Picasso's refined and extreme conclusions about traditional European painting and the first violent signs of his freedom from it.

The energy generated by *Les Demoiselles* was impulsive and raw. The crudely experimental nature of Picasso's other paintings of 1907 maintains this vital **40,41** will to change, hovering on the brink of an unknown. Some of them, like *The Dancer*, make explicit reference to primitive art, but for the most part they express a new urgency through their dynamic formal language. Among the most strongly coloured paintings of Picasso's career, they are a succession of dramatically simple compositions. Still-lifes and figures are aggressively reduced to tensely opposed curves, cut through by coarse hatchings and scorings. At this point of ferment, Braque first met Picasso.

Early Cubism

The main approach to Cubism was a double path: one leading from Cézanne, the other from primitive art; the one analysis, the other invention. In 1907, in the paintings that followed the *Demoiselles d'Avignon*, Picasso was clearly more concerned with the formal and technical freedoms inspired by African sculptures and masks, while Braque was already reconciling the revolutionary aggression of the *Demoiselles* to his more systematic structuring of tone and colour.

Compared with the *Demoiselles*, Braque's *Grande* **37** *Nue* of 1907–8 may be a moderating statement, but in the context of his own work, the sober tenor of his Fauvism is here lifted to a new pitch. In a related **42** drawing of three figures, he is clearly formulating his own reaction to the Picasso painting—in the poses, in the tightly-packed masses of the composition and in a new crude urgency of rhythm and execution. The painting is basically an adaptation of the left-hand figure from the study. Compared with anything in Braque's earlier paintings, it has a stronger opposition of tonal areas, of simplified contours and violent hatchings and a closer affinity between the background spaces and the volume of the figure.

The other feature of the *Grande Nue*—again picking up a lead from the *Demoiselles*—is the apparent fusion of viewpoints in one pose. Braque had justified the drawing by saying that 'it was necessary to draw three figures to portray every physical aspect of a woman, just as a house may be drawn in plan, elevation and section'. In the *Grande Nue*, the straight pro-

file of the legs gives way to a generous three-quarter view of the torso, while the head and shoulders are an open marriage of several aspects. The same line serves more than one function in a far more literal way than Cézanne's two-way edges. For instance the outer profile of the buttocks reads as the right buttock in relation to the legs, but as the left buttock—with a nearer but smaller partner—in relation to the torso.

During the course of 1908, Picasso was drawn, probably under the influence of Braque's sustained concentration, towards a more controlled level of experiment. Since the *Demoiselles*, he had assembled figures out of disparate angular fragments rather than analysed them, until in a painting like the Hermitage *Nude with Drapery*, the urgent expression of the figure **46** was held and almost submerged within a very complicated linear scaffolding. The model, inasmuch as we can discern all of her—and her left leg is particularly elusive—is suspended against the broken background. This ground is quite as strongly articulated as the figure. It is as if the model and the setting were pushing respectively back and forwards against each other; as if the model is reclining and we see her from above as she sinks back, half-engulfed by the drapery. The general ambiguity of object and space relationships now spreads right across the surface, and the broken quality of the surface is much closer to Cézanne and to Post-Impressionism generally than to the *Demoiselles*. The triangles of darkest tone most suggestive of void, are also suggestive of solid. Most of the other planes

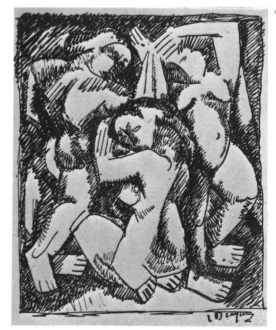

42

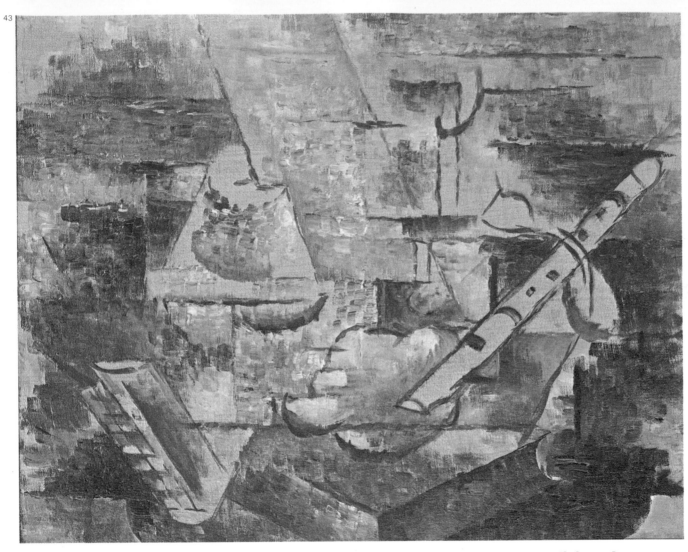

43. *Georges Braque*
Still-Life:
Flute and Harmonica
1911, oil on canvas
13 × 16 in.
(33 × 40.5 cm.)
Philadelphia Museum of Art,
(A.E. Gallatin Collection)

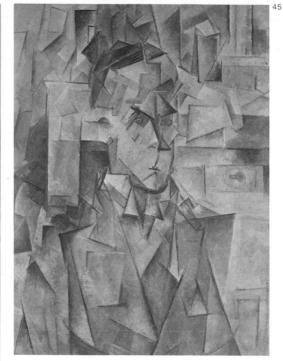

45. *Pablo Picasso*
Portrait of Wilhelm Uhde
1910, oil on canvas
30.75 × 22.75 in.
(81 × 60 cm.)
Private Collection, London

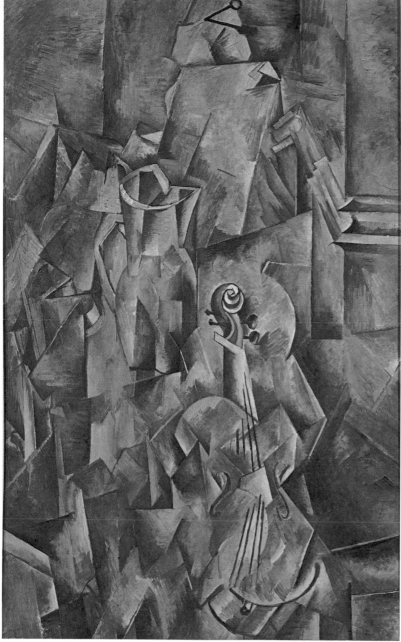

44. *Georges Braque*
Still-Life with Violin
and Pitcher
1909—10, oil on canvas
46.25 × 28.75 in.
(117 × 73.5 cm.)
Kunstmuseum, Basle

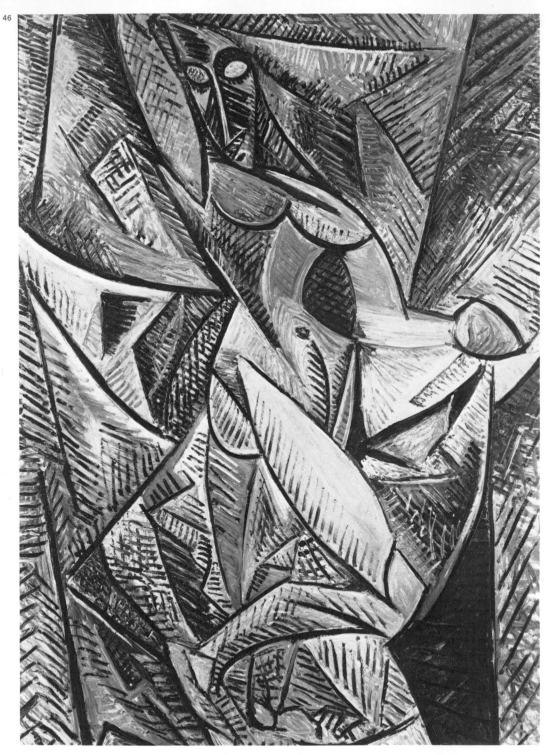

46. *Pablo Picasso*
Nude with Drapery
1907, oil on canvas
59.8 × 39.75 in.
(152 × 101 cm.)
Hermitage, Leningrad

47. *Pablo Picasso*
Nude in the Forest
('La Grande Dryade')
1908, oil on canvas
73 × 42.5 in.
(185 × 108 cm.)
Hermitage, Leningrad

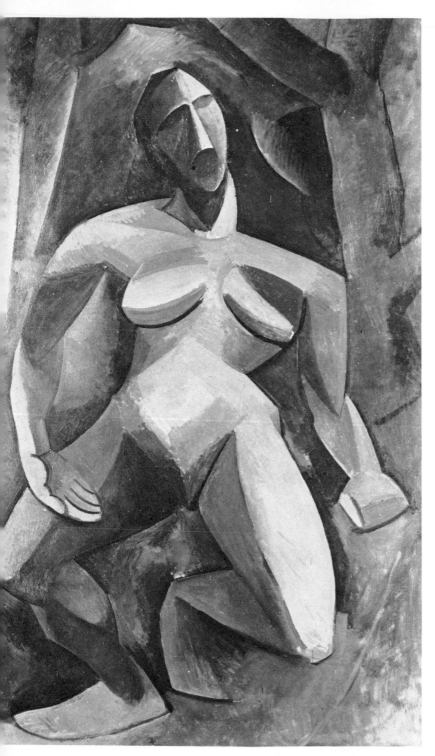

too have dual attributes—of belonging to a point in depth, but also of being magnetised to the surface.

From this proto-Cubist system, Picasso reverted in some paintings of 1908 to a simpler language. The heroic *Nude in the Forest* is more sculptural in feeling; **47** the figure retains its distinct identity and the background is a toned-down complement. The emotional charge of the figure, which was so blatant in the 1907 nudes and dancers, is also reduced. In this nude—also known as *La Grande Dryade* Picasso was at a comparable stage to Braque's *Grande Nue* and to Derain's *Bathers* of the same year. In varying degrees they were **49** all reconciling an extreme freedom, more or less inspired by primitive art, with a tight formal discipline, more or less derived from Cézanne. Differences between them are evident enough—the dynamic edge of Picasso, the sensuality of Braque, the softer and more conservative poetry of Derain—but at this point they were remarkably close.

Picasso and Braque were to stay that way during the next six years. In another nude, *The Bather* painted **38** late in 1908, Picasso's conversion to a moderate Cézannesque language is clear. The Cézannesque palette based on an opposition of warm to cool, of red/brown to blue/green, that he used in *La Grande Dryade* has mellowed to a watercolour translucency. But at the same time, perhaps because of the sober language, Picasso's outspoken redistribution of the figure's components seems even more expressive. The buttocks are undisguisedly grafted to the side of the torso. The 'multiple-viewpoint' freedom makes the figure appear to be opened out like a filetted sardine and we get three-quarter views of back and buttocks as well as of breasts and pelvis. The legs are left to come to some sort of compromise together and the raised arm emerges from a strange invented socket that acknowledges both viewpoints. The same sort of anomaly exists in Braque's *Grande Nue*, but they are stated here with a deadpan finality that is almost surrealist.

The same freedoms and distortions when applied to landscape or still-life never obtain this surrealist quality —a distinction that was already clear enough in Cézanne's œuvre. In the landscapes that Picasso and Braque painted in 1908–9, the rearrangement of forms **48,50** is no less aggressive, but considerably less emotive. In these pictures Cézanne's inspiration is very evident. First, there are strong stylistic similarities: the reduced palette, the division of the motif into consistent and homogeneous planes or facets and the regularity of the brushmarks within these planes—all of these things creating great surface integrity. If anything the traditional sense of volumes in space is more clearly present in these works of Picasso and Braque than in Cézanne's paintings of two or three years earlier. It was, after all, these paintings of Braque's that first earned the

48. *Georges Braque*
Houses at L'Estaque
1908, oil on canvas
23.75 × 23.5 in.
(60 × 59 cm.)
Kunstmuseum, Berne
(Hermann Rupf Collection)

49. *André Derain*
The Bathers
1908, oil on canvas
70.75 × 98 in.
(180 × 225 cm.)
present whereabouts
unknown

50. *Pablo Picasso*
Reservoir, Horta de Ebro
1909, oil on canvas
28.6 × 23.6 in.
(73 × 60 cm.)
Private Collection, Paris

51. *Henri Rousseau*
The Sleeping Gypsy
1897, oil on canvas
51 × 79 in.
(129.5 × 200.5 cm.)
Museum of Modern Art,
New York (Gift of
Mrs Simon Guggenheim)

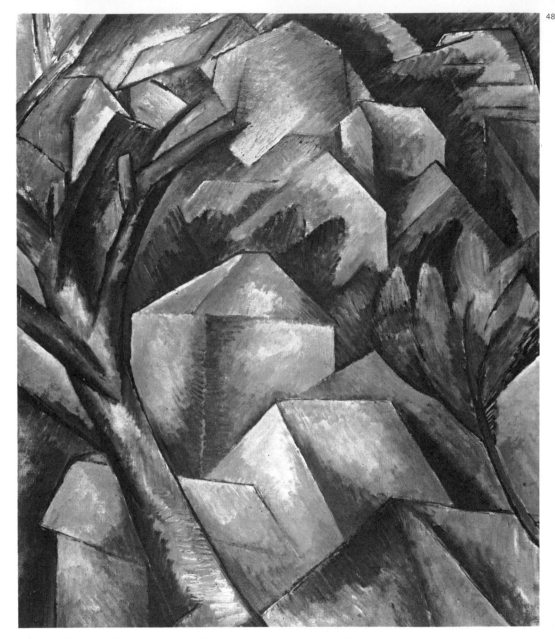

nickname 'Cubism'. The volumetric effect is caused by their emphatic use of contours (while drawing had become anathema to Cézanne) and also because they employed tonal gradation (while Cézanne relied more upon colour modulation for his perspective effects). This more sculptural preoccupation is also expressed in Picasso's interest in carvings, reliefs and masks—in the structuring of three-dimensional objects—as a neces-

sary part of his investigation of painting. His sympathy with a painter like le Douanier Rousseau emphasises both his appetite for new ideas and his interest in a language of monumental simplicity and mass. In 1908 Picasso had bought a Rousseau painting. In 1909 the forms of *The Reservoir*, in all their austerity, **50,5** relate to the singular clarity of Rousseau's naive vision as much as to the multiplicity of Cézanne's structures.

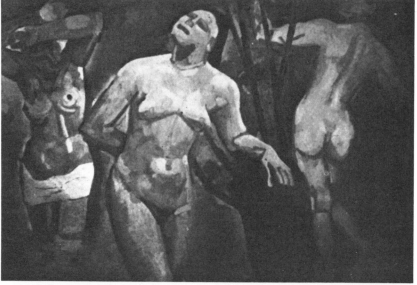

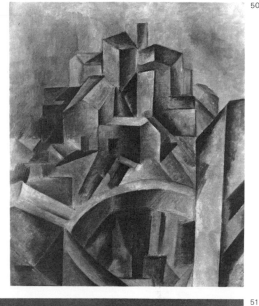

Analytical Cubism

Between 1909 and 1911, Picasso and Braque extended and transformed Cézanne's language. The volumes are pared thinner and thinner; the tipping of planes into depth is slowly moderated until most of them are parallel with the surface, the space is more and more compressed until it is shallow to a point far finer than Cézanne's tightly-controlled 'picture box'. By 1911/12 they had far outreached Cézanne's implications. His sincere and persistent belief that study of the motif was the real solution to all the painter's problems was clearly not the basis of Picasso and Braque's work by this time. By 1911 they had become wholly absorbed in the technical problems of representing reality in art. The distance between the coherent artifice of traditional 'realistic' art and the incoherent processes by which we experience our environment— an important part of what had bothered Cézanne—was now unforgettably clear. (Primitive art had accelerated this clarification). The paintings of 1910–11 saw Picasso and Braque probing further and further into the paradox of realistic illusions and gradually refining the balance in which the spectator was poised, between the internal world of the painting's structure and the external world of its references to reality. By 1911–12 that balance had slipped in almost total favour of the internal structure. The term 'hermetic' sometimes applied to late Analytical Cubist paintings arises from their vacuum-sealed autonomy, apparently devoid of external references—despite their titles.

This point, at which the language of painting appeared to be isolated from all commitments except to its own physical identity, was the basis from which many artists later moved to an art totally and finally devoid of objective figuration. It was scarcely an art which could still be called 'Analytical'. When external references were reintroduced into Cubist art, they were of a very different nature. .

In their paintings of 1909–11, the body of works which are usually defined as 'Analytical Cubism', the landscape was virtually abandoned as a motif. With a few exceptions the paintings are of figures and still-lifes. What is most striking about the motif in the earliest of these pictures is the contrast between those elements or parts of elements which are realistically transcribed and those which are taken to so sophisticated a state of analysis that recognition is at least very

52 difficult. Picasso's *Seated Nude* of 1909/10 only emerges from its sympathetic background through the strong lighting and simple lines of breasts and arms.

43 In Braque's unfinished *Flute and Harmonica* of 1910, the flute is embarrassingly literal amongst shadowy hints of books and glasses, while in his famous *Still-*

44 *Life with Violin and Pitcher*, 1909–10, the neck, strings, f-holes and base of the violin, the lip of the

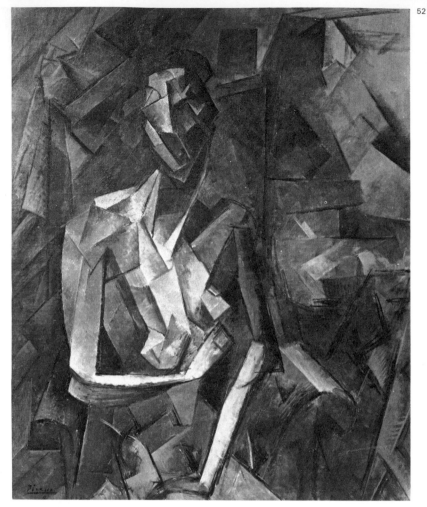

52. *Pablo Picasso*
Seated Nude
1910, oil on canvas
36.25 × 28.75 in.
(92 × 73 cm.)
Tate Gallery, London

pitcher and above all, the illusionistic nail at the top, all fix the subject-matter of the picture very powerfully when most of the other forms could equally well belong to a mountain landscape. Given these strong external references, we acquire a sense of security about the sort of motif we are confronting, and can entrench our security by proceeding to identify less obvious references.

On closer analysis the *Still-Life with Violin and Pitcher* contains few other references anyway. The strong horizontals towards the top on the right, which break in and upwards, represent a moulding of some sort and the sudden clarity of a little jagged dog-ear above suggests a sheet of paper or card. At the top of the picture the canvas is divided into three (the division is echoed lower down) suggesting a central screen or recess. For the rest the surface is covered with a suc-

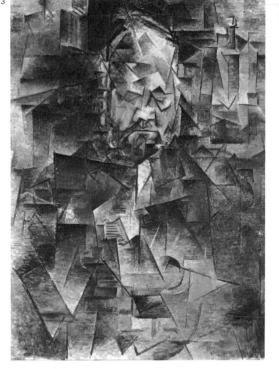

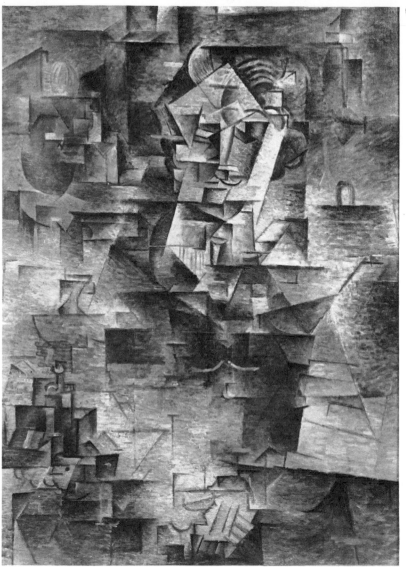

cession of planes. 'Planes' seems the best word since the use of lines and shading does suggest many flat surfaces, some parallel to the picture surface but mostly inclined at an angle towards it. The impressionist looseness of handling and the all-over distribution of the limited palette—blue/grey to purple/brown—do nothing to clarify the sequence of planes. They push the planes closer together, preventing any deep-space relationships.

In the objects that we can easily identify, the violin and the pitcher, the fragmentation again suggests more than one viewpoint. We see the straight as well as the elliptical qualities of the pitcher's base; the separate and the belonging qualities of its beak-like lip; two interpretations of its waist—graphic profile to the right, sculptural meeting of forms to the left. Similarly in the violin, clearly identified by its characteristic attributes, the profile and section of its highest rounded shoulder are combined in one form; the rise and fall of the strings across the bridge is stressed, but the abbreviated strings barely touch the bridge, allowing it to become just another angular plane.

The reassembly of the whole complex has a very subtle and refined continuity compared with the bald masses of his 1908 L'Estaque landscapes. Apart from an implication of deeper space to the right of the violin's waist and a general fading off into softer emp-

tiness in the top corners, the complex of small flat pieces is compressed towards the surface. The flatness of this shallow relief and the flatness of all the pieces is thoroughly compatible with the actual rectangle of the canvas. And yet the image is obviously not flat. Its flattened continuity is achieved without sacrificing the physical identity of the objects, without losing a very luminous quality of light and without in any part of the picture losing the three-dimensional illusion of chiaroscuro. In fact the reduced palette exaggerates the importance of tonal sequences and Braque later explained: 'I felt that colour could create sensations that

53. *Pablo Picasso*
Portrait of Ambroise Vollard
1909—10, oil on canvas
36.25 × 25.6 in.
(92 × 65 cm.)
Hermitage, Leningrad

54. *Pablo Picasso*
Portrait of
Daniel-Henri Kahnweiler
1910, oil on canvas
39.6 × 28.6 in.
(100.5 × 73 cm.)
Art Institute of Chicago (Gift of Mrs Gilbert W. Chapman)

disturbed the space (in my paintings) and it was for that reason that I abandoned it.' (*La Peinture et Nous*, p. 14).

Only the nail at the top of the picture disturbs the spatial continuity. The dilemma that its problemmatic alien presence createś emphasises the integrity of the rest of the composition. It is always described as the '*trompe-l'œil* nail', but the nail itself is graphically, almost diagrammatically drawn like the violin strings, with no highlights on its shaft and even a hint of the background tones showing through its head. What distinguishes it from everything else is first its uncomplicated clarity, implying a single viewpoint, and secondly the strong realistic shadow cast across the ground it transfixes, implying a single light source. Its naturalism conflicts with the gently elusive space of the still-life almost strongly enough to look like a real nail pinning up a reproduction of a cubist painting. And yet the nail is so near the actual edge of the canvas that it is obviously as flat and as painted as the rest of the picture. Its inclusion can only have been an ironic gesture by Braque about the artificiality of illusionism.

Picasso's three great Cubist portraits of Vollard, Uhde and Kahnweiler painted between the winter of 1909–10 and the autumn of 1910, are with the Braque still-life, the masterpieces of early Cubism. Through the three paintings, painted in the above order, the poise between the painting as external image and the painting as internal structure grows more poignant. They are clearly still portraits. Vollard, whose features are well enough known from portraits by Cézanne, Renoir and others, is easily identifiable even to us. Wilhelm Uhde, so the legend goes, was recognised in a café by a stranger whose only previous knowledge of him was Picasso's portrait. But in the Kahnweiler por- 45 trait, last of the three, the presence of the sitter hovers like a ghost behind and amongst the planes.

53 The Vollard portrait is comparable to Braque's still-life inasmuch as the comprehensive statements about one main motif, the head—emphasised here by a pointed localisation of flesh colour—are so persuasive that we are predisposed to identify shoulders, sleeves, lapels, cuffs, buttons and hints of an interior setting as well. Littered with clues, the field is rich in possibilities for the connoisseur. Robert Rosenblum sees the dark rectangle below and to the right of Vollard's head as a work of art being critically appraised by the dealer. Edward Fry, with determined perception, sees the faint rounded forms to the left of Kahnweiler's head as remnants of the Polynesian carvings that hung on Picasso's studio wall. Both ideas are rewarding and would fit with the liking for pictorial narrative and the affection for objects that pervade Picasso's Cubism.

What is above all clear from the three portraits is how far the geometric fragmentation had become an artistic style as much as a means of analysis. It is by no means possible to explain all the fragmentation of Vollard's head for example as the product of several combined viewpoints offering a sum of its characteristics. Indeed the planes that intersect the forehead add very little to our understanding of its character; in a sense they are closer to the vicious stripes that articulated the masks of the *Demoiselles*. The miracle is that from this shattered mass of particles, so powerful and coherent an image of the man can emerge at all.

The presence is less physical in the Kahnweiler portrait. We feel more clearly that this refined crystalline 54 structure, illuminated from within by soft, diffused light sources is endowed with attributes of the motif, rather than the other way round. Compared with the Vollard and Uhde portraits and with Braque's *Still-Life with Violin and Pitcher,* the variety of axes is reduced. Their explosive collision of diagonals is tempered to a static alignment of planes, dominated by the horizontal. The sophistication of the surface is elaborated by drifts of small brushmarks that again stress the horizontal axis. This brick-like texturing, more like Neo-Impressionism than Cézanne, was a crucial part of the refined Cubist technique. In the *Portrait of Kahnweiler*, the darker mass of tones in the centre concentrate to suggest the sitter's body, an object in space. But the looser, atmospheric passages at each side, delicately modulated within the near-monochrome palette, are enriched by a tactile presence of paint on the surface, which by its physical weight holds these recessive areas up to the picture plane. Kahnweiler was and obviously is the literal subject of the picture (he recalls sitting for the portrait at least twenty times), but the technical subtleties weave so intricately in and around the subject, like developed variations around a melody, that this fabric asserts an equal claim as subject.

The crisis of Analytical Cubism; the introduction of typography

The critic Jacques Rivière listing 'The Mistakes of the Cubists' in 1912 gave the 'third and perhaps last mistake' as follows:

'…if the painter gives to what separates the objects the same appearance as he gives to each of them, he ceases to represent their separation and tends, on the contrary, to confuse them, to weld them into an inexplicable continuum.'

('Present Tendencies in Painting', *Revue d'Europe et d'Amérique,* Paris, March, 1912.)

By 1911 Analytical Cubism appeared to have reached just such a stage. There were no clear-cut separations between objects and little distinction between objects and spaces. The analysis was more of painting itself than of a motif. It now seemed to be a question of painting being a matter of colour, drawing and shad-

ing, of illusion and of paint on the surface, which could be distributed at will and still constitute a painting.

66 Braque's *Man with a Guitar*, given the title, is still traceable through a few identity-clues, but in Picasso's
55 *Toreador Playing a Guitar*, even given that title, the last reasonable vestiges of representation seem to have disappeared. The various elements of the medium of painting are isolated and taken apart, then pushed to a point where they achieve a self-sufficient identity, working inter-actively much as they did in Cézanne's art but no longer harnessed to his illusion of visual truth. The independent role of line grows dominant, overlaying and ordering the fluid passages of painterly marks. Freed from external references, Cubism's ambition to represent three dimensions without compromising the flat surface was now realised.

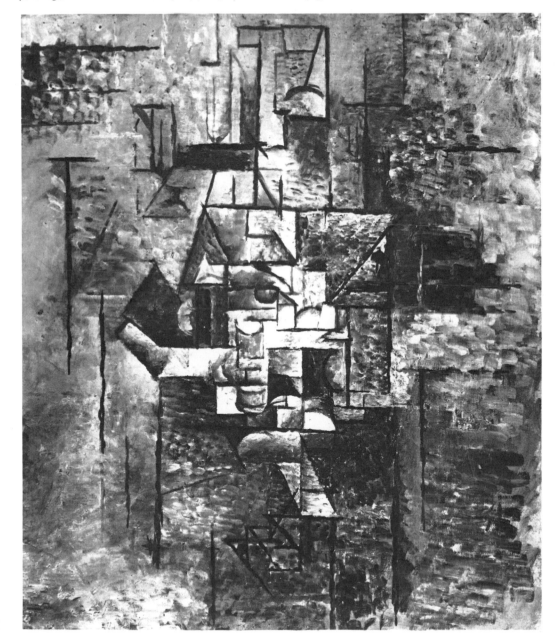

55. *Pablo Picasso*
Toreador playing a Guitar
1911, oil on canvas
25.5 × 21.5 in.
(65 × 54 cm.)
National Gallery, Prague

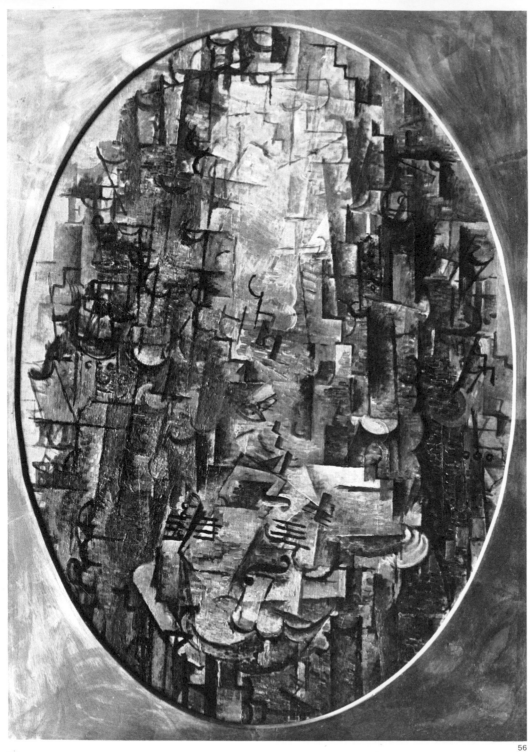

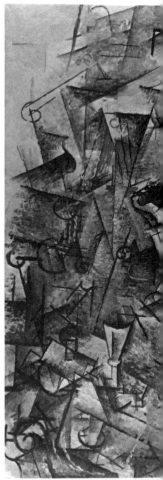

56. *Georges Braque*
Man with a Violin
1911, oil on canvas
39.25 × 28 in.
(99.7 × 71.1 cm.)
Bührle Collection, Zurich

57. *Georges Braque*
Still-Life with Violin
and Harp
1912, oil on canvas
45.75 × 31 in.
(116.2 × 78.7 cm.)
Kunstsammlung Nordrhein-
Westfalen, Düsseldorf

56

56 57

The *Toreador* is an ambiguous configuration of mainly straight lines, some of them coinciding with tonal areas, which thins out into spaces towards the edges of the canvas. The use of an oval canvas—as in 56 Braque's *Man with a Violin*—eliminates even these spaces and the most open area in *this* painting is within the structure, at the position of the head, as if deliberately inverting the role of this traditionally focal area in Cubist figure-paintings. Just as the rectilinear structures of most Cubist paintings echo the rectangular shape of the canvas, so here the lines and rhythms are chiefly complementary arcs and swelling curves. The fragments of the violin towards the bottom of the oval are no longer descriptive, but symbols written into the structure.

It is difficult to imagine these canvases painted in front of a motif. Picasso had often worked without a model earlier and certainly the subjects painted and the emblems selected to denote them were so much second nature to the artists by now, that such direct confrontation would no longer serve a critical function. In a slightly later painting, *Still-Life with Harp and* 57 *Violin*, Braque scatters and echoes the emblems more freely throughout the composition. More than an analysis, this sort of painting is an assembling of parts, some of which are ready-made devices or symbols to denote rather than describe the external world. Included in this still-life (middle right) are four letters 'E M P S' from the word *temps*. Here Braque has done almost all he can to disguise the fact that they are letters, tilting them into the complex of angles and dragging tone up to their lines to suggest edges.

The introduction of letters into a Cubist painting, more clearly than Braque's illusionistic nail of 1909–10 but in a very similar way, is a quotation from another language, another dimension of communication. Inasmuch as letters are signs, they are quite in keeping with the abbreviated symbols of instruments, etc, that Picasso and Braque had been using already. But at the same time they offered a very different sort of challenge to the rest of the painting. This duality is clear in two 67, paintings of 1911, *Le Portugais* and *Ma Jolie*.
71 First of all the words or fragments of words serve as part of the subject-matter. In *Le Portugais*, a picture reputedly inspired by a café entertainer, the characters (letters and numbers) can read literally as part of a poster fixed to a surface behind the figure. In a freer sense, more in keeping with the flexible Cubist approach to subjects, the word 'BAL' is a sub-title to the theme of entertainment. Our readiness to read the word ignores the fact that the 'A' is actually an inverted 'V'. In *Ma Jolie*, the words provide the title. 'Ma Jolie' was apparently Picasso's pet name for his current girlfriend (possibly the sitter) as well as being the title of a popular song. In these senses the writing is the same

sort of oblique external reference as the musical symbol to the right, another emblematic allusion to the content. Considering the importance of titles generally in Analytical Cubism—they are often the critical lead-in to the content—it is quite in accord with Picasso and Braque's ambition for the self-sufficiency of a painting that the title itself should be built into the structure.

Typography has strict formal attributes as well. Its straight lines and regular curves, correspond very happily with the formal language of Analytical Cubism. But letters are essentially two-dimensional, belonging by their very nature to the flat surface. Gertrude Stein, probably quoting Picasso, says that he used them 'to force the painted surface to measure up to something rigid' (*Alice B. Toklas*). Braque said of letters that 'these were forms which being themselves flat were not in space, therefore by contrast, their presence in the picture made it possible to distinguish between those objects which were in space and those which were not.' So as well as adding a new dimension to the content of their pictures, they both saw typography as contributing a new fixed standard of actuality.

In practice, the place of letters in Cubist space is never as cut and dried as Braque describes. Even in *Le Portugais* where their flat, tightly-stencilled nature makes them look like print, several brushmarks of colour are dragged across their edges. Their tone value too is rather faded and these two things draw the letters back into the shallow space of the painting. The letters in other paintings as well seem to drift in and out of space, sometimes latching on to forms beneath them, sometimes only half doing so, sometimes floating clear as if painted on the glass in front.

One of the most important implications of Analytical Cubism to younger artists was the freedom of its attitude towards its subject-matter, towards real motifs. This was seen not as a disregard for reality, but quite the reverse—as a new respect for reality. Braque stressed that his intention was 'always to get as close to reality as possible' and the Russian painter, Malevich, could see later that 'the Cubists have been the first to discover the riches contained in the object. They have been the first to perceive the reality of the object, and we are bound to say that only in Cubism has realism attained its true significance, with the object again becoming real through the prism of Cubism'. (*New Art and Imitative Art*, 1928).

The new 'prismatic' realism of Cubism consisted in an approach to the object that was not tied to a unique situation in time or space. Each image embodied a multiplicity of object-space relationships that exploded the traditional bases of European painting and sculpture. The succession of simultaneous events across the surface of an Analytical Cubist painting and even the ambiguity of this sequence were seen as a

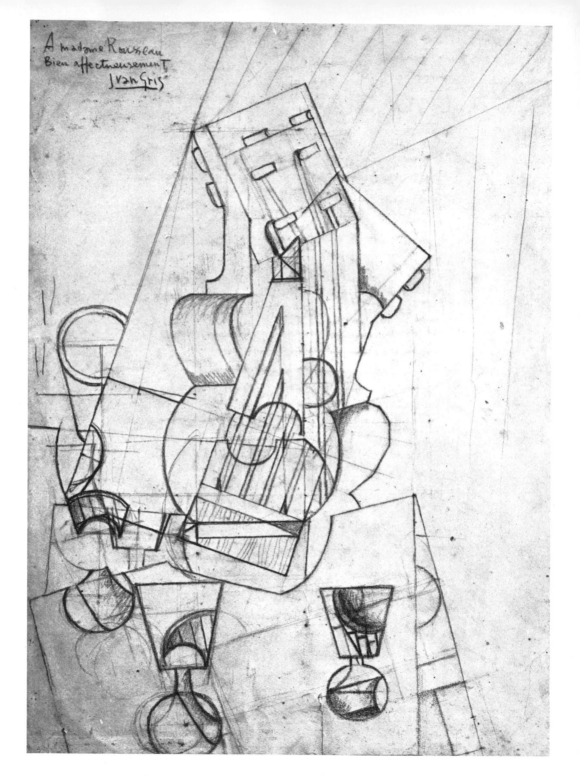

58. *Juan Gris*
Study for Still-Life
c. 1913, charcoal on paper
present whereabouts
unknown

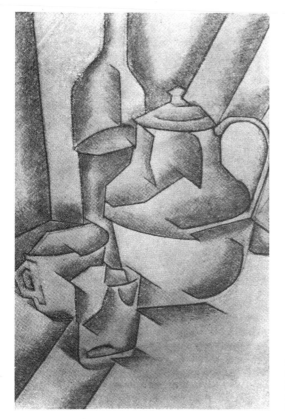

59. *Juan Gris*
Still-Life
*1912, pencil on paper
present whereabouts
unknown*

more real parallel to human experience than the contrived convention of an artist confronting a portrait sitter or a still-life group from a rigidly fixed point in space and painting them as if in one rigidly fixed point in time. Monet's Impressionism was an increasingly painful attempt to resolve the time problem realistically; Cézanne was still inhibited by the space situation, recognising that if, while sitting on his stool in front of the landscape, he so much as bent a little to the left or right, he would see half a dozen other different motifs.

When the Cubist paintings were still as obviously descriptive as Picasso's portraits and Braque's still-lifes of 1910, the fragmented nature of the image did offer a parallel to the many levels of experience and perception—some of them to do with depth or height, some with colour, light or texture, some with a kinetic sequence—that comprise a total visual acquaintance with the object. With the development into the hermetic phase of Cubism, when the identity clues became so elusive that external reality was virtually obscured, the fragmentary or prismatic structure lost something of this total revelation. The inclusion of words, adding in their literal readability another dimension of approach to the subject, offered a dramatic

release from hermetic obscurity. The logic of this solution—at the very moment when titles were vital clues to the decoding of Cubist enigmas—seems disturbingly simple.

The early paintings of Juan Gris

By nature, Juan Gris was a more calculating artist than Picasso or Braque. Heavily indebted to their ideas, almost all of his work has its direct or indirect origin in their paintings, but he approached them with an intellectual circumspection and a technical reserve that produced a very different sort of Cubist painting. His deep, almost puritanical self-consciousness withheld from him the sort of free release into spontaneous improvisation that Picasso and Braque enjoyed and he seemed half afraid of (and at the same time half in love with) sensuality in painting. Even at one of his most self-confident phases, he confided to Kahnweiler that: 'I never seem to be able to find any room in my pictures for that sensitive, sensuous side which I feel ought always to be there....I find my pictures excessively cold' and then went on to justify himself—'One must after all paint as one is oneself. My mind is too precise to go dirtying a blue or twisting a straight line' (Dec. 14th, 1915). His instinct for precision meant that the dirtying of a blue or the twisting of a straight line was a very self-aware action, whereas in the Cubist paintings of Picasso or Braque, this sort of adjustment constantly took place on the working surface of the canvas, almost intuitively.

His writings and his work produce strong impressions of the intuitive having been tested and resolved, intellectually and in preparatory drawings with a degree of finality unparalleled in the work of the others. In the Analytical paintings of Picasso and Braque the whole working process is exposed—the evolution of the painting from white canvas to final state is what constitutes the painting's appearance. But in the context of Gris' more inflexible technique, alteration meant the substitution of another fully resolved statement, concealing the first.

One senses from his letters that he was very much aware of the magnitude and the shadow over his art of Picasso and Braque in a way that must have intensified his self-awareness as an artist. To a degree the awareness was mutual, at least with Picasso. According to Gertrude Stein, Gris was the only contemporary whom Picasso 'wished away'. On the other hand, Picasso saw Braque in the same light as he saw James Joyce—'the two incomprehensibles that everyone can understand'. Gris' respect for Braque was considerable; he experienced a terrific sense of relief when, after the war around 1920, he began to admire Braque's painting less than before—as if a great burden of awe had at last dropped from his shoulders. In

many ways there is a closer affinity between the work of Braque and Gris, particularly after 1912, than between either of them and Picasso.

It was inevitable that Gris should feel very aware of both the older artists. His serious commitment to painting was initiated by the work of Picasso in 1906–7 and his own first works were executed in the context of Picasso's and Braque's experiments and conclusions of 1910–12. He was relatively inexperienced in any other sort of painting. When in the war years he earned a living painting conventional portraits, he expressed a genuine and delighted surprise at how easy it all was. 'It's fun for me to learn now it is done. I can't get over it. I always thought it was far more difficult' (Sept. 7th 1915).

Gris' earliest drawings and paintings show how totally his own understanding could transform the older painters' ideas. Almost from the start the basic principles of Analytical Cubism were there. Simple 59 motifs (still-life groups and a few portraits and landscapes) are submitted to a rigorous formal simplification. The old illusion of separate objects and spaces is modified by broken contours and shading in the interests of a stronger two-dimensional unity, but without destroying the physical properties of objects.

72 In his first paintings such as the *Still-Life* of 1911 he uses paint and colour to create a far more rigid surface than Picasso and Braque were achieving or attempting at the time. Without their elusive, atmospheric manipulation of space, Gris' Cubism threw the tension between two and three dimensions into open conflict. The stark contrast of strong lights and deep shadows creates a powerful effect of relief. The location of each object seems securely fixed; despite the broken contours and the repeated forms, there is an air of rigid and static finality. Yet this whole plastic illusion, for all its metallic luminosity, for all its views into the goblet or through the bottle, never seriously threatens the impregnable mass of the painted surface. It is a dense wall of matter, made of deliberate and regular brushmarks of massively opaque colour and crossed by measured diagonals. Austere and complete, these first Cubist paintings by Gris endowed what Rivière called Cubism's 'inexplicable continuum' of object-qualities with a finite order and a logic that seemed unquestionable.

His paintings of 1912–13, while retaining his instincts for clarity and order, moved closer to Picasso and Braque. He inscribed 'Hommage à Pablo Picasso' 60 on his 1912 *Portrait of Picasso*. The image is still cut through by a system of diagonals, leaving its trail of dislocations and vaporous after-images, but the brushwork and the colour are more sensuous. The broad tonal areas are enriched by small-scale stippling and the monochrome palette (here a luminous blue)

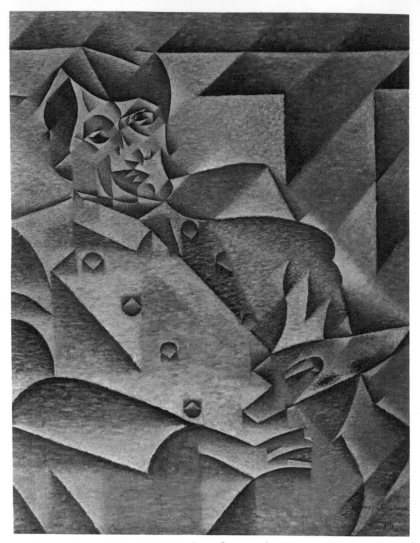

is relieved with overlaid pinks and ochres. Compared with the 1911 *Still-Life* it has also moved closer to Picasso in the more complex analysis of the motif. The fragmentation of the face and head for instance is more reminiscent of the free disposition of elements in Picasso's Kahnweiler portrait of 1910. The skull is cut open by a blade-like chevron and the very complicated intersection of the facial features comes as close as any Gris to Picasso's inventive juggled analysis. The planes that compose the head of *The Smoker* fan out like a hand of cards. The deep shadow 61 below the head to the left emphasises the flatness of the fan-like sheaf of planes. The features and silhouettes that are freely distributed between the planes and the literal smoke-spiral, unusually loose and twist-

60. *Juan Gris*
Portrait of Picasso
1912, oil on canvas
36.75 × 29.25 in.
(93.5 × 74 cm.)
Art Institute of Chicago
(Gift of
Mr and Mrs Leigh Block)

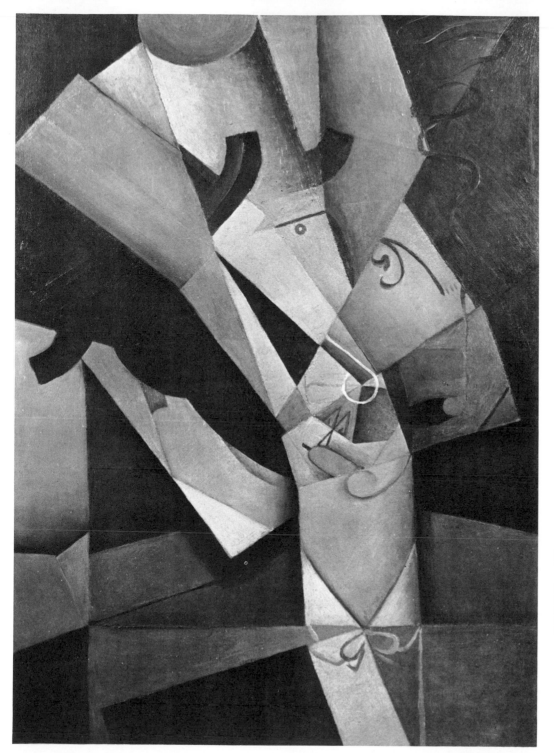

61. *Juan Gris*
The Smoker
1913, oil on canvas
28.9 × 21.5 in.
(73.3 × 54.5 cm.)
Collection of
Mr and Mrs A.P. Bartos,
New York

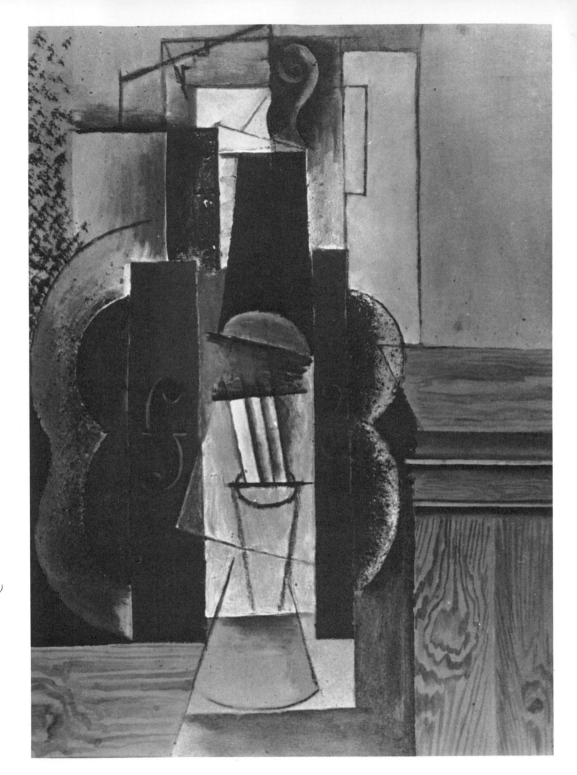

62. *Pablo Picasso*
Violin, *1913*
oil and sand on canvas
25.5 × 18.1 in.
(65 × 46 cm)
Kunstmuseum, Berne
(Hermann Rupf Collection)

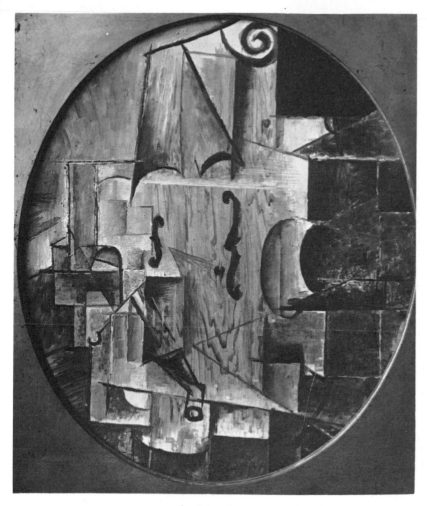

63 *Pablo Picasso*
The Violin
1912, oil on canvas
21.6 × 18.1 in.
(55 × 46 cm.)
Pushkin Museum, Moscow

Collage

By 1912 Picasso, Braque and Gris had all expressed dissatisfaction with the orthodox medium of oil on canvas. Kahnweiler recalls them talking about the 'unfitness' of traditional media for their own purposes. The mixture of sand, ashes or sawdust into the pigment of some paintings of 1912 onwards may be seen as a **62** gesture away from orthodoxy. It was not gesture for the sake of gesture, nor was it without direction. Taken as a whole, the œuvres of Picasso, Braque and Gris form a massive endorsement of the medium of oil-painting. The effect of adding sand, and so on to their paint was to increase the quality of matter on the surface. For Braque it was a means of separating texture from colour and observing their interaction in a way that was not possible in conventional media. (Writings p. 129). This possibility struck the same new chord into the Cubists' medium as typography had struck in their imagery. The invention of *collage* struck both chords simultaneously.

It was probably Braque who had introduced letters and words into the Cubist repertoire and it was Braque again—drawing this time on his early training as a craftsman—who first used the wood-graining and marbling techniques of commercial house-decorators. Like typography, *faux-bois* was a device drawn from outside painting to be used as a ready-made reference to external reality. More obviously than typography it had pictorial as well as symbolic values. In theory it corresponded precisely with the Cubists' mission for representation without illusion. Although in itself an illusionistic or imitative deceit, its undisguised separateness from the rest of the painting (which is emphasised by the strong note of local colour struck by the wood-grained areas), left it exposed as a device that was as two-dimensional as printed type. The wood-grain passages painted into Picasso's *Violin* 1912 and Braque's *The Violoncello* 1912 serve **63,64** to identify an attribute of the motif—what part of it was made of. In the Picasso the texture is loose enough to mingle fairly freely with the other components of the structure and, appearing as it does in the middle of that structure clearly refers to the wood of the violin. The wood-grain of the Braque on the other hand is clearly separated from the graphic references to the violin, suggesting at first a wooden panel beyond it. It is obviously more in keeping with the many-sided Cubist approach to a motif to see this rectangle of wood-grain, evenly painted, highly-coloured and virtually uninvolved in the painting's tonal structure as the separate statement of one of the violin's qualities, enjoying an oblique relationship with its motif, as the words do with the subject of *Ma Jolie*.

This separation is clearly demonstrated in a major Braque of early 1913, *Still-Life with Playing Cards*. **73**

ing for Gris, add a new touch of Picasso-like humour.

If these paintings are less succinct and unambiguous than before, they also retain qualities peculiar to Gris. The object-quality of the planes is never diffused to the degree of Picasso and Braque's 1911 pictures. There is always a clearer relationship between lines and areas of colour; in fact line by itself never became an important part of Gris' technique, while it was a primary element of Analytical Cubism. As a result the separate parts of his motifs have distinct identities as forms; the ambiguity in the *Portrait of Picasso* between the sitter's left shoulder and the back of the chair is as **38** exposed as the ambiguities of Picasso's 1909 *Bather*. In *The Smoker* this clear definition of the separate areas looks less like an analysis than a purely formal arrangement of planes that was afterwards endowed with the attributes and features of a motif. Such a process is the basis of Synthetic Cubism.

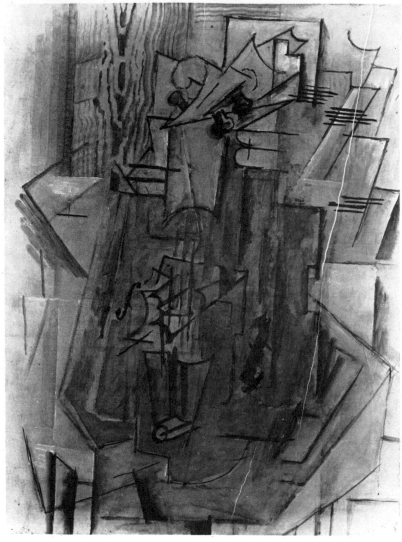

the emblematic reality of the subject to a new degree of fineness. The flat canvas is not now disguised by an all-over coverage of brushstrokes; through a whole central area it is as freely exposed as the paper in a line drawing. Thus the areas which *are* painted, are very clearly sitting on top of that surface. The charcoal drawing is forced into a strange position. It is no longer easy for us to read its illusion as receding into deep space beyond the canvas. The illusion now appears to hover somewhere *in front of* the canvas. The transition from this use of paint on the surface to the application of other materials onto the surface is a short and almost obvious step. In fact the Braque still-life was painted several months after his first collages and its finite use of painted textures owes something to collage.

Braque used collage only in drawings (although some of these are large and on canvas), while Picasso employed a more random variety of materials freely in both paintings and drawings. Gris chose to use collage only in paintings, and to very different effect. Even accepting these personal interpretations of collage, its revolutionary implications are universal. It proposes a completely new vehicle of representation and an outright repudiation of attitudes to surface and media that had remained virtually intact over centuries of European art history.

In the context of 'reality' and its representation, a context that was full enough of ambiguity in Analytical Cubism, collage seems at first a devastatingly simple and obvious gesture. It consisted of cutting out actual pieces of stuff and gluing them onto the paper or canvas, making elements more 'real' than anything in conventional painting. But at the same time many of the materials used were themselves ready-made illusions, quite as false as *trompe-l'œil* painting. Braque frequently uses wood-grained wallpaper—paper masquerading as wood—and Picasso's first collage *Still-Life with Chair-Caning*, Spring, 1912, **77** was with a bit of oil-cloth that is printed with the pattern of wickerwork chair-caning, another manufactured deceit. So in effect the *collé* elements are real imitations of reality. Picasso's use of cut-out coloured pictures of fruit to represent fruit in a still life is a **65** spirited extension of the same idea. Here it is not the fruit themselves that overlap but the squares of paper on which they are printed, emphasising the dual reality involved.

Collage only loses this double-take when, relatively rarely, newspaper represents just newspaper, or when matchboxes, visiting cards, or cigarette wrappings stand in their own right. Perhaps the outstanding coup in this sort of literal realism was Gris' inclusion of a piece of mirror glass to represent a mirror in his *Wash-stand*. With typically phlegmatic logic he explained: **76**

64. *Georges Braque*
The Violoncello
1912, oil on canvas
32.25 × 24 in.
(82 × 61 cm.)
Private Collection,
London

65. *Pablo Picasso*
Still-Life with Violin and Fruit
1913, papier collé and
charcoal on paper
26 × 20 in.
(66 × 50.8 cm.)
Philadelphia Museum of Art
(A.E. Gallatin Collection)

Here the graining is applied with a decorator's comb; this gives its texture a more rigid surface quality. The edges of each area are clearly defined and apart from the red heart, floating enigmatically in space, they are the only coloured areas in the painting. The only other painted areas—the black curves of the table top, the heart and the quiet grey verticals to each side—are blandly unobtrusive. The rest is charcoal drawing and bare white canvas. All these things emphasise the physical applied quality of the grained rectangles.

As well as lending greater clarity to the motif than any Analytical Cubist painting of 1909—12, Braque's *Still-Life with Playing Cards* brings the poise between the material reality of paint charcoal and canvas and

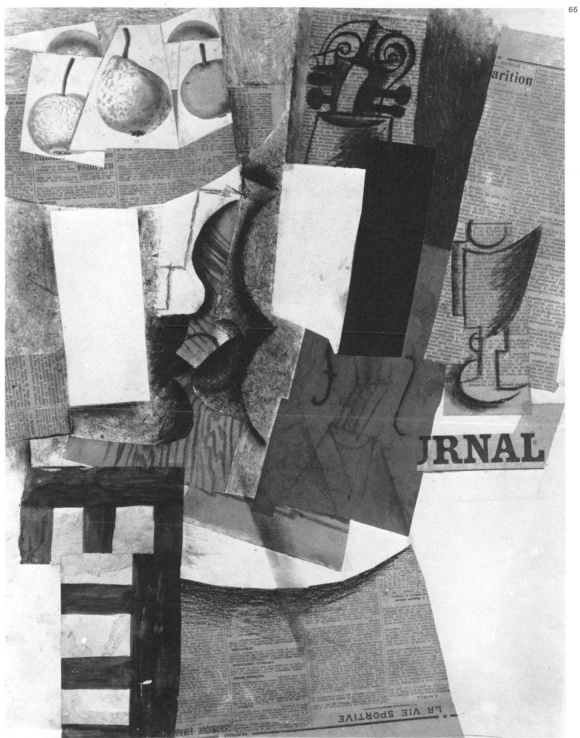

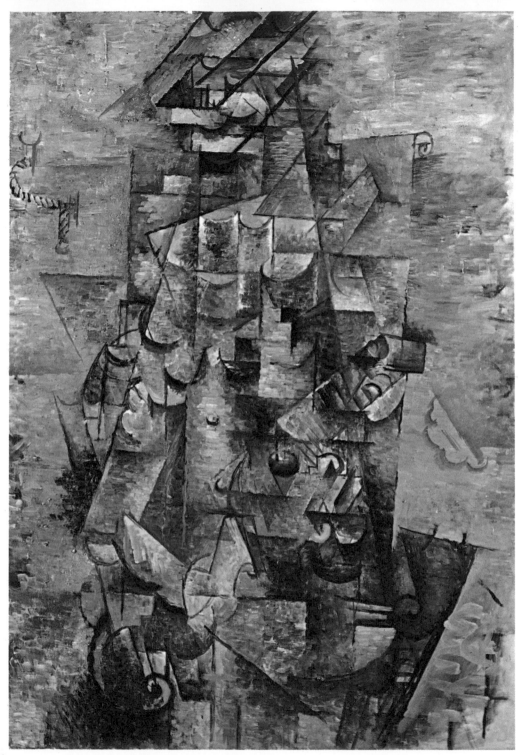

66. *Georges Braque*
Man with a Guitar
1911, oil on canvas
45.75 × 31.9 in.
116.2 × 81 cm.)
Museum of Modern Art,
New York (acquired through
the Lillie P. Bliss Bequest)

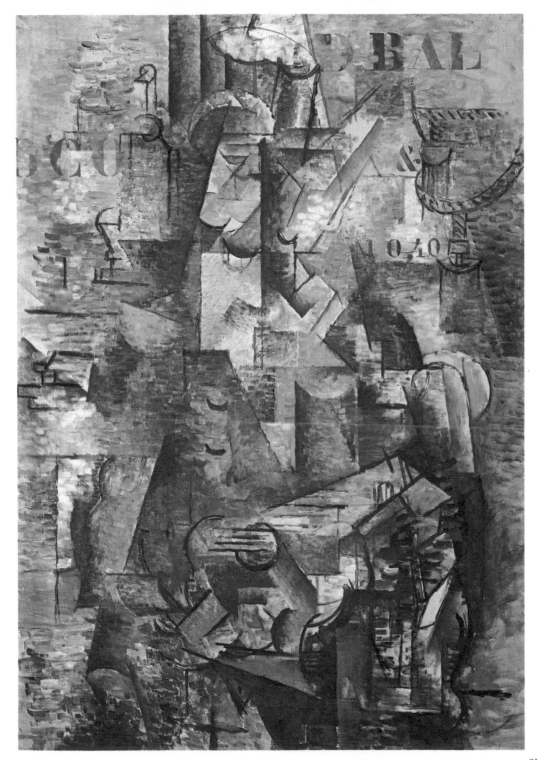

67. *Georges Braque*
Le Portugais
1911, oil on canvas
45.9 × 32 in.
(116.5 × 81.3 cm.)
Kunstmuseum, Basle

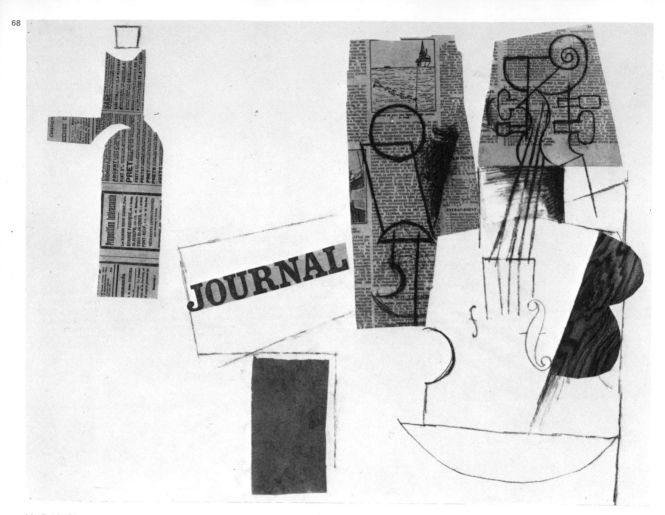

68. *Pablo Picasso*
Bottle, Glass and Violin
1912–13, papier collé and
charcoal on paper
18.5 × 24.6 in.
(47 × 62.5 cm.)
National Museum, Stockholm

'You want to know why I had to stick on a piece of mirror? Well, surfaces can be recreated and volumes interpreted in a picture, but what is one to do about a mirror whose surface is always changing and which should reflect even the spectator? There is nothing else to do but stick on a real piece.' (Kahnweiler, *Juan Gris*).

Kahnweiler, writing in 1920, confirmed Cubism as 'the endeavour to capture the three-diamensional diversity of the outer world within the unity of the painting.' and went on, 'Cubism seeks to reproduce that three-dimensional diversity—the dimension of depth—in contrast to the 'playing cards' of Manet, Gauguin and Matisse' (*The Rise of Cubism*, p. 18). With the invention of collage, Picasso and Braque had so ruthlessly redefined the nature of painting that preserving its unity became quite a different matter. The 'dimension of depth' was as much a matter of

building forwards into real space as of making concessions to illusionistic space behind the flat surface. Once the structure had broken through the 'window pane' of traditional representation into the space occupied by the spectator, the distinction between painting and relief sculpture was vulnerable.

Picasso's first collage, *Still-Life with Chair-Caning* already had an impressive object-quality. The presence of the printed chair-caning, so closely interwoven with the painted pipe and goblet and with the spatially-ambiguous letters JOU, holds the matter of the painting up to the surface. The embossed pattern of the oil cloth pushes through the paint that is dragged over it, pressing everything forwards. In addition to this, the whole painting is framed by a length of heavy rope, emphasising the actual depth of the canvas on its stretcher as well as enclosing the image. In this way the surface of the canvas seems projected towards us

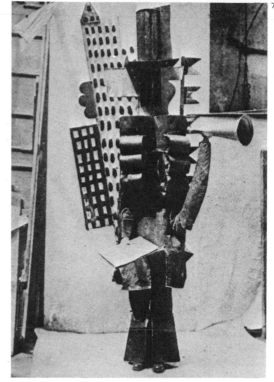

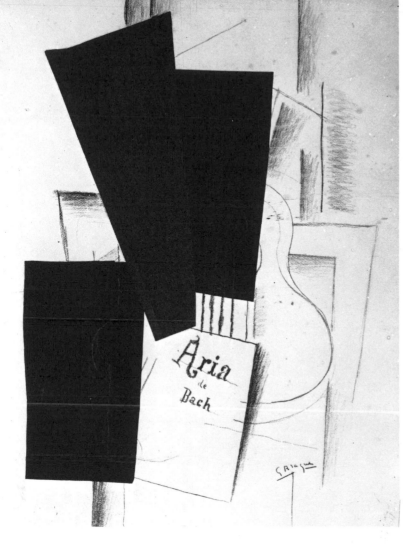

Cubism as 'low art'

From the start Picasso, Braque and Gris had shown a marked disrespect for High Art affectation and an appetite for a wide, popular culture. In the early Montmartre years, Picasso (who always wore a blue electrician's overall to paint in) was an avid follower of the comic strip supplements from Gertrude Stein's American papers. Both he, in an occasional way in Barcelona, and Gris, professionally in Paris, had some experience of commercial art. Both too, were great enthusiasts for the Cirque Médrano and local cabarets and it may be relevant in this respect that among the reproductions that Braque owned and pinned on his wall was Seurat's *Le Cirque*, a painting of the same circus. Pinned on Gris's wall at one time was a colour-lithograph Pernod advertisement.

For the most part their studio walls were not adorned with art so much as with objects: particularly the mandolins, guitars and violins, dishes, masks and carvings that appear in their paintings. Gris owned a hurdy-gurdy. This affection for objects comes through in their paintings and intensifies with the invention of collage. More and more banal articles from everyday life drift into their motifs, often physically. Picasso had already built a painting around the title of a popular song, but now the physically disposable trivia—

69. *Georges Braque*
Aria de Bach
1912–13, papier collé and charcoal on paper
24.5 × 18.25 in.
(62.2 × 46.4 cm)
Private Collection, Paris

70. *Pablo Picasso*
Stage Manager from New York
1917 (costume designed for the ballet Parade*)*
approx. 10 ft. (3 m.)
present whereabouts unknown

and the painting assumes a total physical presence.

In collage the applied materials stood, by and large, for flat objects or surfaces and the plastic dimension was created by painting or drawing around them, as **69** in Braque's *Aria de Bach* of 1912–13. But for Picasso it was a short, inevitable step from there to reliefs and constructions, first in paper and cardboard and then in wood and ready-made materials, which stand somewhere between painting and sculpture. When, **70** in 1917, he was asked to design costumes for Diaghilev, it was quite natural that some of them should encase the figure in towering constructions, like three-dimensional collages of painted Cubist planes and *objets trouvés*.

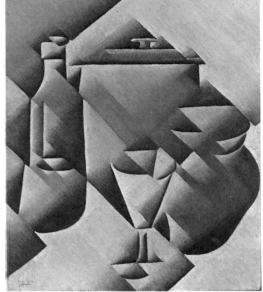

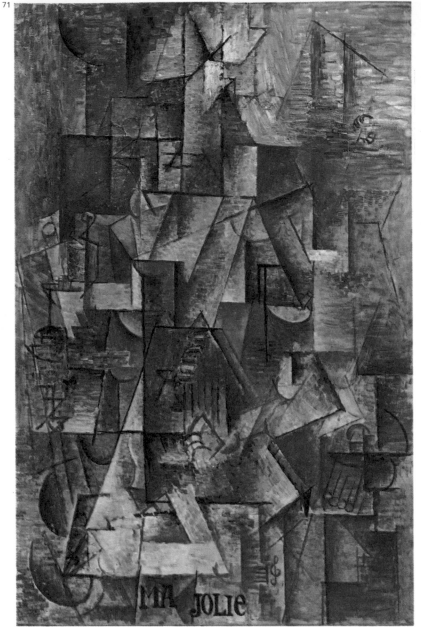

72. *Juan Gris*
Still-Life
1911, oil on canvas
23.5 × 19.75 in.
(59.7 × 50.2 cm.)
Museum of Modern Art,
New York (acquired through
the Lillie P. Bliss Bequest)

73. *Georges Braque*
Composition with the
Ace of Clubs, *1913*
charcoal and oil on canvas
32 × 23.5 in.
(81.3 × 59.7 cm.)
Musée d'Art Moderne, Paris

71. *Pablo Picasso*
Ma Jolie
1911–12, oil on canvas
39.4 × 25.75 in.
(100 × 65.4 cm.)
Museum of Modern Art,
New York (acquired through
the Lillie P. Bliss Bequest)

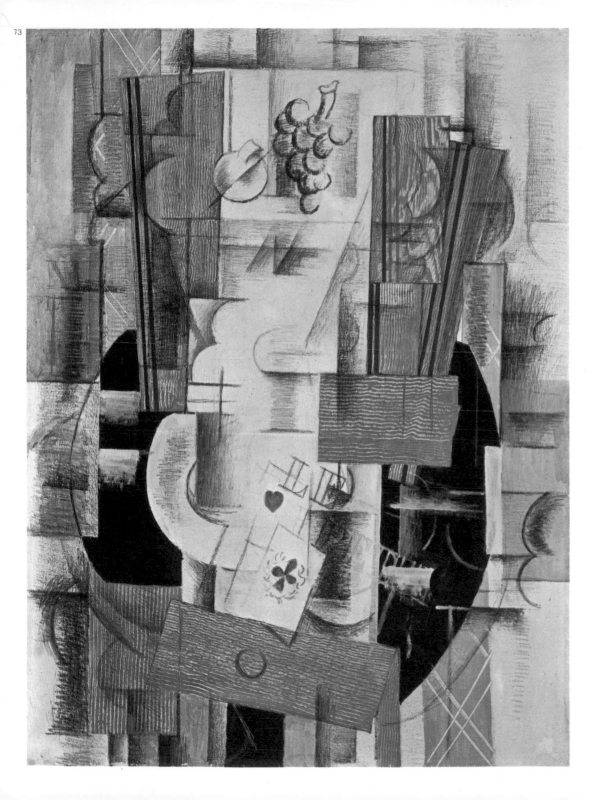

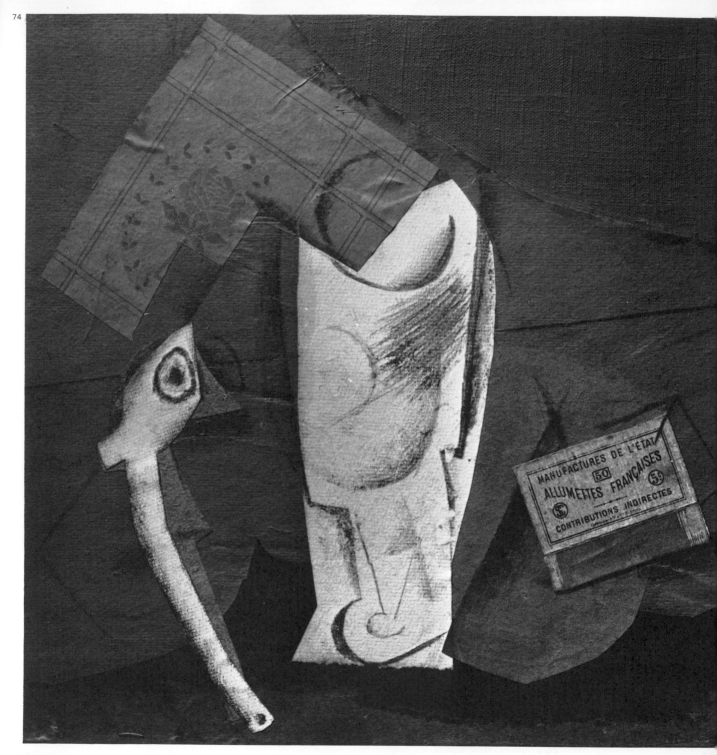

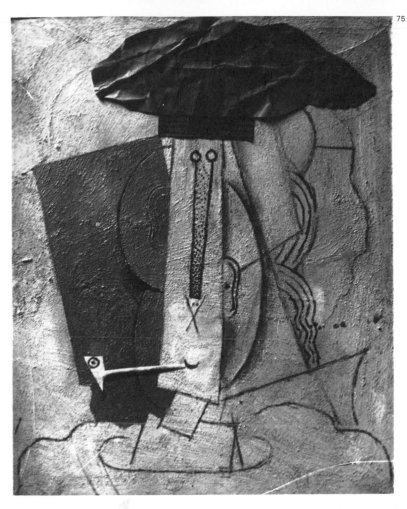

74. *Pablo Picasso*
Still-Life with a Pipe
1914, oil, sand and
papier collé on canvas
28.75 × 23.25 in.
(73 × 59 cm.)
Private Collection, Paris

75. *Pablo Picasso*
Student with a Pipe
1913–14,
oil, sand and
paper on canvas
28.75 × 23.25 in.
(73 × 59 cm.)
Private Collection, Paris

cigarette and tobacco wrappers, matchboxes, brown
paper, newspaper and so on, were incorporated into
painting. When he moved into three-dimensional
constructions, Picasso started making objects that
strongly resembled junk-shop bric-à-brac.

The radical revolution of collage, while having a
logical place within the context of Cubism itself,
represents in a wider sense an outright challenge to
the status of painting. For Picasso, collage seems to
have been a self-consciously revolutionary gesture
against traditional authority. The use of wrinkled and
ragged scraps of paper as the media of art looks like a
total reduction of standards, down from the realm of
muses to studio floorboards. This aspect of collage
anticipates Dadaist desires to be 'of life' and the 'anti-
art' tendencies of the First World War.

The concept of the *objet trouvé* (found object)
and of Duchamp's ready-mades are latent in collage in
the sense that the medium provides its own reality.
Various sorts of imitation of a motif are replaced by a
sort of painting in which the means *are* the motif. The
different materials not only determine the form, but
also the subject-matter of the painting. The reduced
significance of subject-matter in any other sense was
demonstrated in a statement by Gris in 1913. He is
discussing a painting he was about to sell in which an
engraving was pasted onto the canvas. 'You are quite
right', he wrote to Kahnweiler, 'in principle the picture
should be left as it is. But once M. Brenner has
acquired the picture, if he wants to substitute some-
thing else for this engraving—his portrait for example—
he is free to do so. It may look better or it may look
worse, like changing the frame on a picture, but it
won't upset the merits of the picture.' (Sept. 17th,
1913. Kahnweiler, *Juan Gris.* p. 86). Such a confident
declaration of unconcern about the finality of the

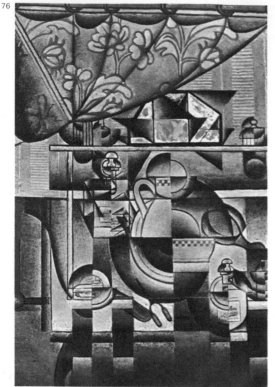

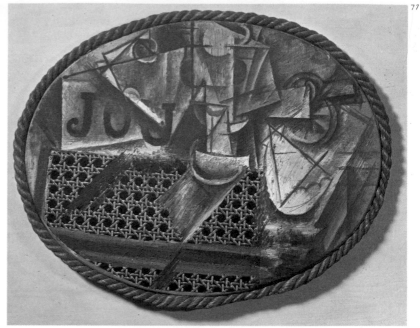

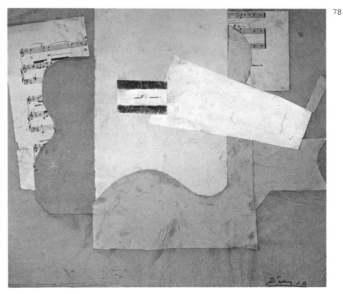

76. *Juan Gris*
The Washstand
1912, oil with mirror and
papier collé on canvas
52 × 35.5 in.
(132.1 × 90.2 cm.)
Collection of the Vicomtesse
de Noailles, Paris

77. *Pablo Picasso*
Still-Life with Chair-Caning
1912, oil, oilcloth and paper
on canvas with rope
surround
10.6 × 13.75 in.
(27 × 35 cm.)
Artist's Collection

78. *Pablo Picasso*
Sheet of Music and Guitar
1912–13, papier collé
18.9 × 16.7 in.
(48 × 42.5 cm.)
Collection of Georges Salles,
Paris

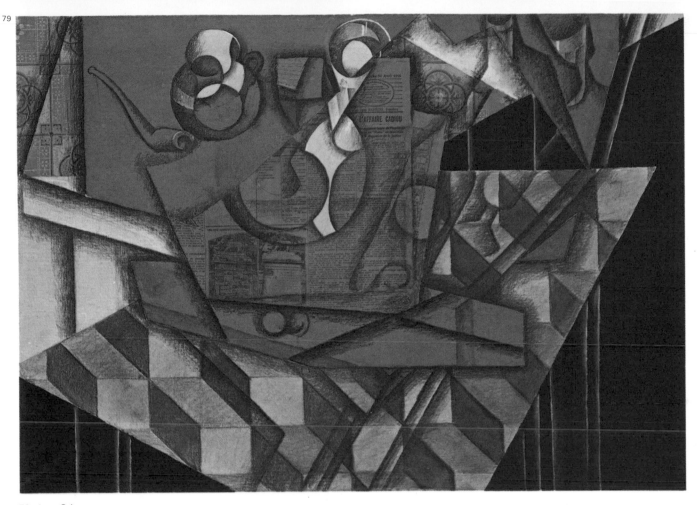

79. *Juan Gris*
The Teacups
1914, oil, charcoal and
papier collé on canvas
25.5 × 36.25 in.
(65 × 92 cm.)
Kunstsammlung Nordrhein-
Westfalen, Düsseldorf

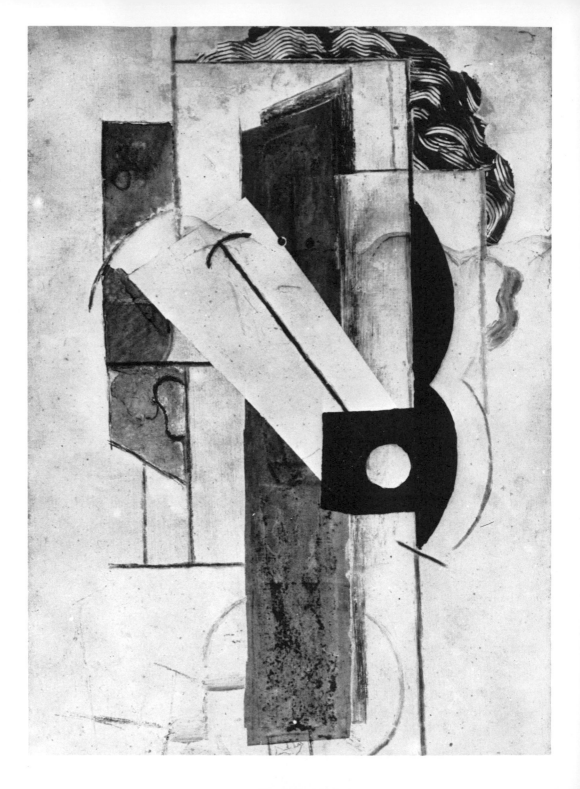

80. *Pablo Picasso*
Head of a Young Girl
1913, oil on canvas
21.75 × 15 in.
(55 × 38 cm.)
Private Collection, Paris

81. *Pablo Picasso*
The Poet
1912, oil on canvas
24 × 19.75 in.
(61 × 50 cm.)
Kunstmuseum, Basle

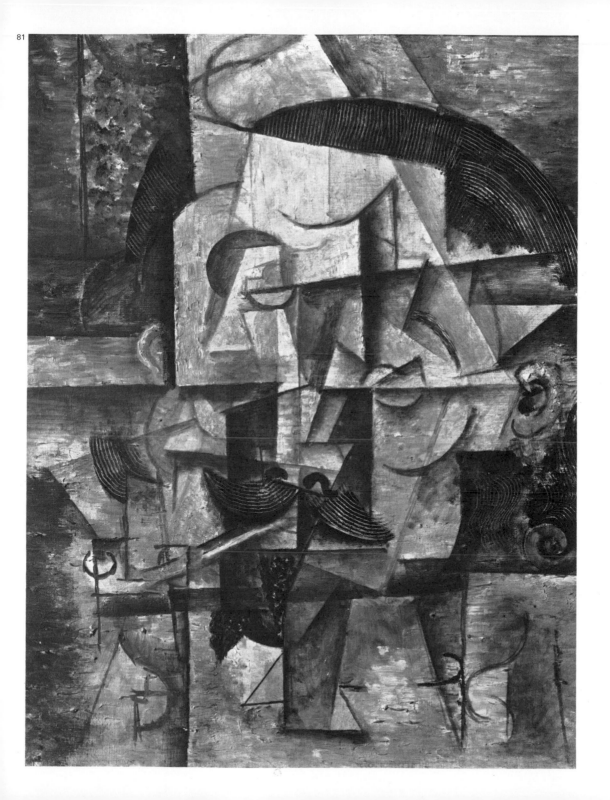

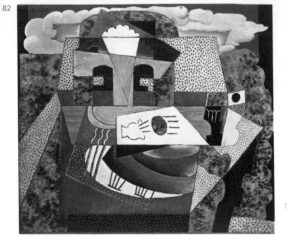

82. *Pablo Picasso*
Still-Life in a Landscape
1915, oil on canvas
24.4 × 29.5 in.
(62 × 75 cm.)
Private Collection

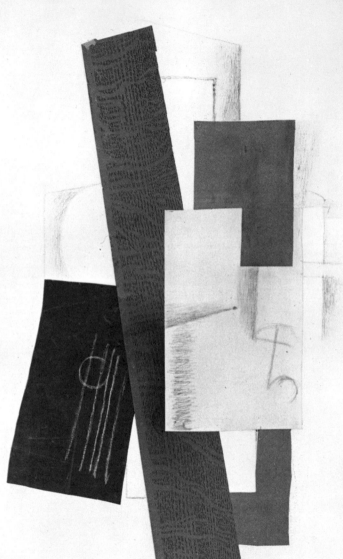

83. *Georges Braque*
Guitar
1913/14, collage, pencil and
chalk on canvas
39.25 × 25.6 in.
(99.5 × 65 cm.)
Museum of Modern Art,
New York (acquired through
the Lillie P. Bliss Bequest)

84. *Pablo Picasso*
The Three Musicians
1921, oil on canvas
80 × 74 in.
(203 × 188 cm.)
Philadephia Museum of Art
(A.E. Gallatin Collection)

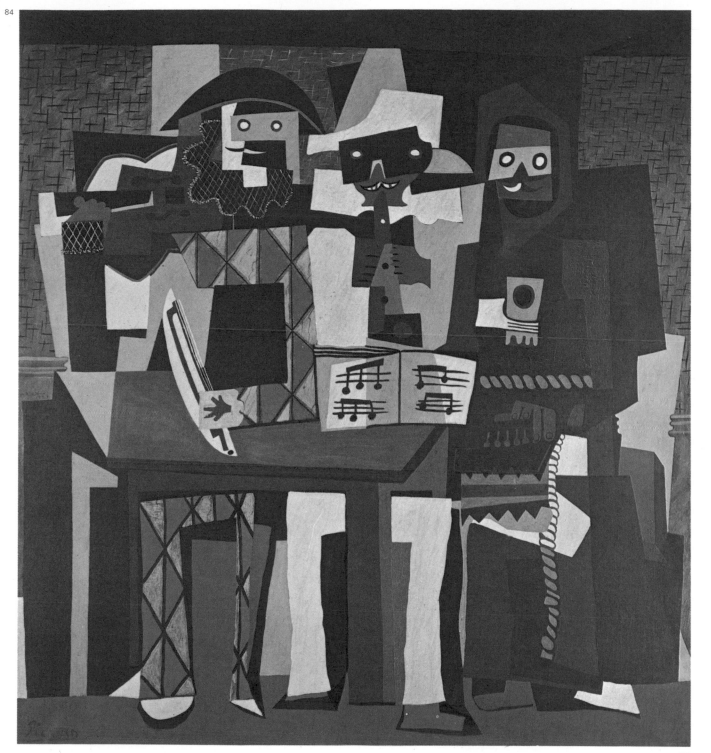

artist's personal statement is inconceivable before Cubism and irreconcilable with conventional values.

Picasso once called Cubism an intellectual game. If this devalues the conscious seriousness of its principles, there is certainly a strong 'play' element in much Cubist improvisation. This too comes to the fore in Picasso's collages and use of lettering, full of an adolescent, witty irreverence. The newspaper title JOURNAL recurs in part in dozens of Cubist paintings: the closeness of URNAL to *urinal* and of JOU to *jouer* (play) are probably no coincidence. In a slightly more serious vein Braque often uses the word TEMPS in still-lifes including newsprint and musical elements so that it could refer to the name of the newspaper *Le Temps* as well as to time in the sense of musical rhythm.

The majority of the humour comprises in-jokes about painting, about Cubism itself. Typically when Picasso first used a decorator's comb, he ignored its true function of imitating wood-graining and used it instead to comb hair and a moustache into a portrait. The lettering BASS in his *Bottle, Glass and Cards* is an ultimate comment on the surface quality of the letter. Here the letters are real voids, cut out of the pasted paper, completely inverting the original function of the letter in Analytical Cubism. A number of the news-

85. *Pablo Picasso*
Bottle, Glass and Cards
1913/14
pencil and papier collé
12.6 × 18 in.
(32 × 46 cm.)
National Gallery, Prague

paper headlines in their pictures make allusions to the revolution and spirit of Cubism—'*La Bataille s'est engagé*' and '*La Vie Sportive*' by Picasso—or to its preoccupations—'*Le Vrai et le Faux*' and '*On ne truquera plus les Œuvres d'Art*' (both by Gris). Gris became something of specialist in this field, more than once taking advantage of the ease with which he could find the word *gris* (grey) to use as a signature. His greatest coup (a good word in this context) was to find an illustrated cutting about the prohibition of the pasting of posters, etc., on the plinth of a public monument (i.e. a work of art) and to paste it into his still-life, *The Teacups*, which is virtually covered with collages. A ready-made visual pun, it pinpoints the homogeneity of Cubism's meaning, means and spirit.

The formal use of *collé* elements—the play between their physical reality and the pictorial reality of representation—is also full of high-spirited improvisation. When Picasso stuck his squashed matchbox onto his *Still-Life with Pipe*, he symbolised its full depth in a drawn linear projection, which is mainly on the paper beneath the matchbox. In a simpler *papier collé* of 1912—13, *Sheet of Music and Guitar*, the overlap of forms bears no sequential relationship to the motif. The sheet of music to the left is cut as if overlapped by the guitar shape, but is held away from it and at the bottom actually edges in front of it. The loose assembly of the forms is ironically symbolised by the pin at the centre, which pretends to transfix all the pieces and hold them together.

The nature of these materials, wrinkled, stained by the glue, tattered at the edges and fairly roughly put together, epitomises Cubism's disrespect of High Art. It may seem ironic that these throw-away stuffs—the newspaper usually badly-discoloured with time—have hung on High Art museum walls for several decades already. But Cubist collages were never simply anti-art statements. They were redefinitions of art and of art's bearing on reality. If their humour, their temporal fragility, or their vulgarity seem at odds with the standards and morals of traditional art, then this is some measure of the new standards of reality that Picasso, Braque and Gris proposed for art.

Synthetic Cubism

As a whole the Cubism of 1912—15 was not lacking in a sense of permanence and seriousness: the casual insolence of Picasso's collages is peculiar to him. The name Synthetic already suggests a more finite quality of resolution and structure than 'Analytical'. The reasoning behind collage did not only apply to *collé* materials: its new demonstration of surface was already latent in the emblematic quality of letters and other symbols in late Analytical Cubism and is fundamental to all Synthetic Cubist paintings. In this wide sense collage belongs to Synthetic Cubism. Like all the terminology of Cubism, 'Synthetic' is open to several interpretations, but however it is dated, it was more than a technical development. It was a moment of resolution. It saw the profound changes of attitude from the Cézannesque concept of analysis that Picasso and Braque had set out with reach maturity.

Gris later said that 'when it began, Cubism was a sort of analysis that was no more painting than the description of physical phenomena was physics' and for him personally, the early Analytical phase of Cubism was a period of preparation, acquainting himself with what he called 'the architecture' and 'the mathematics' of painting. Most of Gris' work is by definition Synthetic and his own definition, recorded by Kahnweiler in 1920, was as follows: 'I begin by organising my picture; then I qualify the objects. My aim is to create new objects which cannot be compared with any objects in reality. The distinction between synthetic and analytical lies precisely in this. These new objects, therefore, avoid distortion. My *Violin*, being a creation need fear no comparison.' (13th March, 1920. Kahnweiler, *Juan Gris*). Elsewhere he describes the synthetic process as moving from the general to the particular' as opposed to analysis which was the reverse. He says that Cézanne made a cylinder out of a bottle, whereas Gris, starting from a cylinder, transforms it into a particular bottle of his own making. (Writings, p. 129).

This process was obviously behind most of the collages already discussed. With the illusion of the picture plane as a transparent window substantially a thing of the past already, collages are essentially new inventions. Starting from the flat surface, each work sees assembled certain 'general' objects which gradually assume—by their juxtaposition, by the cutting of them, by the drawing or shading that may be superimposed on and around them—a particular identity.

Synthetic Cubist paintings, in more conventional media, observe the same principles as collage with the same creative results. Analytical Cubism had presented a balance between the surface and the compressed version of illusionistic space beyond it. In Synthetic Cubism, as in collage, the integrity of the surface is absolute and is nowhere compromised by atmospheric illusions of depth. The space which was just behind the surface is now on or just in front of it. The painted planes seem applied to the canvas like *papiers collés*. With the simplification of technique necessary to eradicate all illusion of depth and atmosphere, the appearance of Cubist painting changed radically. It made for a reconsideration of the role of colour, (deliberately abandoned around 1909 in the interests of formal analysis) and a series of simpler, more lucid compositions.

The small passages of tonal shading are held tightly into the structure. The integration is tighter than in comparable Picassos or Braques.

A similar distinction emerges from their respective use of collage. As already mentioned, Gris used collage only in his paintings, and its effect is always to strengthen the rigid division of the surface. Sometimes the entire surface is covered with pasted papers. There is no hint of Picasso's ragged edges and random encounters, nor of Braque's simple elements floating in a spacious arena. The total effect is of tight concentration; the particular details—the layout of the print in his newspaper cuttings—always make a specific contribution to the total relationship. The word MATIN for example in *The Man in the Café* 86 exemplifies his meticulous discipline. Each letter is cut out separately and staggered so that, independently, each of them corresponds with the diagonal columns of type below, while collectively they echo the horizontal line underneath them.

The subjects of his pictures remain domestic still-lifes: *The Teacups* and *The Table* are typical. The 79,8 formal language, however, is in no sense inhibited. *Papiers collés* (some of them richly decorative), flat painted tones and realistic drawing are freely interwoven. Even if Gris never conducted the sort of vast baroque symphonies that Cézanne had composed from humble still-life material, he made in 1914 a series of very elaborate compositions, full of formal and literal counterpoint. The relationship between the formal arrangement and the literal motif fluctuates between their mutual identity in newspaper and exclusively formal elements like the stark black ground of *The Teacups*, or exclusively informational elements like the drawn key of *The Table*. The clear elipse of the *The Table* constantly varies its character within this scale and works complementary transformations on each form which challenges or crosses its perimeter. The *collé* newspaper here is at the heart of the dialogue. As literature its headline ('the true and the false') identifies this world of reality and artificiality. Formally it makes a stabilising horizontal. A painted cigarette overlaps its flar printed letters but another, lightly drawn like the pipe below, appears to insinuate itself somehow between the print and the paper. To the right, the horizontal of the newspaper fans out into three segments, one of wallpaper, one of wood-graining and the other—a drawn shape with a drawn letter—that still claims to be the newspaper.

The conversation between the geometric structure and these identifications was crucial to Gris. The language of painting was, he agreed, 'a flat coloured architecture', but if it was not employed as a vehicle of representation it remained 'an incomplete technical exercise'. At the end of *On the Possibilities of Painting*

The Synthetic Cubism of Gris
This new clarity of organisation was already a characteristic of Gris' earlier work. For him at least, the new absolute surface quality did not seem like a radical change of manner or concept. He had been painting densely saturated surfaces in 1911. The 1912 *Wash-* 76 *stand* with its rigorous plan-section-elevation analyses already had a very precise, non-atmospheric geometry.

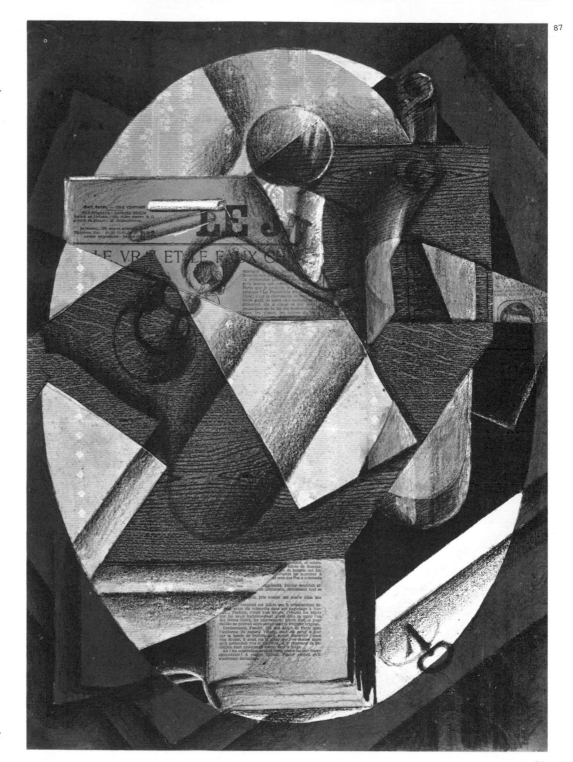

86. *Juan Gris*
Man in a Café
1914, oil and
papier collé on canvas
39.5 × 28.5 in.
(100 × 72 cm.)
Collection of André Lefèvre,
Paris

87. *Juan Gris*
The Table
1914, collage, charcoal and
gouache on canvas
23.5 × 17.5 in.
(59.5 × 44.5 cm.)
Philadelphia Museum of Art
(A.E. Gallatin Collection)

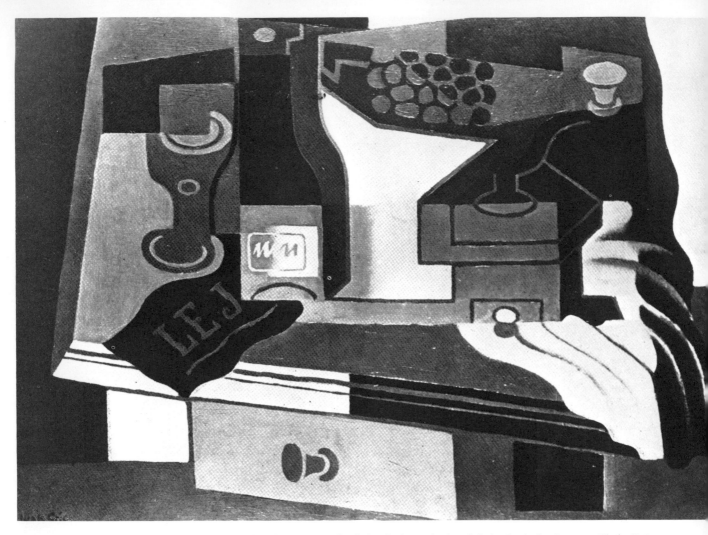

88. *Juan Gris*
The Coffee Mill
1920, oil on canvas
23.5 × 32 in.
59.5 × 81 cm.)
Galerie Pierre, Paris

he puts it very simply: 'the essence of painting is the expression of certain relationships between the painter and the outside world' and 'a picture is the intimate association of these relationships with the limited surface which contains them.'

He wrote this in the early 1920s, but he had reached such a faith by 1914. All of his later work, until his death in 1927, including periods of considerable uncertainty, was a pursuit of this fundamental. Quickly abandoning collage and methodically simplifying his language, he worked by 1920 to a sort of painting that was quite unambiguous in its formal clarity. A fretwork of thick contours shared by simple shapes, its expression of relationships with the outside world is simple and direct. There is no danger of 88 confusing the elements in *The Coffeemill*, and no

doubt of their physical substance. Their distinctness is further emphasised by colour changes, but the opaque, even saturation of the colour areas also reinforces the limited surface of the painting. The more neutral margins around the still-life offer no relief in the way of illusory space: they are no less the dense matter of the surface on which the whole synthesis is realised.

The most powerful of Gris's last paintings rank among the archetypal images of Synthetic Cubism. In *The Yellow Guitar* of 1926, the muted ground forms an 89 unequivocal surface with two forms applied to it. One of these is a pale rectangle, the other overlapping it is the main motif. The still-life motif is defiantly outlined as a single shape; this shape echoes the edge of the flat canvas at its right and lower edges. It emulates

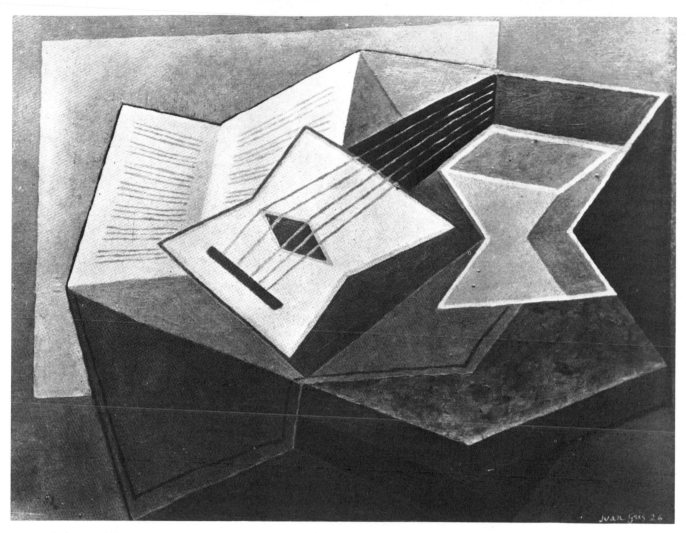

juan gris 26

very precisely a carefully aligned collage, but within the contour, the harmonic sequence of concave and convex angles builds a table top and objects of monolithic monumentality. The interlocked planes hinge outwards into sculptural relationships, the plane of the guitar strings twists from a horizontal into a vertical inclination, but nowhere is the cohesion to the surface seriously challenged. At two points—the neck of the guitar and the flattest edge of the table-cloth—there are coincidences between the still-life and the plain rectangle and a few continued diagonals from one form to another within the still-life itself. For an artist with Gris's reputation and aura of solemn calculation and mathematical precision, there are remarkably many near-coincidences. Even at this extreme reduction of his style to an austere geometry, the evolution of his

relationships remained an exploratory process, measured chiefly by his intuition.

The Synthetic Cubism of Braque

Braque's development between 1912 and 1914 was no less considered and coherent. The incorporation of extraneous elements into drawing and painting (wood-graining, sand and sawdust, and finally collage) were part of a single pursuit for him. They did not act as they had for Picasso, as the catalyst for a series of inspired, often tangential diversions. The new substances allowed him to exploit the determining effect of texture on colour, as in the sawdust passages of the 1914 painting, *Music*. Collage too he justified in **92** terms of colour: '*Papier collé* enabled me to dissociate clearly colour from form and to see that they were in-

89. *Juan Gris*
The Yellow Guitar
1926, oil on canvas
28.5 × 36 in.
(72.5 × 91.5 cm.)
Galerie Louise Leiris, Paris

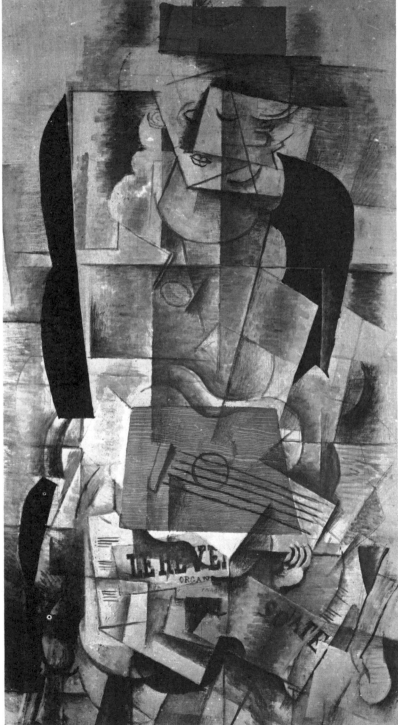

dependent of each other. That was the great revelation. Colour and form make their effect simultaneously, though they have nothing to do with each other.' (Writings, p. 129) This concept, the antithesis of Matisse for whom form and colour were as one, emphasises the revived importance of colour in Synthetic Cubism.

The innovations of 1912 were slowly tested and assimilated into Braque's art. In 1914 he still painted *Woman with a Guitar* in identical terms to the *Still-* **90** *Life with Playing Cards* of 1912–13. Simple areas of **73** black and combed *faux-bois* dominate what is basically still an Analytical Cubist painting. Braque did not use collage in his paintings: he explored its potential in *papiers collés* and then interpreted its lessons in paint.

His collages are remote in almost every way from the mood of Picasso. The reality of their images was dignified, even solemn, most of them on musical themes. They have a classical restraint, without even the dry wit of Gris. The process behind them accords exactly with Gris' definition of Synthetic Cubism. Braque himself wrote in very similar vein, towards the end of his life: 'I do not have to distort; I start from formlessness and create forms.' The disposition of a very few formal elements is refined and amplified until it has an identity. Technically though, Braque's collages are very different from Gris', with a more relaxed open structure. Braque expressed the surface by exposing it, not by packing it tight.

In the *Still-Life with Mandolin, Violin and Newspaper* of 1913, the composition is relatively informal: **91** the irregular overlapped *papiers collés* are surrounded and crossed by free charcoal drawing. By 1914 Braque had elevated the *papier collé* to an art of great strength and simplicity. The monumental *Guitar* of 1913–14 is **83** built from the simplest of means. The informal edges have gone and the definition throughout is more exact. Without the compressed relationship of planes that Gris used, the painted and *collé* elements enjoy a spacious freedom and as a result the composition's balance seems more delicately held in poise. Braque said repeatedly that he was concerned with representing 'the real' and 'reality' in art. Here in a work of great aesthetic sensitivity and refinement, he is not tied to appearances. But both the reality of his guitar—far more lucidly represented than that of his *Man with a Guitar* of 1911 for instance—and the reality of his **66** medium are manifest.

His paintings of the period, like the *Woman with Guitar* already mentioned, are formally more complex. In *Music*, 1914, a strange mixture of formality and in-**92** formality, he gives the same sort of applied appearance to the painted motif as Gris was to do in his *Yellow Guitar*. The painting is enclosed by a loose, drawn

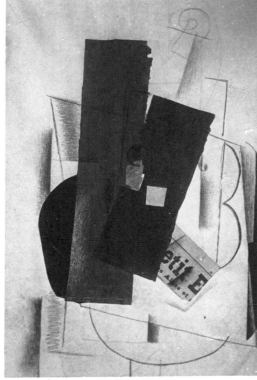

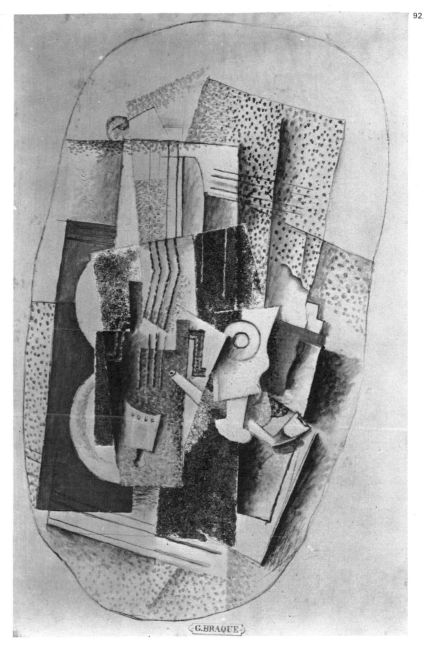

contour, as if, like the illusionistically drawn identity tag below, it is laid onto the surface. The painting itself has substantial surface qualities; its overlaid planes enriched by varied brushwork and textures. The contour acts as a sort of safety fence. Countering the last remnants of *trompe-l'œil* shading, it makes a token separation of the painted area from the bare surface.

The abstract title, *Music*, typifies the oblique Synthetic Cubist approach to motifs. It is a far remove from the intensive analysis, the penetrating objective study in front of specific motifs, that lay behind the still-lifes and portraits of 1909–10. Perception had little directly to do with this process. In 1917 Braque wrote in his *Cahier*: 'Painting is a means of representation. It is wrong to imitate what one wants to create. One does not imitate appearances; appearances are results. In order to achieve pure imitation, painting must disregard appearances.'

In this new realm of more subjective and imaginative creation, the distinct personalities of Picasso and Braque re-emerged. Ultimately it was the outbreak of war and Braque's mobilisation that broke their phenomenal partnership, but the break was already imminent. The invention of collage and other ready-made devices created a new importance for intuitive selec-

90. *Georges Braque*
Woman with a Guitar
1914, oil on canvas
51.25 × 29 in.
(130 × 75.5 cm.)
Collection of Raoul la Roche, Paris

91. *Georges Braque*
Still-Life with Mandoline, Violin and Newspaper
1913, papier collé and charcoal on paper
36.25 × 25.75 in.
(92 × 65.5 cm.)
Private Collection, Paris

92. *Georges Braque*
Music, *1914*
oil with gesso and sawdust
36 × 23.5 in.
(91.5 × 59.5 cm.)
Phillips Collection, Washington
(Gift of Katherine Drier)

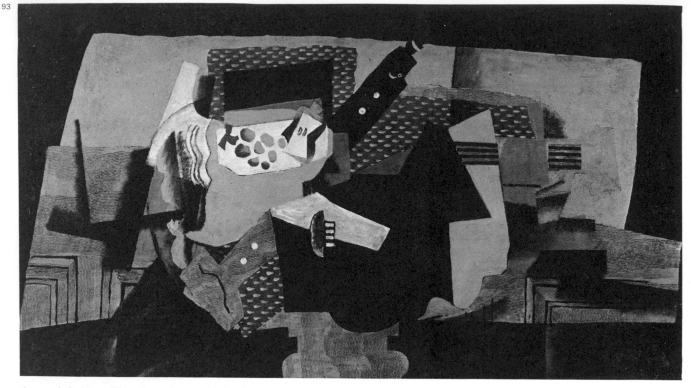

tion and decision. This alone threatened the homogeneity of their unsigned and impersonal Cubism.

After the war, Braque resumed work in an angular Synthetic Cubist manner comparable to Picasso's current paintings, but he soon moved towards a more 93 fluid, painterly interpretation of Cubism that was to fill the rest of his career. Sensual and poetic, his mature works explore the world of still-lifes and interiors.

The Synthetic Cubism of Picasso

Picasso's Synthetic Cubist period was at once more decorative and more expressive. Equipped with a new repertoire of means he returned to the themes of his pre-Cubist years. He continued to include collage in 75 whimsical paintings like *Student with a Pipe* and when it came to simulating the new flatness of collage in oil on canvas, his paintings (many of them figure images) were flamboyantly inventive in both technique and 38 imagery. In 1909 his dissection of human anatomy had been ruthless in the extreme: now without a model, his invention was no less wilful. The macabre *Woman in* 94,95 *an Armchair*, 1913, and the *Seated Man with a Glass* of a year later, a pure fantasy of great decorative charm, show the poles of his imagined anatomy. Needless to say the means of the two paintings are very different. As with Gris and Braque, means and content deter-

mine each other and it became almost a matter of principle to Picasso later to employ different means concurrently for different purposes. As a result, the overall character of his art may seem more diffuse than the others, but in its individual statements, at least until the 1930s, it sustained a concentrated force and distinction.

The 1913–15 phase of Picasso's art has been called 'Rococo Cubism'. The decorative and exuberant lightness of works like *Seated Man with a Glass* merits the label. One of a series (which includes several still-lifes) 182 it is painted against a coloured ground of dense pale green, opaque but luminous. Lines, flat tones and patterns are juxtaposed with a freedom gained directly from collage. The pointillist stippling which, in Analytical Cubism, had been a subtle tonal device for the modulation of space, is now applied in clearly defined areas and in predetermined colour scales. Any spatial effects are the product of simultaneous colour contrasts, but the principal effect is decorative. The converging of the various forms into a figure has the playful spontaneity of a child's fantasy. Any question of real anatomy — or distortion — does not arise.

A similar scale of textures appears in *Man Leaning on a Table*, 1915, but the hard-edged planes are locked 96 in a tight architectural fabric. The angular severity and

93. *Georges Braque*
Le Guéridon Noir, *1919*
oil and sand on canvas
29.5 × 51.5 in.
(75 × 130 cm.)
Musée d'Art Moderne
Paris

94. *Pablo Picasso*
Woman in an Armchair
1913, oil on canvas
51 × 39 in.
(148 × 99 cm.)
Ex Collection
Dr Ingeborg Pudelko

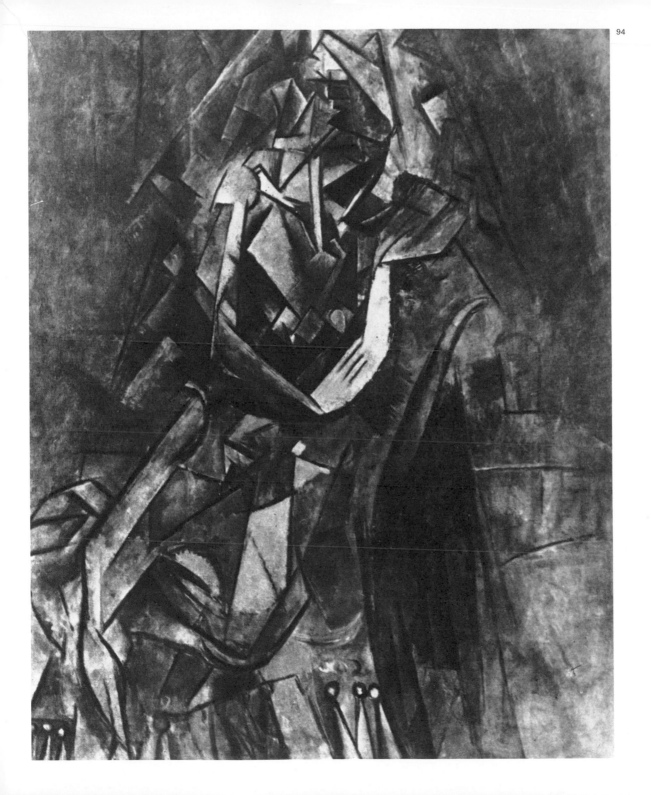

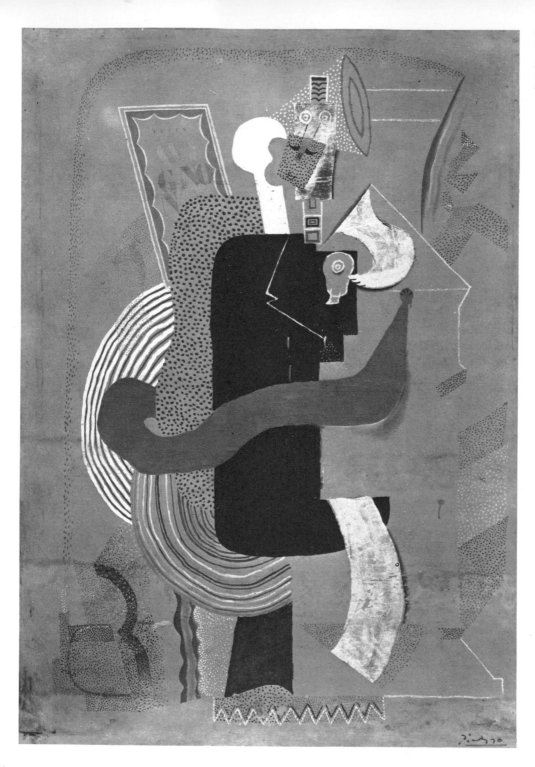

95. *Pablo Picasso*
Seated Man with a Glass
1914, oil on canvas
93 × 64.5 in.
(236 × 164 cm.)
Private Collection, Milan

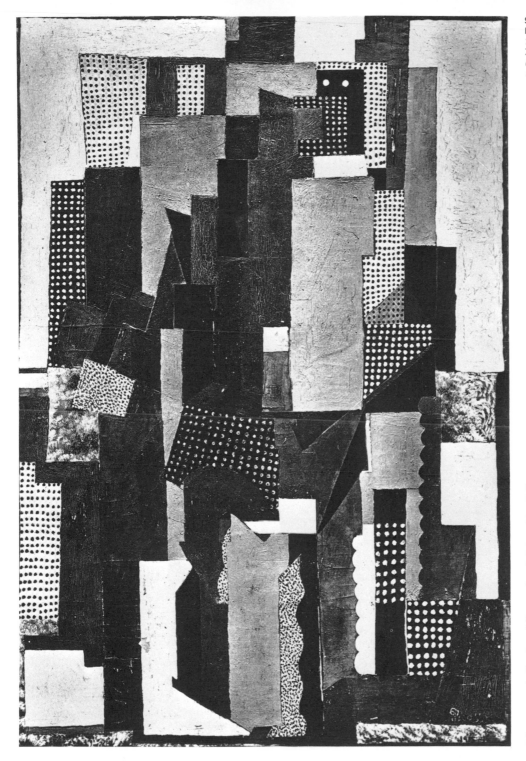

96. *Pablo Picasso*
Man Leaning on a Table
1915, oil on canvas
78 × 52 in.
(200 × 132 cm.)
Private Collection

97. *Pablo Picasso*
Harlequin
1915, oil on canvas
72.25 × 41.4 in.
(183.5 × 105 cm.)
Museum of Modern Art,
New York (acquired through
the Lillie P. Bliss Bequest)

98. *Pablo Picasso*
Harlequin and Woman
1915, watercolour and
pencil on paper
8.3 × 4.6 in.
(21 × 11.7 cm.)
Private Collection, Paris

99. *Pablo Picasso*
Ambroise Vollard
1915, pencil on paper
18.75 × 12.5 in.
(46.5 × 31.7 cm.)
Metropolitan Museum of Art,
New York (Elisha Whittelsey
Collection, 1947)

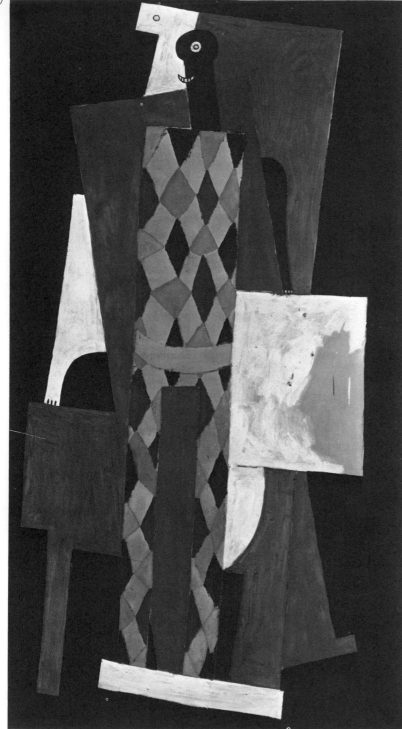

subdued colour are anything but rococo. The painted image is inanimate, more like a skyscraper city centre than a figure, and the appearance above of his helmet-like head makes a sinister presence. Only after recognising the head can we appreciate his tilted pelvis and the bend of his left elbow, but the first shock of ambiguity is never quite erased. More starkly theatrical than in the Cubist portraits of 1910, the effect is reminiscent of those turn-of-the-century paintings by the Austrian Klimt or the Russian Vrubel where a haunted face suddenly emerges through a wall of decorative matter.

In two Harlequin paintings of 1915, this emotive ambiguity is more outspoken. In one the flat, coloured **97** or patterned planes are overlaid with the simplicity of a Braque *papier collé*. This rich and innocently formal arrangement is transformed by the paw-like hands of its black and white arms, by its separate eyes and grinning teeth into a grotesque hallucination. In the other painting, *Harlequin and Woman*, the two figures **98** are absorbed into the black oval behind them which, borrowing an eye from each of them, becomes a negroid mask and threatens to inhale the harlequin through its open mouth. The same Surrealist metamorphosis pervaded the 1913 *Woman in an Armchair*, her **94** dismembered breasts sprouting wooden pegs like the handles of a drawer. But perhaps the most Surrealist of Picasso's Cubist paintings was the passively titled *Still-Life in a Landscape*. **82**

Motifs combining interior and exterior became frequent in later Cubism, providing a field of interrelationships richly suited to the Cubist view of reality. The fusion of landscape and still-life elements is the basis of this picture's hallucinatory power. It is exaggerated by the use of easily-readable flat symbols for each of the elements. Clouds, sky and grass are separated, realigned and overlapped as dispassionately as collages. The introduction of elements with such strong associations of scale and place into the secure domestic world of Cubist still-lifes, creates a devastating transformation, changing this lucid formal structure into a fantastic arena of uncertainties. The vastness of fields and sky is interleaved with the scale of a guitar, a glass and a wood-grained table-top. Emerging through the middle of this ambiguous world (where grass grows in the sound hole of guitars) is the hint of another mask-like face, with red-spotted eyes and a pointed nose. It may be fortuitous, but Picasso was very happy to let such things suggest themselves. Even in one of the masterpieces of Synthetic Cubism, the great *Three Musicians* of 1921, monumental and with **84** an hieratic sense of dignity, a comic profile emerges like a conjuring trick from the clarinet at the centre.

As if to demonstrate the concurrent validity of very different means of expression, Picasso chose this moment, 1915, to embark on a series of highly natural-

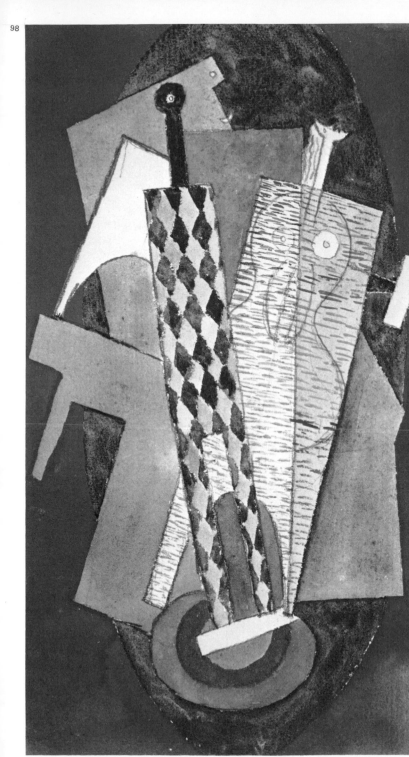

istic drawings. The *Portrait of Vollard* reverts to a sort **99** of direct transcription he had not undertaken since his precocious drawings from the antique at the age of thirteen. The drawing is subtle and sensitive, with a virtuoso facility. Almost academic in technique, it is nevertheless impregnated with Cubism. Even its disposition on the page is like a Cubist painting: a central complex spreading out more tentative lines to involve the spaces around.

For Picasso, the beginning of Cubism was when he faced a self-generated artistic crisis. His dialogue with Braque between 1909 and 1912 had concentrated that crisis into a relatively coherent set of problems. Now, with the resolution of those problems providing a vast and new armoury of means, his expansive and inventive energies again came to the fore. After the war years, which formed a uniquely un-prolific interval in Picasso's career, he pursued side by side the two extremes of 1915. The compatibility between his classical figure paintings and his highly abstracted Synthetic Cubist pictures of the early '20s, and the sudden appearance in the middle of them of an expressionist Surrealism—all clearly indebted to pre-war Cubism—suggest how widely the influence of Cubism could and would reach.

Léger

In 1919 Fernand Léger summarised his early career as follows: 'Impressionism was an all-powerful influence —I floundered like the rest until I discovered Cézanne and realised in a confused way that Impressionism was an end and not a beginning . . . everything I produced between 1902 and 1908 was destroyed as I went along . . . The period of influences, the transition and finally the period of creation.' Elsewhere he wrote that it took three years to shake off Cézanne's influence: 'its grasp on me was so strong that to disentangle myself I had to go almost as far as abstraction.' Much of this could apply equally to the other painters who around 1910 formed a second, larger nucleus of Cubism. Although few saw Impressionism as just 'an end', all were deeply impressed by Cézanne around 1907 and recognised in his work a more structured type of painting than the atmospheric diffusion of Impressionism. This background prepared the way for their response to the early Cubist paintings of Picasso and Braque.

Among this group Delaunay and Léger stand out most clearly as individuals. Their friendship began around 1907 and their whole careers have several points of contact and mutual preoccupation. Temperamentally they were as unlike as Picasso and Braque: Léger an aggressive realist with no intellectual pretensions, Delaunay more suave and self-aware and intensely ambitious. In their painting they shared ambitions for an art that was demonstrably relevant to life in the modern environment. Both by 1910 had made a serious appraisal of Cézanne's significance and, in paintings of restricted colour and severely simplified forms, had embarked on a course parallel to, but largely independent of Picasso and Braque. In 1910, through Kahnweiler's interest in Léger, they became regular visitors to his gallery and recognised in the Analytical Cubist paintings of Picasso and Braque potential means of furthering their own ideas.

101 Léger's 1909 painting *The Bridge* shows at once a remarkable similarity to the very first Cubist Braque's (some of which he probably saw at the 1909 Salon) and those powerful individual qualities that were to distinguish Léger's whole œuvre. Like Braque's landscapes of l'Estaque and Picasso's of Horta, the motif is reduced to simple angular forms and the colour is limited. These economic means establish a Braque-like consistency of structure, welding foreground and distance and rising from the bottom to fill the whole canvas. What at first sight seem marginal differences of technique between the Braque and the Léger emerge in other works as fundamentally distinct attitudes. The clean contours and abrupt passages of shading in Braque create an effect of sharp-edged planes or facets overlapped up the surface. The rounder painting of

48,50

100. *Fernand Léger*
Nudes in a Forest
1909 10, oil on canvas
47.25 × 66.9 in.
(120 × 170 cm.)
Rijksmuseum Kröller-Müller, Otterlo

The Expansion of Cubism in Paris

Léger creates a monolithic sense of volumes: more like a fantasy landscape of boulders than the crisp domesticity of Braque's painting.

The same romantic energy and the same dynamic formal character pervade his first major work, *Nudes in a Forest*, 1909–10. In the light of his later work it is a remarkably complete and prophetic first statement. The mechanistic nude figures appear to be occupied in wood chopping. Both they and the landscape elements are portrayed in dislocated, cylindrical forms, some of them polished like metal tubes or pipes, others lightly fluted, more like chopped celery. This smaller division of elements creates a very agitated surface. But apart from its all-over texture, there is relatively little stress on surface. The clear modelling and the perspective of the cylinders, supported by the narrative nature of the subject, evoke dramatic recessions into deep space.

Léger described the painting as 'a battle of volumes', a romantic generalisation that clarifies the differences between his concerns and those of Picasso and Braque. His art was about physical energies. His subject-matter was drawn from the vital world of human activity, embodying its scale, its forces, its humanitarian sympathies and ideals. In 1913 he defined the 'dynamic divisionism' of contemporary painting as primarily the expression of 'present-day life, more fragmented and faster-moving than preceding periods' and stressed the influence of the camera and the cinema in making a new sort of art inevitable. (Writings p. 130).

Nevertheless the renewed influence of Braque and Picasso is evident in 1910. In a series of paintings and drawings called *Fumées sur les toits,* views from a window across a smoky sky-line of Paris rooftops, the volumetric language of 1909 is modified. He utilises the flatter, more linear structure he had seen in Picasso's painting at Kahnweiler's to express what he described as the 'contrast of soft and hard forms' in reality. Soft, billowing shapes of smoke and clouds create relaxed intervals between the tight angular scaffolding of the buildings.

By 1912 this new language was highly developed — as applicable to figures as to landscape. The contrast is now between simple forms, flatly and often quite strongly coloured, and monochrome tonal passages that are highly fragmented and have a nervous agitation. The *Woman in Blue* is one of the most impressive figure paintings to come out of pre-war Cubism. It can be compared in many ways to the current work of Picasso and Braque. Without recourse to collage or any non-fine art devices, he succeeds in juxtaposing clear references to the motif (face, arms, chair, table) with unequivocally flat shapes and exposed canvas. Colour and tone are separated but together determine

the total effect, as if in demonstration of Braque's statement that 'Colour and form make their effect simultaneously though they have nothing to do with each other.' Like Braque, Léger was restoring colour after a period of deliberate restraint in the interests of structure. He uses colour far more positively than in any Braque of the period, controlling the space and the surface. Recessive blues dominate the foreground, a strong vermilion pushes forward among the furthest planes.

This separation of strongly localised colour areas was taken further in 1913–14. In *The Staircase* of 1913 he used only primary colours applied in crude stripes. Their placing in relationship with the drawing intensifies the sense of volume, the white stripes resembling highlights on the metallic limbs of two colossal figures. But at the same time the intensity of separate colour areas sets up a jazzy vibration across the surface. In this and the *Woman in Blue*, Léger reaches the critical point of near-abstraction he had described. His art seems held in poise between a dynamic formal language, self-sufficient in its charged relationships, and the profound instinct for a new realism such as had prompted his admiration of Le Douanier Rousseau. In other paintings of 1913–14 which he called simply *Contrast of Forms* and which depict nothing else, he seemed to incline towards a non-figurative art.

101. *Fernand Léger*
The Bridge
1909, oil on canvas
36.5 × 28.5 in.
(92.7 × 72.5 cm.)
Museum of Modern Art,
New York (Sidney and
Harriet Janis Collection)

102. *Fernand Léger*
Smoke on the Rooftops
1910, *oil on canvas*
26.25 × 20 in.
(66.5 × 50.8 cm.)
Collection of Richard S. Weil,
St Louis

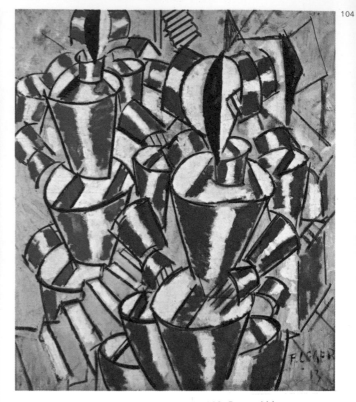

103. *Fernand Léger*
Woman in Blue
1912, oil on canvas
76.5 × 51.2 in.
(194 × 130 cm.)
Kunstmuseum, Basle

104. *Fernand Léger*
The Staircase
1913, mixed media
55.5 × 46.5 in.
(141 × 118 cm.)
Kunsthaus, Zurich

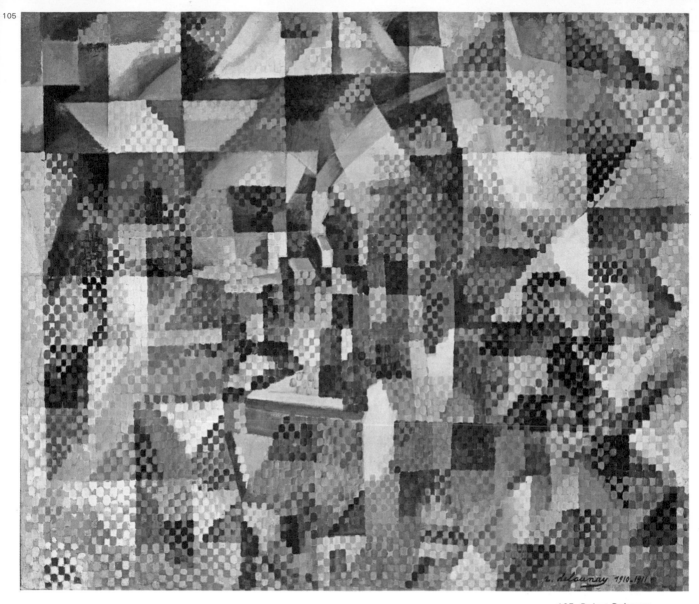

105. *Robert Delaunay*
Window on the City No 4
1910–11, oil on canvas
44.75 × 51.5 in.
(113.5 × 131 cm.)
Solomon R. Guggenheim
Museum, New York

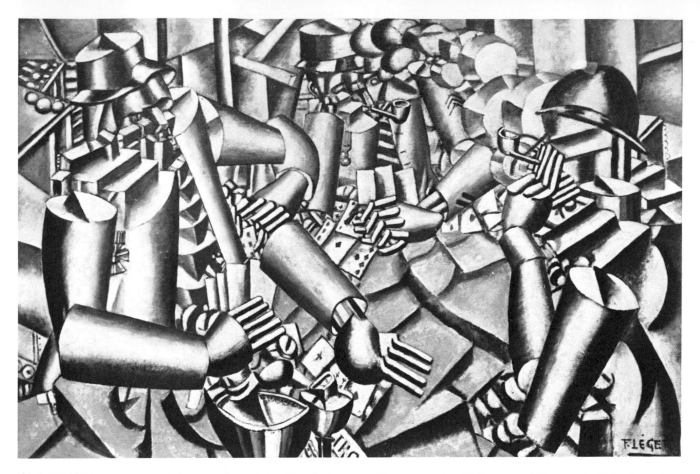

106. *Fernand Léger*
The Card Players
1917, oil on canvas
50.75 × 76 in.
(129 × 193 cm.)
Rijksmuseum Kröller-Müller,
Otterlo

In his own view what settled the issue was his experience during the war. Serving with the engineers, he was reimmersed in the worlds of machines and people. It is as if the world of Parisian experiments had distracted him from his real values: his hope now was 'to be free and yet not lose touch with reality.' In a well-known statement he has described the human camaraderie and the Futurist worship of the machine that were instilled in him. (Writings, p. 130). His painting 106 *The Card Players*, one of the first works after his discharge, integrates the two. 'I found I could use the machine', he writes, 'as others used the nude or the still-life'. Compared with the *Nudes in the Forest* of seven or eight years earlier, the similarities may seem more remarkable than the differences, but the fusion of man and machine here is complete. The strong local colours are remarried with forms, the crude stripes of 1913 soften to suggest the high polish of machine-turned components. The figures, perhaps munition workers, are mechanically articulated and their monumentality has the power and scale of heavy industry.

As with Braque and Picasso, all of Léger's development was pursued in terms of a greater reality, but Léger's vision of reality brought a very different set of values into Cubism. His sense of scale was monumental, not intimate and his subject-matter is well outside the domestic still-life world. His forms were sculptural, penetrating deep into space and although by 1917, he echoes the clarity of Synthetic Cubism, the respect of surface did not inhibit him from his use of massive plastic effects. His analysis and composition were of dynamic and collisive energies, held in tense, diagonal assymetry.

Finally his whole art is an affectionate and admiring tribute to humanity, an expression of man's nobility in the context of banal, even vulgar day-to-day living and working. To him the 19th century was not just a fertile source of technical means and concepts, but an era with which he also felt some romantic sympathy. He wrote poetry about artisans with 'trousers like tree-trunks'. He stands for the 20th century in rather the same way as Millet had for his own.

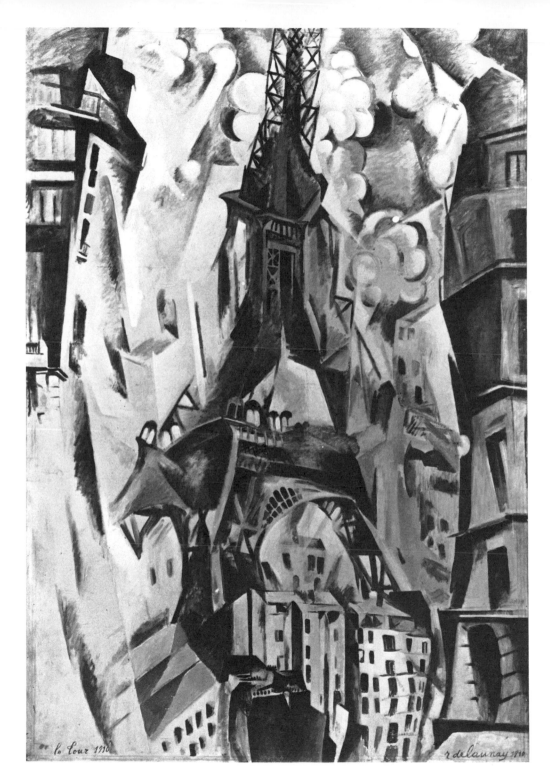

107. *Robert Delaunay*
Eiffel Tower
1910, oil on canvas
79.5 × 54.5 in.
(202 × 138.5 cm.)
Solomon R. Guggenheim
Museum, New York

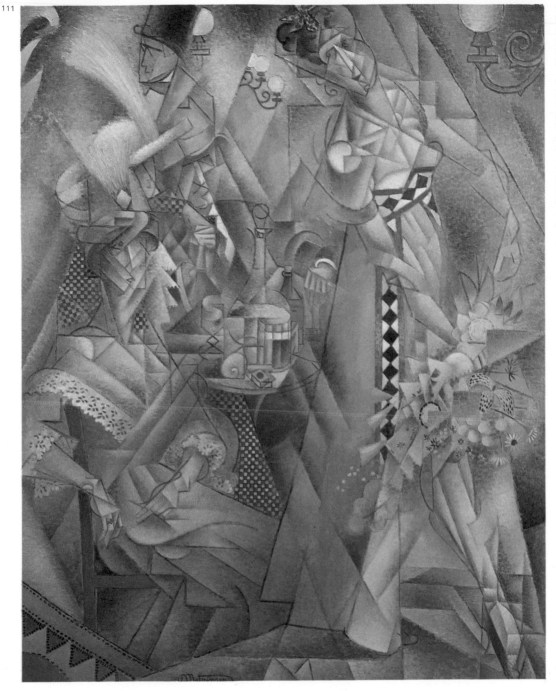

108. *Robert Delaunay*
Simultaneous Windows
1912, oil on canvas
18 × 15.75 in.
(46 × 40 cm.)
Kunsthalle, Hamburg

109. Robert Delaunay
Disc
1912, oil on canvas
53 in. diam. (134.5 cm.)
Collection of Mr and
Mrs Burton G. Tremaine Jr,
Meridon, Connecticut

110. *Marcel Duchamp*
Nude descending a Staircase
No. 2, *1912, oil on canvas*
58 × 35 in.
(147 × 89 cm.)
Philadelphia Museum of Art
(Louise and Walter Arensberg
Collection)

111. *Jean Metzinger*
Café Dancer
1912, oil on canvas
57.5 × 45 in.
(146 × 114 cm.)
Albright-Knox Art Gallery,
Buffalo, N.Y.

Delaunay

Delaunay's art is less simple than Léger's. Like Léger he was deeply involved in the world around him. He painted whole series of canvases of the city of Paris and of the Eiffel Tower, which since Seurat's time had been respected by progressive thinkers as a symbol of the new world. He painted an allegory of Paris and commemorated events as transitory as the visit of a Welsh rugby team to Paris or as historic as Blériot's first flight across the channel. His explicit imagery was of a new world and of the men who were building it.

Unlike Léger, Delaunay was heavily involved in the world of Parisian art. He consciously measured himself against the original achievements of his contemporaries and, one senses, was competing for a place in the Parisian avant-garde in a way that would not have occurred to Léger. His letters and articles of the prewar period and the fragmentary notes on painting intended for publication that he started to assemble in the 1920s are littered with art-political polemics, self-justifications and the denigration of other tendencies. In the winter of 1913—14 he got involved in a heated exchange over primacy of ideas with Boccioni and other Italian Futurists.

112. *Robert Delaunay*
The City of Paris
1912, oil on canvas
104.5 × 158.5 in.
(265.5 × 402.6 cm.)
Musée d'Art Moderne, Paris

113. *Robert Delaunay*
Homage to to Blériot
1914, watercolour on canvas
98.5 × 98.5 in.
(250.2 × 250.2 cm.)
Private Collection, Paris

112

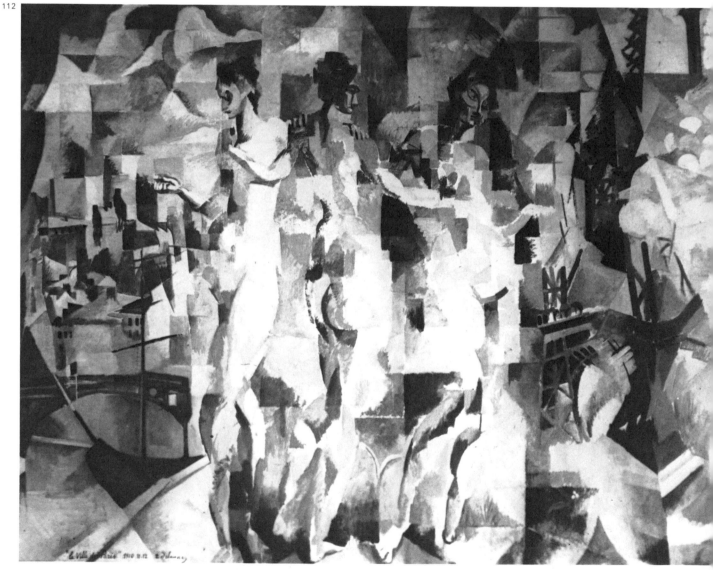

What also emerges from these writings is how clearly Delaunay saw his own art as a development of a modern French tradition, usually starting from what he called the 'anarchy' of the Impressionists, but occasionally citing Delacroix and even 'certain Englishmen' (supposedly Constable and Turner). Cézanne, who had 'demolished all painting since its origin' was important for employing a technique that depended not on line and chiaroscuro, but on colour. Delaunay's pre-occupation with colour also led him to feel a profound respect for Seurat. Cézanne's first importance to the other Cubists had been in terms of formal analysis, but

Delaunay spoke out as strongly against analytical art as Gris: 'Science has need of analysis,' he wrote, 'but art hasn't.'

Around 1910 Delaunay was deeply influenced by the fragmentation of objects in Picasso and Braque's analytical paintings, but critical of their sombre palette. (According to Léger, his comment in 1910 was 'these boys paint with spiders' webs'.) In the *Eiffel Tower* paintings of 1910–11 he used Cubist dislocations 107 rather like Léger, to express the dynamism of the urban environment. The formal tensions set up between the shattered tower and its flanking buildings generate a

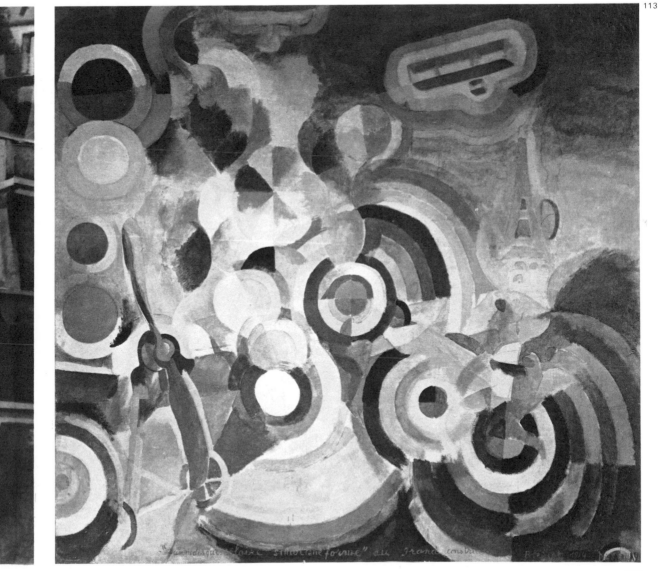

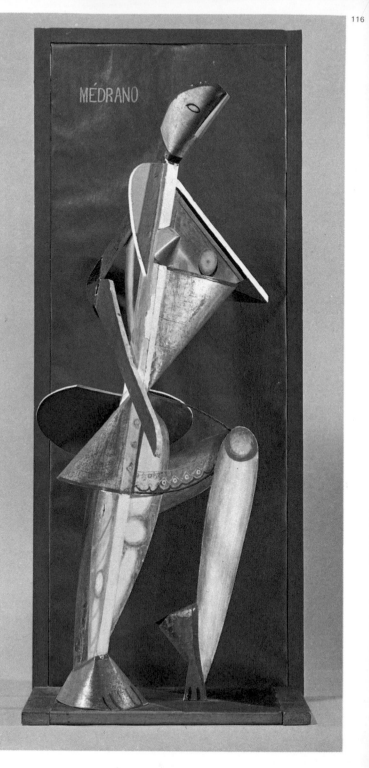

MÉDRANO

114. *Francis Picabia*
Udnie
1913, oil on canvas
118 × 118 in.
(299 × 299 cm.)
Musée d'Art Moderne, Paris

115. *Pablo Picasso*
Glass of Absinthe
1914, painted bronze
with silver spoon
h. 8.75 in. (22.2 cm.)
Museum of Modern Art,
New York
(Gift of Mrs Louise Smith)

116. *Alexander Archipenko*
Médrano
1915, painted tin, glass,
wood and oilcloth
h. 50 in. (127 cm.)
Solomon R. Guggenheim
Museum, New York

117. *Pablo Picasso*
Guitar
1914, painted iron
37.4 × 26 × 7.5 in.
(95 × 66 × 19 cm.)
Private Collection

vital sense of energy. In another series which began
105 slightly later called *La Ville* (views across Paris some
of which include the tower), the composition is more
static and instead of being centralised, spreads more
evenly out to the edges. The fragmentation is not so
much a vehicle of representation as a vehicle of colour
relationships. In the more elaborate of these, the town-
scape motif almost disappears. The basic disposition of
rectangular planes is overlaid with a divisionist fabric
of small coloured squares. The units are big enough not
to blend optically and so create vibrant simultaneous
contrasts. But there is still a tonal element. The che-
quered pattern drifts out of colour into neutral atmos-
pheric greys and the saturation of colours is variable.
108 In the *Windows* series, line and tone were virtually
abandoned from painting: the vestigial traces of the
motif are formed from colour edges. The fragmentation
of Cubism provided the catalyst for an art of separate
colour planes whose interaction was the whole basis
of each painting. 'Orphism' (Apollinaire's term for
Delaunay's colour painting) lay in direct descent from
Seurat's ideas but freed of Seurat's 19th-century obli-
gations to a tradition of naturalism.
 In 1912 Delaunay became the first French painter
to paint totally non-representational canvases and in
doing so dissociated himself from Cubism except as a
means to that end. He later defined Cubism as 'the
transitional state between Impressionism and abstract
art'. In his own eyes the critical turning point came with
the *Windows* series, 1910–12. Although their title
may originate in window views of Paris and the Eiffel
Tower, its significance for him was poetic and sym-
bolic. He writes of the paintings in his notes as 'win-
dows opening onto new plastic horizons'. He warmly
approved of Apollinaire's poem *Les Fenêtres*, inspired
by his paintings, in which the poet writes: 'The window
opens like an orange, the beautiful fruit of light'. For
Delaunay the structural freedoms of Cubism opened
the way to a poetic language, and he compares an art
of colour and light to music and poetry. Presumably
Apollinaire chose the name 'Orphism' on the basis of
musical analogies.
109 The *Disc* of 1912 shows how extreme was Delau-
nay's departure from current Parisian painting and
from his own earlier work. Each colour area is fairly
evenly saturated and the direct optical effects of their
simultaneous contrast are unimpaired by any other
consideration. He considered that the dynamic move-
ment stimulated by colour contrasts was the only true
dynamism in painting, since it grew out of painting
itself. He despised the kinetic effect of successive
viewpoints for instance because this was just another
sort of imitation. The vibration of the colours against
each other is intensified here, as if regenerated per-
petually by the concentric circular arrangement (a form

which probably derives from the colour circles and
diagrams of theoretical writings). This is another basic
departure of Delaunay's. Although he seldom used
anything but a rectangular canvas, the triangular divi-
sions of his *Window* paintings gave way after 1912 to
a circular or more loosely organic set of shapes. He
explained this in terms of 'a sense of plastic dynamism
which must find its realisation in the sphere . . . as op-
posed to the antique cube', again setting himself apart
from Cubism. The circular form had a certain symbolic
value as well; some pictures of 1912–13 are titled
Sun and Moon and his writings often refer to the discs
as 'solar' discs.
 What separates Delaunay from the other pioneers
of non-figurative or non-objective art (Malevich,
Kandinsky, Mondrian) is that such an art was not for
him an absolute point of no return. In the same year as
his *Disc* was painted, he completed his very large *La
Ville de Paris*, 1910–12. Fragments of the Seine, 112
houses, the Eiffel Tower and over life-size figures of
the Three Graces are compiled into a modern allegory,
strangely conservative in the context. In 1914 he
painted the *Homage to Blériot*. Here he attempted to 113
reconcile the dynamic colour language of the *Disc* to
very literal figurative elements. The tension between
the two is symbolised above, where a disc contain-
ing Blériot's biplane goes half-way to meeting the ir-
regular shape of the aircraft. It is like a piece of modern
heraldry, a Blériot-badge. Inevitably this fusion seems
a compromise of Delaunay's declarations about pure
painting, but for certain purposes the wedding of his
pure poetry to more specific symbols of the modern
world was an acceptable, even a necessary practice.
 A wide range of painters, including a group of
Americans in Paris and the *Blaue Reiter* painters in
Munich, were inspired by Delaunay's free use of col-
our. The art of František Kupka on the other hand ran a
parallel course. He probably anticipated and may even
have influenced Delaunay in his ultimate conclusions.
According to some accounts Kupka had been experi-
menting with paintings composed of pure colour
planes as early as 1907, but the uncertain dating of his
work makes the relationship problematic. After study-
ing in Prague, he had come to Paris via Vienna in 1894.
He came into personal contact with Cubist circles
around 1911 through his friendship with the Du-
champs. His contact with the creative *Art Nouveau*
atmosphere of Vienna prompted very different interests
from the Cubists' concern with the representation of
objects in space. His early work had been characterised
by a more decorative treatment of surface and a very
liberal mixture of descriptive and 'pure', non-descrip-
tive elements in a painting. By 1912 at least and prob- 118
ably earlier, this concern with formal values evolved
into an uncompromising non-objective art.

118. *František Kupka*
Arrangement in
Yellow Verticals
1912–13, oil on canvas
27.5 × 27.5 in.
(70 × 70 cm.)
Musée d'Art Moderne, Paris

119. *Ernst Ludwig Kirchner*
Five Women in a Street
1913, oil on canvas
47.5 × 35.5 in.
(120.9 × 91 cm.)
Wallraf-Richartz-Museum,
Cologne

120. *Umberto Boccioni*
Forces of a Street,
1911, oil on canvas
31.5 × 39 in.
(100 × 180 cm.)
Collection of Dr P. Hänggi,
Basle

121. *David Bomberg*
In the Hold
1913–14, oil on canvas
78 × 101 in.
(198.1 × 253.3 cm.)
Tate Gallery,
London

122. *Louis Marcoussis*
Still Life with a
Draughtsboard
1912, oil on canvas
54.7 × 36.6 in.
(139 × 93 cm.)
Musée d'Art Moderne, Paris

participants in the group exhibitions were painting in a manner that was more or less identifiable as 'Cubist'. As explained earlier, it was this stylistic homogeneity among a large number of artists that was responsible for the public awareness of Cubism as a movement in Paris, and contributed greatly to Cubism's recognition by avant-garde artists throughout Europe. Furthermore it was from this outer circle of Cubism that most statements by artists about Cubism came. In 1912 Gleizes and Metzinger published their essay *Du Cubisme*, the first book on the subject, (Writings p. 131), but this had been preceded by several shorter statements in reviews or newspapers, notably by Metzinger. It was their explanations of Cubism that formed the first framework for critical writing and public understanding of Cubism.

The fragmented, near-monochromatic language or Analytical Cubism which all of the minor Cubists adopted at first, was succeeded by a more decorative, often highly-coloured treatment of Synthetic Cubist forms. Collage was never taken up by the minor Cubists, some indication of a more conservative attitude. Marcoussis's *Still-Life with Draughtsboard* was **122** the closest they came to collage. A subdued analytical structure is laced with letters and other elements, flatly and separately enough painted to appear applied. From this subtle, sensuous type of painting Marcoussis later moved to a more tightly schematic manner, derived from Gris.

The work of Le Fauconnier, Gleizes and Metzinger— the original trio of second-stream Cubists—shows both the assimilation of Picasso's and Braque's language and the strength of Léger and Delaunay as alternative influences. The more romantic, sometimes narrative subjects that Léger and Delaunay treated, the assertively 'modern' nature of these subjects and the very large scale of their paintings made a profound influence on younger artists, both in Paris and abroad.

Le Fauconnier's chunky, Cézannesque *l'Abondance* **123** of 1910/11 was already a traditional allegory, far-removed from the still-life world of Picasso and Braque, close to Léger at that period. The Cubist facetting of the forms while producing an integrated surface, enhances the sculptural weight of the near life-size figure. *Married Life* by Roger de la Fresnaye is **124** an extreme example of this sort of Cubism. He more than any other painter converted certain superficial aspects of Cubism and Orphism into a modern academic idiom. Here the analysis is more of the subject than any of the objects represented. Cubism provides a sense of formal discipline, but there is none of the serious questioning of first principles that created Cubism in the first instance.

Metzinger's painting of a *Café Dancer* 1912, a subject more in the tradition of Degas, Seurat or Lautrec,

The minor Cubist painters and Marcel Duchamp
The work of the minor Cubists not only reflected the various phases of Picasso's and Braque's art, but also the separate influences of Gris, Léger and Delaunay. The few paintings illustrated here demonstrate the range of interpretations put upon the main aspects of Cubism by these artists rather than the emergence of other, distinct artistic personalities. By 1911 all the

shows another common feature in paintings by the lesser Cubists. This is the programmatic use of dislocation to suggest multiple or successive viewpoints, an aspect of Cubism often mentioned in early theoretical statements. Here it has a kinetic quality suggesting the movement of the figures depicted. With the exotic detail and the textural richness it helps evoke the gaiety and mobility of Parisian night-life. Albert Gleizes was a mainstay of the Cubist movement: *Woman at the Piano* of 1914 typifies his rather solid, conservative painting. It is typical too of a lot of later Cubist paintings in using the simplified formal language of Picasso's Synthetic paintings in what is still basically an Analytical context. It bears little comparison with the process of synthesis and particularisation so clearly described by Gris and so brilliantly demonstrated by Picasso.

125

The appearance of the Duchamp brothers in Cubist circles around 1910—11 was the only potential challenge to the dominant influence of the major Cubists. Their studios at Puteaux very quickly became focal meeting points for a wide circle of Cubist artists and interested writers, and Villon and Duchamp-Villon assumed leading roles in the organisation of exhibitions. The emergence of the *Section d'Or* group in 1911 was an expression of their energy and influence and its title reflects their interests.

Outside art, mathematics and chess were the most absorbing preoccupations of the Duchamp family, both activities involving intellectual discipline and coherent system. The painting of Jacques Villon demonstrates his feeling for analytical precision. Preceded in most cases by preparatory drawings, his painted images reduce the motif to a diagrammatic, linear structure. The taut grid of lines laced with thin colour in *Marching Soldiers* (1913) shows how close to Cubism this process led him.

126

The youngest brother, Marcel Duchamp was from the start a conceptual artist. Like Picasso, but in an extreme degree, he could see the existing condition of art as objectively as if he were standing outside it and then act on the strength of his observations. But he was intellectually far more sophisticated than Picasso and, whereas for Picasso the revolutionary decisions of Cubism opened artistic fields which he could explore with imagination and invention for several decades, for Duchamp art became a matter of one intellectual decision after another and very little else. Within a matter of two or three years he had exhausted Cubism's relevance to him. His great importance for later artists lies outside the scope of Cubist art.

The originality of his first interpretations of Analytical Cubism already indicated the extent to which he was to strain Cubist ideas. The theme of chess players was recurrent in his work and he said of the subject

later that 'the succession of movements in a chess game has a beauty all of its own'. In a study on the theme of 1911 the two opponents appear as Cubist heads at each side. In a central complex roughly the shape of the board, fragments of heads, chess-board pattern and chess pieces are freely interspersed as if suggesting that the game of chess is more a matter of the position of the pieces in the minds of the players

127

123. *Henri Le Fauconnier* *L'Abondance* *1910–11, oil on canvas* *75.2 × 48.4 in.* *(191 × 123 cm.)* *Gemeentemuseum, The Hague*

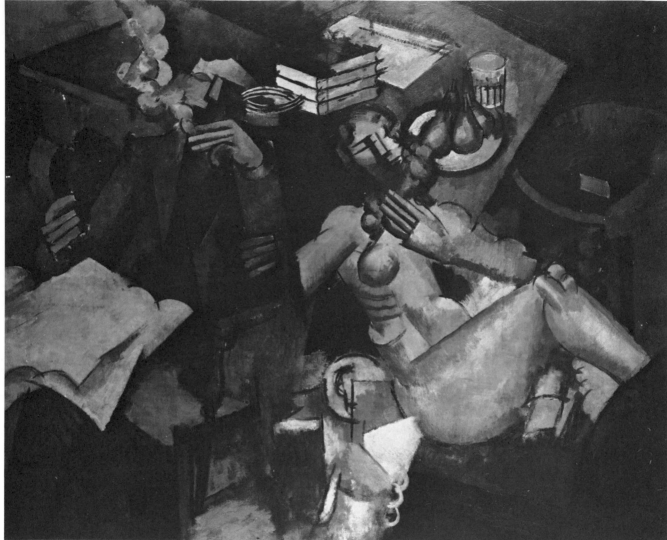

than of their actual location on the board. Cubist analysis and fragmentation were the basis for representing the idea, but the idea itself was antipathetic to Cubism.

Duchamp has described the *Nude Descending a*
110 *Staircase* (1911–12) as 'a real break'. . .'It was my way of understanding Cubism'. The pictorial idea was
128 inspired by Marey's sequential photographs (published in *L'Illustration*, Paris, 1909–10). Although the painting is still Cubist in the sense that they are fragmented images of largely linear, monochromatic forms, the *Nude* pictures reverse the multiple-viewpoint aspect of some Cubist paintings. As with sequential photography, the spectator is now static,

recording successive perceptions of a motif that itself moves through space and time.

It was the second version of this painting that caused an open break with the Cubists. At the 1912 Salon des Indépendants, there were objections to its inclusion alongside Cubist paintings and Duchamp withdrew it. The kinetic element alone cannot explain its adverse reception: Duchamp's next paintings prove that it was only a part of *his* concern as well. The poet Blaise Cendrars, writing in 1919, distinguished between the 'mechanics' of Futurist analysis and the 'chemistry' of Cubism. It is a perceptive comment on Cubism generally, but one with particular relevance

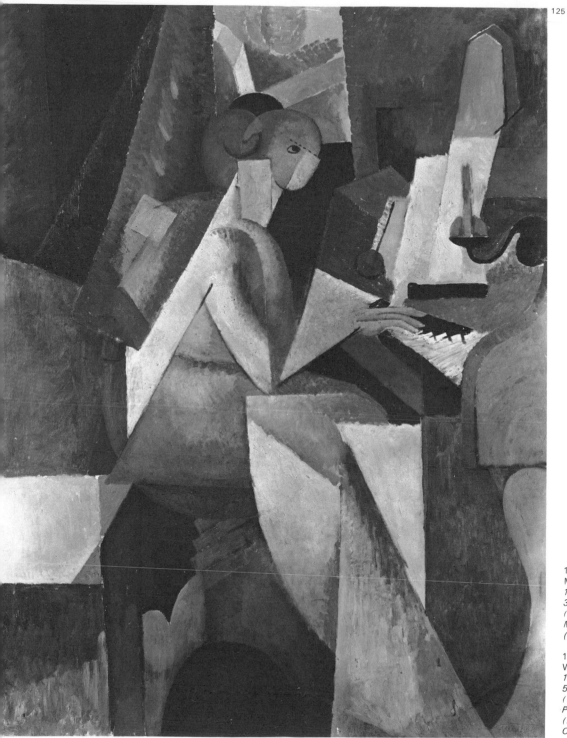

124. *Roger de la Fresnaye*
Married Life
1913, oil on canvas
38 × 46.25 in.
(96.5 × 117.5 cm.)
Minneapolis Institute of Arts
(John R. Van Derlip Fund)

125. *Albert Gleizes*
Woman at the Piano
1914, oil on canvas
57.6 × 44.75 in.
(146.5 × 113.5 cm.)
Philadelphia Museum of Art
(Louise and Walter Arensberg
Collection)

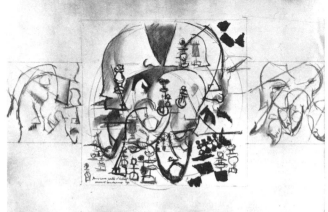

126. *Jacques Villon*
Marching Soldiers
1913, oil on canvas
25.5 × 36.25 in.
(65 × 92 cm.)
Musée d'Art Moderne,
Paris

127. *Marcel Duchamp*
Study for Chess Players
1911
charcoal and ink on paper
18 × 24 in.
(45 × 61 cm.)
Collection of Mme.
M. Duchamp, New York

128. *Etienne-Jules Marey,*
Chronophotograph of a
lunging fencer, c.1880,
Archives de la Cinémathèque
Française, Paris

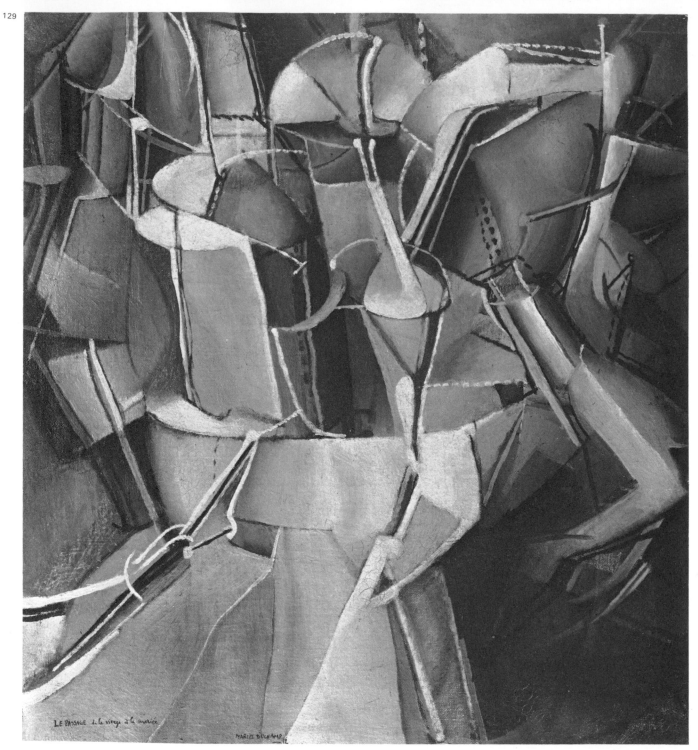

LE PASSAGE de la vierge à la mariée

MARCEL DUCHAMP 12

to Duchamp, for this is precisely the difference between Duchamp's and the Futurist Giacomo Balla's **151** interpretations of chronophotography. Duchamp saw sequential images almost as if the motif were undergoing a chemical change. His painting *The Passage* **129** *from Virgin to Bride* (1912) no longer depicts a process through space or time, but a process of organic metamorphosis. Far less rational than Picasso's strange, half-human images of 1915, these characters were born in Duchamp's art and lived out their transformation in that unique context. Duchamp himself was sceptical about their surreal significance: '*I don't want the subconscious to speak,*' he said, '*I don't care*'. Nevertheless as images they are remote from the objective reality of Gleizes and Metzinger's Cubism and of far greater relevance to Surrealism.

Similarly Duchamp's ready-mades, while perhaps relatable to the actuality of matter in Cubist collages and to the general Cubist quest for a greater closeness to reality, were an intellectual denial of art as anything but reality, a denial of anything but a conceptual role for the artist.

Duchamp's conclusions were prompted by the radical atmosphere of the French avant-garde (including Cubism), by his own peculiar intellectual and satirical bias and, more immediately, by discussions he had in 1912—13 with Apollinaire and Francis Picabia. (Picabia, who had already explored the whole **114** gamut of avant-garde idioms and toyed with the idea of a pure, non-figurative painting, became a vigorous disciple of Duchamp, his exuberance the perfect foil to Duchamp's intellect.) The discussions with Apollinaire sought to prolong and deepen the state of enquiry about the nature of art from which Cubism was born. Duchamp parted company with the Cubists at the point where Gleizes and his contemporaries had ceased to enquire. They had accepted Cubism as an established modern tradition and made of it, in effect, a new academy. Picabia, on the other hand, now denounced Cubism as 'a cathedral of shit'.

Cubist sculpture

Cubist painting had been an intensive exploration and revision of the ambiguities of the art of painting. Its revolutionising of space conceptions had been undertaken in a medium where space was illusory, in an activity whose whole basis was the paradox of three-dimensional reality represented on a two-dimensional surface. Cubism's marshalling of forms on or near the picture plane would appear to have little relevance to the real volumes and the real spaces of sculpture. It is some measure of Cubism's absorption with painting that Picasso, who had made sculptures on and off since 1901, should abandon the activity completely between 1909 and around 1914.

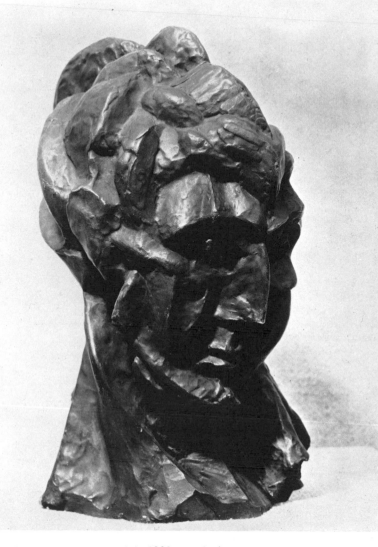

His most important work in 1909 was the bronze, *Woman's Head*. Comparable in its tough assembly of **130** simple broken forms to contemporary paintings, it also anticipates the subsequent phase of Cubist painting. While retaining a massive sense of solid substance, the effect of light on the tilted sequence of planes creates an area all around the head which is neither all substance nor all space. Between the two absolutes—the dense matter of the head and the clear space outside it—exists this halo of interplay between form and space. It is a sculptural reconstruction of Cézanne's painterly passage, linking foreground and background or object and object. In Picasso's own painting it finds a close parallel in the Vollard portrait of 1909—

129. *Marcel Duchamp*
Passage from Virgin to Bride
1912, oil on canvas
23.4 × 21.25 in.
(59 × 54 cm.)
Museum of Modern Art,
New York

130. *Pablo Picasso*
Woman's Head
1909, bronze
h. 16.25 in. (41.3 cm.)
Museum of Modern Art,
New York

10, where the physical volume of the head is powerfully realised but opens out all over its surface into affinities with the environment. To achieve anything approaching this painting—with its subtly translucent crystalline structure—in such an opaque and immutable substance as bronze was remarkable.

In a very real sense the evolution of Cubism meant a suppression of Picasso's wide-ranging instincts. But even within this tight concern with painting his sense of plastic values emerged. His paintings of 1906–8 have clearly sculptural qualities. Inasmuch as they were profoundly influenced by three-dimensional art—
131 Iberian stone reliefs and then African masks and carvings—they are paintings about sculpture and sculpture's values. Colour is at a low premium and the manipulation of paint was never anything to Picasso but a means to plastic effect. He was never seduced by the activity of painting, the *'belle peinture'* of the Parisians. Perhaps this was the critical factor in his contribution to Cubist painting.

More than Braque he felt an urgent need to escape from the limitation of paint on canvas into the improvised invention of collage. From collage he developed a sort of Synthetic Cubist painting that was anything but painterly: flat sheets of colour or pattern are welded into an aggressively formal construction.
133, From collage too, he progressed to a series of painted
117 three-dimensional constructions around 1914, made in wood or sheet iron. These mostly pre-date the very flat, hard-edged paintings just mentioned and this was probably another instance of his painting deriving directly from sculpture. So he entered Cubism via sculptural thinking and in a sense emerged from it through sculptural activity as well.

For Picasso sculpture was not a question of reconciling painting's revolutions to another medium. Painting and sculpture were not that distinct. The constructions that he made from 1912 onwards were
132 really a part of collage. The *Still-Life* of 1914 is full of collage's spirited references to reality and to art. The real fringe around the table top is adjacent to slices of sausage and cheese, carved in wood but painted realistically. The wooden beading is real, but the glass is a satirical three-dimensional reconstruction in wood of the sort of two-dimensional plan-section-and-elevation analysis of objects that characterised early Cubist painting.
115 The famous *Absinthe Glass* also of 1914 is in some senses closer to the 1909 *Woman's Head*: cast in bronze, free-standing and about life-size. It is hollowed out to fuse interior and exterior: the liquid level is visible through the aperture, like a tongue in a gaping mouth. At the other side the level projects through the glass's contour, another reference to the transparency of the glass. Cast in an edition of six, each is painted

120

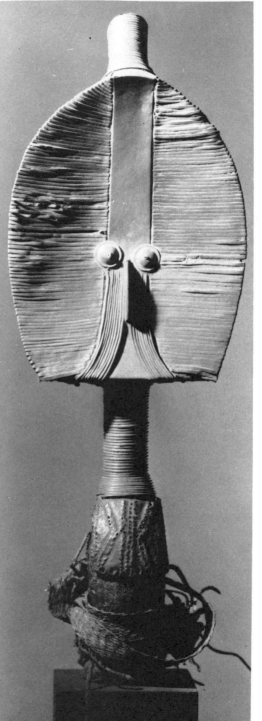

131. Gabon (Osyeba), reliquary figure, wood and copper strips h. 19.25 in. (49 cm.) Musée de l'Homme, Paris

132. *Pablo Picasso*
Still-Life
1914, painted wood with
upholstery fringe
18.9 in. (47.9 cm.)
Tate Gallery, London

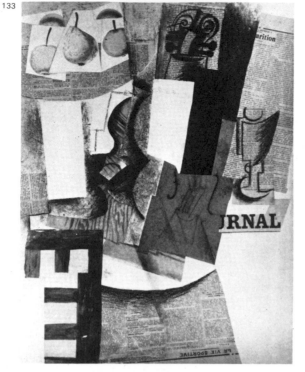

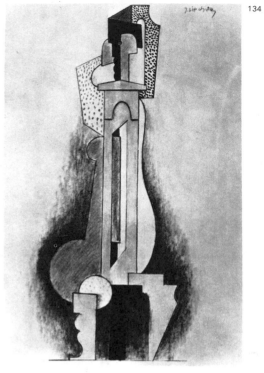

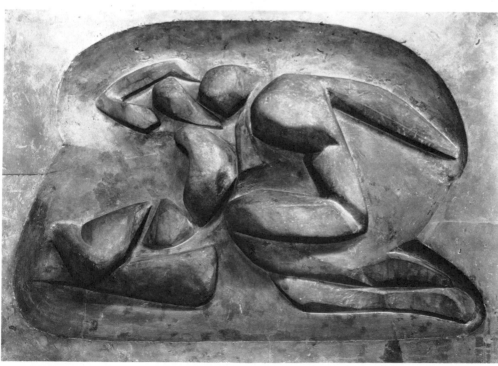

133. *Pablo Picasso*
Violin
1913, papier collé, chalk and gouache on cardboard
20 × 11.75 in.
(50.8 × 29.5 cm.)
Artist's Collection

135. *Jacques Lipchitz*
Study for Sculpture
1915, pencil, crayon and indian ink
Collection of J. Tucker,
St. Louis

135. *Raymond Duchamp-Villon* The Lovers
1913, bronze
13.5 × 20.5 in.
(34.3 × 51.4 cm.)
Museum of Modern Art,
New York

differently but no less audaciously, with the same free, decorative improvisation that characterised his 1914 paintings. If this were not enough to transmute the traditional bronze into a new world, then the inclusion of a ready-made component—a real absinthe *grille*—poised between the painted bronze glass and the painted bronze sugar cube, finalises the distinction. This tiny, almost insignificant bronze is a major event, ancestor to a whole tradition of objects and assemblages that is still not spent. Almost the whole span of Cubism's liberating propositions for sculpture are here: the reduction of representation to an emblematic language; the interchangeability of object and space; the uninhibited attitude to materials, including ready-made forms and images; the extension of subject-matter to include commonplace trivia and finally, the transfer of the painting/sculpture fusion from near-painting to near-sculpture.

Nearly all the Cubist sculptors worked in terms directly related to Cubist painting—this is almost the only common factor that enables us to speak of 'Cubist sculpture' at all. None of them, with the possible exception of Archipenko who coined the term 'Sculpto-painting', rode the transition with Picasso's disconcerting ease. All of the sculptors—Picasso apart—joined Cubist circles when Cubist painting was already well advanced. Lipchitz's 1915 *Study for Sculpture* looks like a Synthetic Cubist drawing with shading around the edges to translate it to sculpture.

134

Cubist sculpture falls into two general areas. First there are those works, which following Picasso's lead of 1909, pursued aspects or Cubist painting in the conventional media of sculpture—plaster, stone, bronze. Running concurrently and sometimes in the work of one artist, the second area exploited the technical and formal freedoms of collage and *papier collé*. Most of these works were not strictly sculptures but constructions, a genre with its own modern history.

136 In his *Walking Woman* of 1912 Alexander Archipenko made the first pierced-form sculpture, taking Cubism's destruction of absolute form-space values to an extreme conclusion. The ratio of volume to space is inverted. The bronze figure is pierced and its points of maximum density—the head and the torso—are voids. In the light of subsequent sculpture and constructions —in which the measurement and articulation of volumes by space has become a major, almost conventional preoccupation—the *Walking Woman* looks a very primitive prototype. Nevertheless it was a historic moment.

Movement was a particular preoccupation in Cubist circles. Léger and Delaunay were both concerned with dynamic rhythms. According to Kahnweiler, Picasso in 1912 was discussing the idea of moving sculptures: so, in 1913 was Duchamp. Duchamp-Villon never

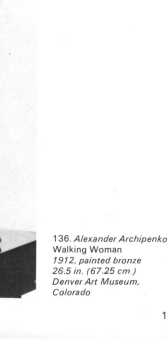

136. *Alexander Archipenko*
Walking Woman
1912, painted bronze
26.5 in. (67.25 cm)
Denver Art Museum,
Colorado

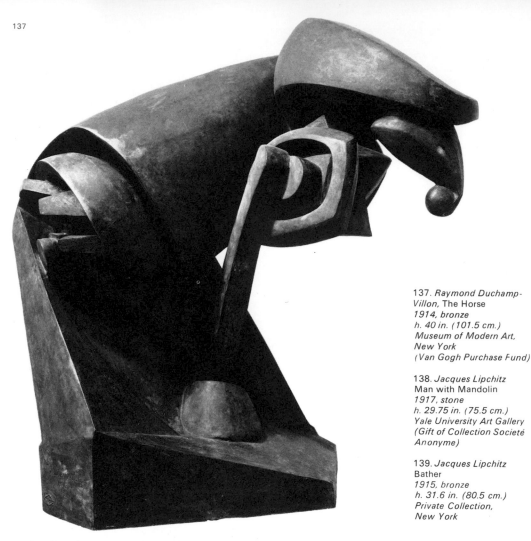

137. *Raymond Duchamp-
Villon,* The Horse
*1914, bronze
h. 40 in. (101.5 cm.)
Museum of Modern Art,
New York
(Van Gogh Purchase Fund)*

138. *Jacques Lipchitz*
Man with Mandolin
*1917, stone
h. 29.75 in. (75.5 cm.)
Yale University Art Gallery
(Gift of Collection Societé
Anonyme)*

139. *Jacques Lipchitz*
Bather
*1915, bronze
h. 31.6 in. (80.5 cm.)
Private Collection,
New York*

achieved, perhaps never aspired to actual movement
in sculpture. But in his very short career—he died in
1918—he produced the most dynamic Cubist sculp-
ture, the bronze *Horse*. In his 1913 plaster relief *The
Lovers*, he had employed a sunken relief form directly
analogous to painting, simulating movement through
the compressed space and formal dislocations of
Analytical Cubism. Compared with it *The Horse* is a
very complete, authoritative statement. Close to the
spirit of Léger's art, it has a dynamic sense of urgent
energy. A great piston shaft springs from a socket in
the neck to couple onto the jawbone and the head is
a spiral of interleaved cylinders, creating a strong
mechanical flavour. There may be a direct link with
Futurism: Boccioni's sculpture was exhibited in Paris
in 1913 and Duchamp-Villon almost certainly saw it

then. The simple inclined planes of the base and neck
are very like the substructure of Boccioni's *Bottle*. In
its general character *The Horse* is actually a far more
explicit expression of the machine age than any of
Boccioni's art-conscious bronzes.

Jacques Lipchitz, a close friend of Juan Gris, was
drawn by Cubism into a free exploratory approach to
the figure. His instinctive respect of traditional sculp-
ture prevented any real impulse to depart from the
conventional bases of subject and media: his entire
œuvre appears, like Braque's or Gris' rather conserva-
tive in the whole 20th-century context. Nevertheless
in the figures of 1915—17, all of them in stone or
bronze, he undertook to reconcile some of Cubism's
radical freedoms to free-standing sculpture. The
distortions and simplifications of the bronze *Bather* 159

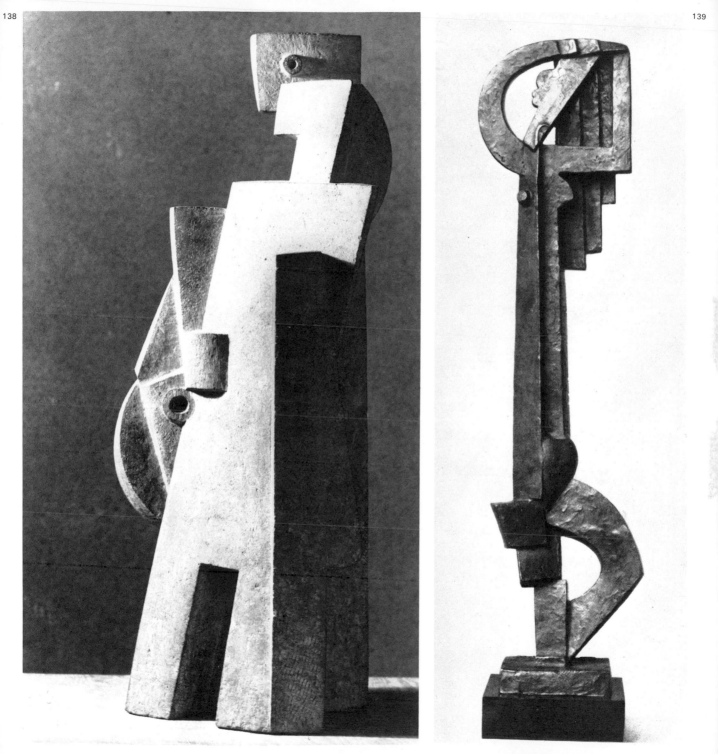

derive directly from Cubist painting. In other works
138 like the *Man with Mandolin* there is massive sculptural
volume. Its outward character is articulated by inter-
locking flat surfaces, simple and sharp-edged like
Synthetic Cubist painting. It is an impressive equiva-
lent to the simple formal orchestration of Gris's con-
temporary paintings.

Much of Henri Laurens' work is of the same mas-
sively architectural character, simple flat surfaces
relieved by Cubist textures and schematic features. But
by far the most inventive aspect of Laurens' art lies in
the second field of Cubist sculpture, constructions.
Between about 1914 and 1918 he made a series of
still-life and figure constructions that exemplify col-
lage's importance for three-dimensional art. Some of
them are direct extensions of Synthetic Cubist still-
lifes with the same simple colour composition as
Gris' 1915 paintings. Translated into three dimensions
they hover somewhere between the conventions of
painting and reality itself. Others like the grotesque
140 *Head* assemble brightly-coloured jagged elements
into an expressive, dislocated image closer to Picasso.
The poise here is between aesthetic values and the
aggressive animation of a mask.

In terms both of colour and materials, it was Archi-
penko who made the most outspoken statements. In
1912, aligning himself with Apollinaire's Orphism, he
had denied any common interest with Cubism. If this
is not borne out by his work as a whole, it is certainly
true that compared with Lipchitz and Laurens he was
more able to shake himself free from the inhibitions
116 of conventional sculpture. His *Médrano* of 1915 is
made of tin, wood, glass and oilcloth, much of it
painted. As an image it is remarkably free of any 'high
art' solemnity. Decorative and rather frivolous, its title
is probably taken from the famous Circus Médrano, a
favourite haunt of many Cubist artists. It is a popular
motif treated in very unorthodox materials. At a more
serious level, it is a significant extension of the breaking
down of form-space distinctions that he had tackled
136 so baldly in the 1912 *Walking Woman*. The figure's
volume is inferred rather than represented, by inter-
locking planes. Some of the planes are transparent,
demonstrating the thesis so vital to 20th-century
sculpture that form and space are not mutually ex-
clusive. The use of transparent materials was to be-
come a critical factor in later developments.

141 The bizarre *Pierrot Carrousel* of 1913, is in many
ways the most extraordinary sculpture to emerge from
Cubist circles. Another motif from popular entertain-
ment, its crude forms and vulgar fairground colours
have the brashness of much 1960s Pop Art. Apart
from its general simplifications and its compatibility
with the 'low art' tendencies within Cubism, it would
appear to have little to do with Cubism. This appear-

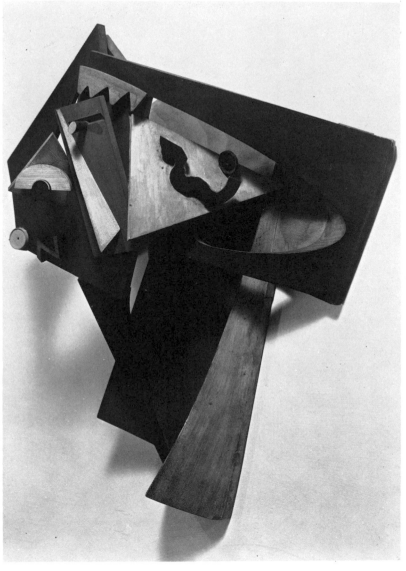

ance is not without significance. The sculpture that
remained stylistically close to Cubist forms was the
least remarkable.

The main importance of Cubism for later sculpture
was that it instilled a liberating energy, a broadening of
the scope and means of the art, a breaking down of its
boundaries. In its most revolutionary implications—the
invasion of form by space—which made vulnerable the
whole basis of traditional sculpture, the Cubists them-
selves were the least adventurous, almost as if the
Cubist sculptors were too close to the evolution of Cu-
bist painting to read its deeper meaning for sculpture.

140. *Henri Laurens*
Head
1918, painted wood
h. 20 in. (50.8 cm.)
Museum of Modern Art,
New York
(Van Gogh Purchase Fund)

141. *Alexander Archipenko*
Pierrot Carrousel
1913, painted plaster
h. 23.6 in. (60 cm.)
Solomon R. Guggenheim
Museum, New York

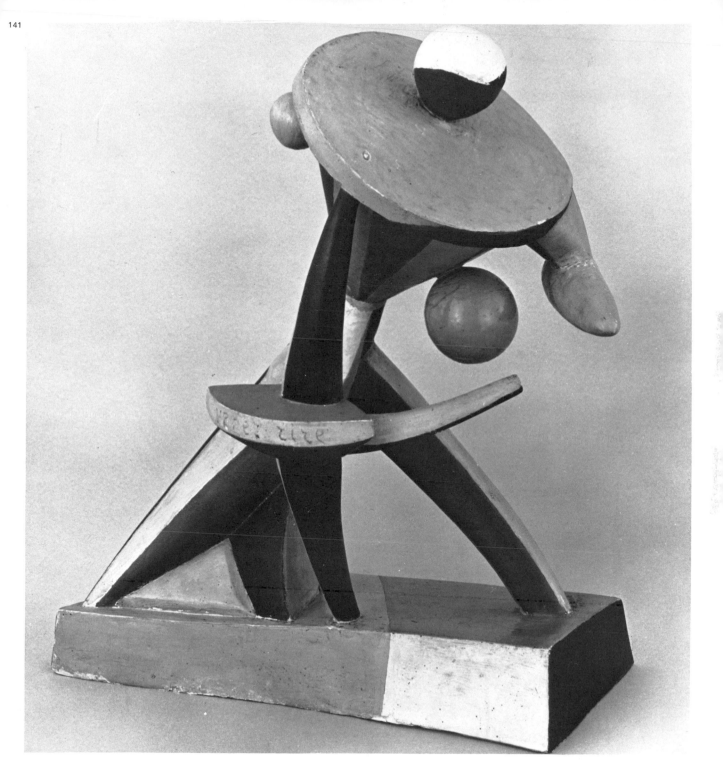

Writings

Statements by the Cubist painters

Picasso 'Many think that cubism is an art of transition, an experiment which is to bring ulterior results. Those who think that way have not understood it. Cubism is neither a seed nor a foetus, but an art dealing primarily with forms, and when a form is realised it is there to live its own life. A mineral substance, having geometric formation, is not made so for transitory purposes, it is to remain what it is and will always have its own form. But if we are to apply the law of evolution and trans-formation to art, then we have to admit that all art is transitory. On the contrary, art does not enter into these philosophic absolutisms. If cubism is an art of transi-tion I am sure that the only thing that will come out of it is another form of cubism.

Mathematics, trigonometry, chemistry, psychoana-lysis, music and whatnot, have been related to cubism to give it an easier interpretation. All this has been pure literature, not to say nonsense, which brought bad results, blinding people with theories.

Cubism has kept itself within the limits and limita-tions of painting, never pretending to go beyond it. Drawing, design and colour are understood and prac-tised in cubism in the spirit and manner that they are understood and practised in all other schools. Our subjects might be different, as we have introduced into painting objects and forms that were formerly ignored. We have kept our eyes open to our surroundings, and also our brains.'

Part of a Statement by Picasso: 1923
From Picasso: *Fifty Years of His Art* by Alfred H. Barr, Jr. copyright 1946 The Museum of Modern Art, New York, and reprinted by permission of the publisher. The "Statement by Picasso: 1923" was made in Spanish to Marius de Zayas. Picasso approved de Zayas' manuscript before it was translated into English and published, originally, in *The Arts*, New York, May 1923, under the title "Picasso Speaks."

'The artist is a receptacle for emotions that come from all over the place: from the sky, from the earth, from a scrap of paper, from a passing shape, from a spider's web. That is why we must not discriminate between things. Where things are concerned there are no class distinctions. We must pick out what is good for us where we can find it—except from our own works. I have a horror of copying myself. But when I am shown a portfolio of old drawings, for instance, I have no qualms about taking anything I want from them.

When we invented cubism we had no intention whatever of inventing cubism. We wanted simply to express what was in us. Not one of us drew up a plan of campaign, and our friends, the poets, followed our efforts attentively, but they never dictated to us. Young painters today often draw up a programme to follow,

and apply themselves like diligent students to performing their tasks . . .

It's not what the artist *does* that counts, but what he *is*. Cézanne would never have interested me a bit if he had lived and thought like Jacques Emile Blanche, even if the apple he painted had been ten times as beautiful. What forces our interest is Cézanne's anxiety —that's Cézanne's lesson; the torments of Van Gogh— that is the actual drama of the man. The rest is a sham.'

Part of a Statement by Picasso: 1935
From Picasso: *Fifty Years of His Art* by Alfred H. Barr, Jr., copyright 1946 The Museum of Modern Art, New York, and reprinted by permission of the publisher. Christian Zervos put down these remarks of Picasso immediately after a conversation with him at Boisgeloup in 1935. They were first published under the title "Conversation avec Picasso" in *Cahiers d'art*, 1935, volume 10, number 10. The above translation is based on one by Myfanwy Evans.

Braque 'Speaking purely for myself, I can say that it was my very acute feeling for the *matière*, for the substance of painting, which pushed me into thinking about the possibilities of the medium. I wanted to create a sort of substance by means of brushwork. But that is the kind of discovery which one makes gradually, though once a beginning has been made other discoveries follow. Thus it was that I subsequently began to introduce sand, sawdust and metal filings into my pictures. For I suddenly saw the extent to which colour is related to substance. If, for instance, two pieces of white material, each of a different texture, are dipped in the same dye, they will emerge a different colour. Now, this intimate relationship between colour and substance is inevitably even more delicate when it comes to painting. So my great delight was the "material" character which I could give to my pictures by introducing these extraneous elements. In short, they provided me with a means of getting further away from idealism in art and of getting closer still to the possibility of "representing" the things with which I was concerned . . .

Papier collé enabled me to dissociate clearly colour from form and to see that they were independent of each other. That was the great revelation. Colour and form make their effect simultaneously, though they have nothing to do with each other.'

From *Georges Braque, La Peinture et Nous*. Statements by the artist recalled by Dora Vallier. *Cahiers d'Art*, 1954, p. 17.

Gris 'The exaggerations of the Dada movement and others like Picabia, makes us all look like classics: I can't say I mind about that. I should like to continue the painting tradition with plastic means while bringing to it a new aesthetic based on the intellect. There seems to me no reason why one should not pinch Chardin's technique without taking over the appearance of his pictures or his conception of reality. Those who believe in abstract painting are like weavers who think they can produce a material with only one set of threads and forget that there has to be another set to hold these together. Where there is no attempt at plasticity how can you control representational liberties? And where there is no concern for reality how can you limit and unite plastic liberties? For some time I have been quite pleased with my own work, because I think that at last I am entering on a period of realisation. What's more, I have been able to test my progress: formerly, when I started on a picture I was satisfied at the beginning and dissatisfied at the end. Now the beginning is always rotten and I am fed up, but I get an agreeable surprise at the end. I have also been successful in ridding my painting of a too brutal and descriptive reality. It has, so to speak, become more poetic. I hope I shall come to express with great precision a reality imagined in terms of pure intellectual elements; this really means painting which is inaccurate but precise, that is to say the reverse of bad painting which is accurate but unprecise.'

Letter to Kahnweiler, August 25th, 1919.

'I work with the elements of the intellect, with the imagination. I try to make concrete that which is abstract. I proceed from the general to the particular, by which I mean that I start with an abstraction in order to arrive at a true fact. Mine is an art of synthesis, of deduction, as Raynal has said.

I want to endow the elements I use with a new quality; starting from general types I want to construct particular individuals.

I consider that the architectural element in painting is mathematics, the abstract side; I want to humanise it. Cézanne turns a bottle into a cylinder, but I begin with a cylinder and create an individual of a special type: I make a bottle—a particular bottle—out of a cylinder. Cézanne tends towards architecture, I tend away from it. That is why I compose with abstractions (colours) and make my adjustments when these colours have assumed the form of objects. For example, I make a composition with a white and a black and make adjustments when the white has become a paper and the black a shadow: what I mean is that I adjust the white so that it becomes a paper and the black so that it becomes a shadow.

This painting is to the other what poetry is to prose.'
From *L'Esprit Nouveau*, No. 5. Paris, 1921.

'Now I know perfectly well that when it began Cubism was a sort of analysis which was no more

painting than the description of physical phenomena was physics.

But now that all the elements of the aesthetic known as "cubist" can be measured by its pictorial technique, now that the analysis of yesterday has become a synthesis by the expression of the relationships between the objects themselves, this reproach is no longer valid...

Cubism is not a manner but an aesthetic, and ever a state of mind; it is therefore inevitably connected with every manifestation of contemporary thought. It is possible to invent a technique or a manner independently, but one cannot invent the whole complexity of a state of mind.'

From a reply to a questionnaire 'Chez les Cubistes', *Bulletin de la Vie Artistique*. Paris, January, 1925.

Léger 'During those four war years I was abruptly thrust into a reality which was both blinding and new. When I left Paris my style was thoroughly abstract: period of pictorial liberation. Suddenly, and without any break, I found myself on a level with the whole of the French people; my new companions in the Engineer Corps were miners, navvies, workers in metal and wood. Among them I discovered the French people. At the same time I was dazzled by the breech of a 75 millimetre gun which was standing uncovered in the sunlight: the magic of light on white metal. This was enough to make me forget the abstract art of 1912—13. A complete revelation to me, both as a man and as a painter. The exuberance, the variety, the humour, the perfection of certain types of man with whom I found myself; their exact sense of useful realities and of their timely application in the middle of this life-and-death drama into which we had been plunged. More than that: I found them poets, inventors of everyday poetic images—I am thinking of their colourful and adaptable use of slang. Once I had got my teeth into that sort of reality I never let go of objects again.'

Quoted by Douglas Cooper in *Fernand Léger et le Nouvel Espace*, 1949.

'The realistic value of a work is completely independent of all imitative quality.

This truth should be recognised as axiomatic in the general understanding of painting.

I am using the word 'realistic' on purpose in its strictest sense, for the quality of a pictorial work is in direct proportion to its quantity of realism.

What is meant by realism in painting?...

In my view, pictorial realism is the simultaneous ordering of the three great plastic qualities, line, form and colour.

Present-day life, more fragmented and faster-moving than preceding periods, was bound to accept, as its means of expression, an art of dynamic "divisionism"; and the sentimental side, the expression of the subject (in the vulgar sense of the word "expression"), has reached a critical moment which we must define clearly...

I am anxious to point out that modern mechanical achievements such as colour photography, the cinematograph, the profusion of more or less popular novels and the popularisation of the theatres have made completely superfluous the development of the visual, sentimental, representational and popular subject in painting...

Visual realism has never been achieved with such intensity in art as it now is in the cinema...

Each art is isolating itself and limiting itself to its own field.

Specialisation is a characteristic of modern life, and pictorial art, like all other manifestations of the human mind, must submit to it. The law of specialization is a logical one, for by confining each man to the pursuit of a single aim it intensifies the character of his achievements.

This results in a gain in realism in visual art. The modern conception of art is thus not a passing abstraction valid for a few initiates only; it is the total expression of a new generation whose condition it shares and whose aspirations it answers.'

From an essay 'The Origins of Painting and its Representational Value.' *Montjoie!*, Paris, May—June, 1913.

'If pictorial expression has changed, it is because modern life has made this necessary. The daily life of modern creative artists is much more condensed and more complex than that of people in earlier centuries. The thing that is imaged does not stay as still, the object does not exhibit itself as it formerly did. When one crosses a landscape in an automobile or an express train, the landscape loses in descriptive value, but gains in synthetic value; the railway carriage door or the car windscreen, along with the speed imparted to them, have altered the habitual look of things. A modern man registers a hundred times more sensory impressions than an eighteenth-century artist, so that, for instance, our language is full of diminutives and abbreviations. The condensation of the modern picture, its variety, its breaking up of forms, are the result of all this. It is certain that the evolution of means of locomotion, and their speed, have something to do with the new way of seeing...

An art of painting that is realist in the highest sense is beginning to appear; and it is here to stay.

It is a fresh measure, coming on to the scene in response to a new state of affairs. The breaks with the past that have occurred in our visual world are in-

numerable. I will choose the most striking. The advertisement hoarding, which brutally cuts across a landscape in obedience to the dictates of modern commerce, is one of the things that have aroused most fury among men of so-called good taste . . .

And yet that yellow or red billboard, shouting in a timid landscape, is the finest of possible reasons for the new painting; it knocks head over heels the whole sentimental and literary conception of art and announces the advent of true plastic contrast . . .

From a lecture 'Contemporary Achievements in Painting' delivered at the Académie Wassilieff, published in *Soirées de Paris*, June, 1914.

Metzinger 'Because they use the simplest, most complete and most logical forms, they have been dubbed "cubists". Because they labour to elicit new plastic signs from these forms, they are accused of betraying tradition.

. . . The men known as cubists are trying to imitate the masters, endeavouring to fashion new types (to the word new I attach the idea of difference, and exclude from it the idea of superiority or progress). Already they have uprooted the prejudice that commanded the painter to remain motionless in front of the object, at a fixed distance from it, and to catch on the canvas no more than a retinal photograph more or less modified by "personal feeling". They have allowed themselves to move round the object, in order to give, under the control of intelligence, a concrete representation of it, made up of several successive aspects. Formerly a picture took possession of space, now it reigns also in time. In painting, any daring is legitimate that tends to augment the picture's power as painting. To draw, in a portrait, the eyes full face, the nose in semi-profile, and to select the mouth so as to reveal its profile, might very well—provided the craftsman had some tact—prodigiously heighten the likeness and at the same time, at a crossroads in the history of art, show us the right road.'

From 'Cubisme et Tradition'. *Paris-Journal*, 16th August, 1911.

Gleizes and Metzinger 'Only those who are conscious of the impossibility of imagining form and colour separately can usefully contemplate conventional reality.

There is nothing real outside ourselves; there is nothing real except the coincidence of a sensation and an individual mental direction. Far be it from us to throw any doubts upon the existence of the objects which strike our senses; but, rationally speaking, we can only have certitude with regard to the images which they produce in the mind.

It therefore amazes us when well-meaning critics try to explain the remarkable difference between the forms attributed to nature and those of modern painting by a desire to represent things not as they appear, but as they are. As they are! How are they, what are they? According to them, the object possesses an absolute form, an essential form, and we should suppress chiaroscuro and traditional perspective in order to present it. What simplicity! An object has not one absolute form; it has many. It has as many as there are planes in the region of perception. What these writers say is marvellously applicable to geometrical form. Geometry is a science; painting is an art. The geometer measures; the painter savours. The absolute of the one is necessarily the relative of the other; if logic takes fright at this idea, so much the worse! Will logic ever prevent a wine from being different in the retort of the chemist and in the glass of the drinker?

We are frankly amused to think that many a novice may perhaps pay for his too literal comprehension of the remarks of one cubist, and his faith in the existence of an Absolute Truth, by painfully juxtaposing the six faces of a cube or the two ears of a model seen in profile.

Does it ensue from this that we should follow the example of the impressionists and rely upon the senses alone? By no means. We seek the essential, but we seek it in our personality and not in a sort of eternity, laboriously divided by mathematicians and philosophers.'

From *Du Cubisme*. Paris, 1912.

Writings on Cubism by later artists
Futurism 'I have already seen the modern painters who interest me. I shall continue to study them, but I see that I have intuitively apprehended almost everything. Only the external appearance (due to the *incredibly* enormous influence of Cézanne and Gauguin and others) makes it seem that the works of some are more venturesome than they really are. Of the Cubists I have not yet seen Picasso, Braque and some others. Of those whom I have seen—Metzinger, Fauconnier (sic), Léger, Gleize (sic) etc.—only the first really searches in an unexplored field.'

Umberto Boccioni, Letter dated October 15th, 1911.

'We must begin from the central nucleus of an object as it strives for realisation, in order to discover the new laws, that is, the new forms, that relate it invisibly but mathematically to the plastic infinity within, and visible plastic infinity without. The new plasticity will thus be the translation into plaster, bronze, glass, wood, or any other material, of the atmospheric planes that unite and intersect visible objects. . . Thus sculpture must bring objects to life by rendering apprehensible, plastic and systematic their prolongations into space, since

it cannot be doubted any longer that one object finishes where another begins, and that there is not one object around us—bottle, automobile, tree, house or street—that does not cut and section us with some arabesque of curved or straight lines.

. . . We proclaim the absolute and complete abolition of determined lines and closed statues. We split open the figure and include the environment within it. . .

· ·

For us the straight line will be alive and palpitating; will lend itself to all the expressive necessities of our material, and its basic bare severity will be a symbol of the metallic severity of the lines of modern machinery

· ·

(We propose to) Destroy the purely literary and traditional nobility of bronze and marble. Deny that any one material should be used exclusively for the whole of a sculptural construction. Affirm that even twenty different materials can join in one work to increase the scope of its plastic emotion. We enumerate some: glass, wood, iron, cement, hair, leather, cloth, electric light, etc.'

Umberto Boccioni, *Technical Manifesto of Futurist Sculpture*, April, 1912.

Purism 'Of all recent schools of painting, only Cubism foresaw the advantages of choosing selected objects, and of their inevitable associations. But, by a paradoxical error, instead of sifting out the general laws of these objects, Cubism only showed their accidental aspects, to such an extent that on the basis of this erroneous idea it even recreated arbitrary and fantastic forms. Cubism made square pipes to associate with matchboxes, and triangular bottles to associate with conical glasses.

From this critique and all the foregoing analyses, one comes logically to the necessity of a reform, the necessity of a logical choice of themes, and the necessity of their association not by deformation, but by formation.

If the Cubists were mistaken, it is because they did not seek out the invariable constituents of their chosen themes, which could have formed a universal, transmittable language.'

Le Corbusier & Ozenfant, 'Purism'. *L'Esprit Nouveau* No. 4, 1920.

'Picasso's influence was fruitful down to 1914. The first period of Cubism is inspiring, because it testifies to a high and noble aim. But from the outbreak of war, the work of the master began to reveal a preference for the standards of the embroiderer and the lacemaker: it was besprinkled with dots, spots, squiggles, charmingly pretty or aggressive colour, and paradoxical

forms. His grand manner degenerates into intriguing mannerisms . . . we must, alas! admit, that even if the majority of Picasso's works after 1914 are extraordinary, they are also not important.'

Amédée Ozenfant, *Foundations of Modern Art*, 1928. (First English edition, 1931).

Constructivism 'The attempts of the Cubists and the Futurists to lift the visual arts from the bogs of the past have led only to new delusions.

Cubism, having started with simplification of the representative technique ended with its analysis and stuck there.

The distracted world of the Cubists, broken in shreds by their logical anarchy, cannot satisfy us who have already accomplished the Revolution or who are already constructing and building up anew.

One could heed with interest the experiments of the Cubists, but one cannot follow them, being convinced that their experiments are being made on the surface of Art and do not touch on the bases of it seeing plainly that the end result amounts to the same old graphic, to the same old volume and to the same decorative surface as of old. . .

Neither Futurism nor Cubism has brought us what our time has expected of them.'

Naum Gabo and Antoine Pevsner, *The Realistic Manifesto*, 1920.

Kandinsky 'Cubism, as a transitory form, demonstrates how natural forms are subordinated to constructive purposes and what unessential hindrances these realistic forms are. Cubism is a transition, in which natural form, by being forcibly subjected to constructional ends, becomes an impediment.'

Concerning the Spiritual in Art, 1912.

Malevich 'If for thousands of years past the artist has tried to approach the depiction of an object as closely as possible, to present its essence and meaning, then in our era of Cubism the artist has destroyed objects together with their meaning, essence and purpose.

The new picture has sprung from their fragments.

Objects have vanished like smoke, for the sake of the new culture of art.'

Essay, *Futurist Painting*, c. 1915.

'Academic naturalism, the naturalism of the Impressionists, Cézannism, Cubism, etc.,—all these, in a way, are nothing more than dialectic methods whlch in no sense determine the true value of art work.'

Essay, *Suprematism*, 1920.

Mondrian 'It was during this early period of experiment that I first went to Paris. The time was around 1910 when Cubism was in its beginnings. I admired

Matisse, Van Dongen and the other Fauves, but I was immediately drawn to the Cubists, especially to Picasso and Léger. Of all the abstractionists (Kandinsky and the Futurists) I felt that only the Cubists had discovered its right path: and, for a time, I was much influenced by them.

Gradually I became aware that Cubism did not accept the logical consequences of its own discoveries: it was not developing abstraction towards its ultimate: the expression of pure reality.'

Essays 1941—43, New York, 1945.

'Since Cubist art is still fundamentally naturalistic, the break which pure plastic art has caused consists in becoming abstract instead of naturalistic in essence. While in Cubism, from a naturalistic foundation, there sprang forcibly the use of plastic means, still half object, half abstract, the abstract basis of pure plastic art must result in the use of purely abstract plastic means.'

Plastic Art and Pure Plastic Art, 1937.

Dada and Surrealism 'We have had enough of the cubist and futurist academies.'

Tristan Tzara, *Dada Manifesto,* 1918.

'Cubism has taken shape in France as a result of that nation's fondness for soup.'

Raoul Haussmann, *A Return to Objectivity in Art,* 1920.

'The disdain in which Dada held all forms of modernism was indispensable to its own vitality; but it is necessary to add that experience has taught us to distinguish from futurism and abstract art—which, despite their relative riches, brought us nothing—cubism, the singularly poetic and poetry-inspiring grandeur of which had a powerful influence on our times, and even on Dada's most moving plastic expressions.'

Georges Hugnet, *The Dada Spirit in Painting,* 1932—34.

'. . .dancers dragging fragments of marble mantelpieces behind them. . . Braque is responsible for the fact that the invariable pattern of the paper which covers the walls of our room now resembles for us a tuft of grass on the face of a precipice. . .

If Surrealism ever comes to adopt a line of moral conduct, it has only to accept the discipline that Picasso has accepted and will continue to accept.''

André Breton, *La Surréalisme et la Peinture.* Collected Writings, 1945.

Since 1945

'This trend away from the mirror towards "equivalence" reached its climax in Cubism, but in Cubism the process of atomisation and reconstruction was carried so far that the object of representation finally disintegrated on the canvas. However, in destroying the visual object the cubists opened the doors to greater emphasis on the plastic qualities of the painting as a thing in itself. As a result the spectator was forced to see the painting per se before the object it represented . . .The step from cubism to complete autonomy of form, therefore, is a very short one.'

Victor Pasmore, *What is Abstract Art?*
The Sunday Times, Feb 5th, 1961.

'Cubism was a revolution in that the artist broke with tradition by changing from a line to a plane concept. . .

Each plane is a fragment of the architecture of space. When a number of planes are opposed to one another, a spatial effect results.'

Hans Hofmann. Quoted in William Seitz, *Hans Hofmann,* Museum of Modern Art, 1963.

'Personally, I do not need a movement. What was given to me, I take for granted. Of all the movements, I like Cubism most. It had that wonderful unsure atmosphere of reflection—a poetic frame where something could be possible, where an artist could practise his intuition. It didn't want to get rid of what went before. Instead it added something to it. The parts that I can appreciate in other movements came out of Cubism. Cubism *became* a movement, it didn't set out to be one. It has force in it, but it was no "force-movement".'

Part of a Statement by Willem de Kooning: 1951
From *What Abstract Art Means to Me,* Bulletin of The Museum of Modern Art, New York, Volume XVIII, No. 3, Spring 1951, and reprinted by permission of the publisher.

'I realise that my paintings have no link with, nor any basis in, the art of World War I with its principles of geometry—that tie it into the nineteenth century. To reject Cubism or Purism, whether it is Picasso's or Mondrian's only to end up with the collage scheme of free associated forms, whether it is Miró's or Malevich's, is to be caught in the same geometric trap. Only an art free from any kind of the geometry principles of World War I, only an art of no-geometry can be a new beginning.'

Part of a Statement by Barnet Newman: 1958
From *The New American Painting,* 1949. All rights reserved by The Museum of Modern Art, New York, and reprinted by permission of the publisher.

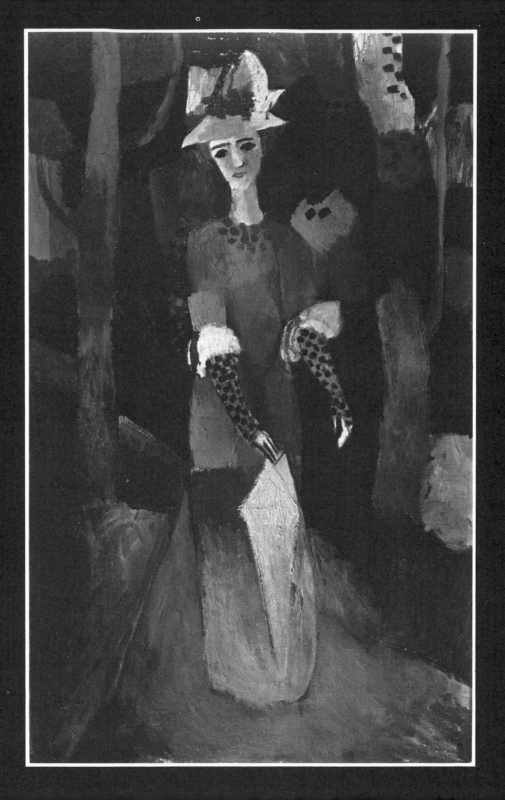

Preface

The explicit influence of Cubism at both superficial stylistic and profound theoretical levels is so extensive and so various that the whole fabric of modern art history seems to depend on it. Even where later generations have condemned certain aspects or principles of the movement, their own evolution has been directed by a consideration of problems raised in the first instance by Cubist art. Partly because Cubism was not tied to any moral programme and was free of any social, political and national strings, its exploration of art's means and art's potential was open-ended, undated and readily accessible. In the hands and minds of other artists the Cubist aesthetic provided the vehicle for a wide range of ideologies.

In the French context, Cubism came as the fulfilment and metamorphosis of several tendencies latent in the avant-garde art of earlier generations. Cubism's relationship to 19th-century art is outlined on pp. 23–30. Paramount in this relationship was the precedent of divisionist techniques. As early as Impressionism, French painters had treated the canvas in terms of a multiplicity of small units, making a simultaneous assault on the spectator's senses. In their respective ways, Cézanne, Seurat and Van Gogh were all concerned with building a new sort of synthesis out of this small-unit fragmentation. By 1912 Cubism had developed beyond systematic fragmentation to a point where former standards of coherence were shattered beyond significance. Partial images, random fragments of media, ambiguous transitions—these things did not have to be justified or explained: the activity of creating relationships was self-sufficient. From this point many paths were open. Within the Cubist movement itself, Picasso, Delaunay and Duchamp had already demonstrated how deeply and how deviously the liberating experience of Cubism could penetrate new fields.

Outside Paris the background had been very different. The new centres of avant-garde art that sprang up all across Europe, as well as in Russia and America, had no equivalent to the French Post-Impressionists. In many cases they were inspired more by social and political pressures, by the restive philosophical malaise that characterised early 20th-century culture, than by primarily artistic motives. They became articulate as artists through Cubism.

Very few artists picked up the threads of Cubism simply at their face value. Its influence was conditioned and often transformed by local traditions, temperaments and needs. This sort of competitive, almost partisan distinction was at its fiercest around 1910–18, the period of Cubism's first epidemic flood across Europe. Its formative influence was crucial for the pioneer modern art of Italy, Russia, Czechoslovakia,

The Influence of Cubism

142. *August Macke*
Lady in a Park
1914, oil on canvas
38.5 × 23.5 in.
(96.5 × 58.5 cm.)
Museum of Modern Art,
New York (Gift of the
Henry Pearlman Foundation)

Holland and (less directly) of Germany, England and America. Between the wars the international character of modern civilisation with its universal communication and exposure, dispersed the tight-knit, cellular structure of pre-war avant-gardes. In this phase the lessons of Cubism were more profoundly interpreted. They were reflected in international movements of Abstract Art, Realism and Surrealism rather than within national or local schools. The dominance of French art and of Paris began to decline. Since 1945 these characteristics of modern art have intensified. Cubism has become somewhat distant, securely placed in history and viewed through subsequent interpretations as often as directly. The pre-eminent place of American art in post-World War II history has sealed the demise of Paris. While American painting of the early '40s and '50s started from formal premises that were clearly descended from Cubism, much of it has since shifted away from Cubist concepts. But this has not meant that Cubism's importance in the current context has disappeared. The mid-20th century has been a history-conscious era in which many younger artists have felt obliged (perhaps in face of a self-conscious vogue for change) to reconsider their whole context and heritage. The presence of Cubism in that heritage will not easily become irrelevant. Reality and ambiguity, construction and assemblage, painting about the process of painting—these are all very live concerns.

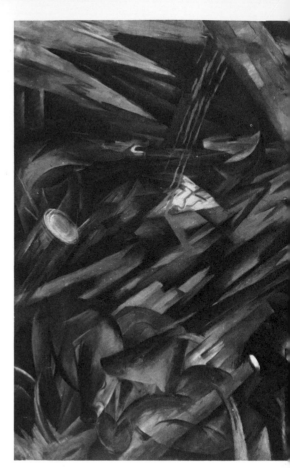

Cubism and Expressionism

At first sight the comparatively formal concerns of Cubism would seem very remote from the romantic ideals and the Gothic traditions of the German Expressionists. But the *Brücke* group, founded in Dresden in 1905, had already shown a readiness to assimilate an art-conscious French aesthetic. Kirchner, Heckel and Schmidt-Rottluff in their paintings of 1907/8 had modified the brilliant palette of late Neo-Impressionism and of Matisse's Fauvism for their own purposes. Similarly in the last Berlin phase of their activity, the *Brücke* painters absorbed certain aspects of Cubism. Kirchner's paintings of around 1912—13 show a dramatic lowering of colour scale towards a
119 Cubist monochrome. In his *Five Women in the Street* (1913) the more fluid contours of his earlier work give way to a sharp angular structure. The crystalline composition of Analytical Cubism lends an edge of anxiety to Expressionism. The rhythms are jagged and staccato; the whole mood is more nervous and ominous.

This sort of adaptation of Cubism's superficial aspects was a common feature of the first spread of the style across Europe. In its geometric fragmentation it was recognisably a new style, departing radically from the languorous curves of *Art Nouveau*. The response of the *Blaue Reiter* artists in Munich was at a deeper

level and their transformation of Cubism more complete. Kandinsky, the main force behind the movement, was more an interested spectator of Cubism, but for Macke and Marc the contact with Cubism (and particularly with Delaunay) was a turning point. For Macke the planear colour-structure of Orphism was a means to realising his own expressive colour relationships, 142 while for Marc Cubist fragmentation became the basis of a universal nature-symbolism. In paintings like the 1913 *Animal Destinies*, his transformation of the 143 Cubist idiom from a world of objective analysis and formal synthesis to the mystical sphere of German romanticism was direct but remarkably complete. Cubism enacted a similar role in the evolution of Feininger's art. He worked in Berlin but was in contact 144 with the *Blaue Reiter*. His later work distilled the crystalline agitation of 1914 into a remote, spiritual architecture of austere, translucent planes.

The avant-garde of Prague, perhaps the youngest of any consequence in Europe, had like the Germans been inspired by the pioneers of Expressionism. Just

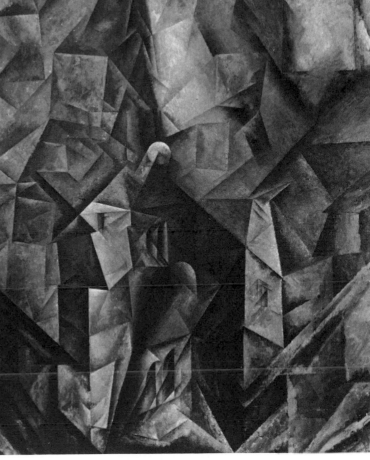

as Cubist ideas were to reach some artists via Futurism, so in Czechoslovakia, Cubism was partly coloured by the Expressionist vision of Berlin, Munich and Vienna. Accepting these inevitable local overtones, the assimilation of Cubism, on its own terms, by Czech painters from as early as 1910 was extraordinary, and unparalleled outside Paris. The painters Kubišta, Filla, Procházka, Kremlicka, Capek and Spála moved with rapidity from a Cubist reduction of realism to a very complete exploration of the Cubist language. Kubišta's

145 *Motif from Old Prague* (1911—12) exemplifies the first stage. Its colour is drained to a metallic greybrown monochrome. As in an early Gris, the near-monumental forms are kept fluid by opened contours and a constant manipulation and reversal of tone

146 values. From there to Filla's *Woman* of 1914 is from Cubism as a style to the adoption of Cubist principles. If Filla's acceptance of Cubism was as understanding this stage as Mondrian's, then the sculptures and constructions of Guttfreund were by 1912 a more advanced interpretation of Cubism than anything

143. *Franz Marc*
Animal Destinies
1913, oil on canvas
51.75 × 39.75 in.
(131.5 × 101 cm.)
Kunstmuseum, Basle

144. *Lyonel Feininger*
Umpferstedt I
1914, oil on canvas
51.75 × 39.75 in.
(131.5 × 101 cm.)
Kunstsammlung Nordrhein-
Westfalen, Düsseldorf

being done by Parisian sculptors. He was probably aware of Boccioni's work but his realisation of Cubist space-form processes in the 1912 bronze *Bust* is 147 original and complete.

Cubism and Futurism

If the revolutions of Cubism epitomised the early 20th century's need for a new language, then the radical philosophies and the breathless verbosity of the Futurists symbolised its political and spiritual radicalism. Futurism was not primarily an art movement. Its numerous manifestoes deplore the inadequacy of existing art, but—like Dada and much of Surrealism—it was primarily an ideology, a state of mind. The search for artistic means of expression came afterwards. The Futurist movement was in full flood, had stated its ideas and chosen its name (significantly the first

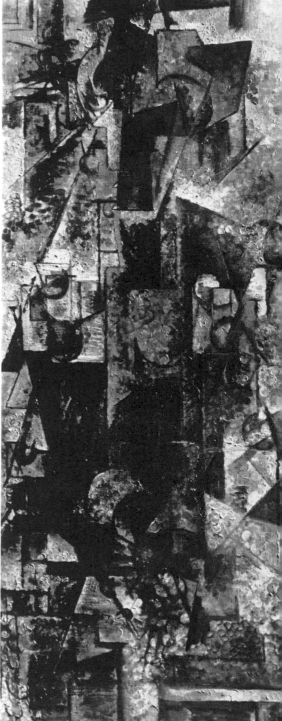

145. *Bohumil Kubišta*
Motif from Old Prague
(Charles Bridge)
1911, oil on canvas
38.5 × 33 in.
(98 × 84 cm.)
National Gallery, Prague

146. *Emil Filla*
Woman
1914, oil on canvas
42 × 17 in.
(106 × 42.5 cm.)
National Gallery, Prague

147. *Otto Gutfreund*
Bust
1912—13, bronze
h. 25 in. (64 cm.)
National Gallery, Prague

modern movement not to be labelled by someone else) before any Futurist art existed. A degree of antipathy between Cubists and Futurists was inevitable: Cubism appeared immorally art-conscious, while Futurism to some intellectuals of the Cubist movement was 'a tumour on the healthy stem of art'. (Allard, 1912).

A competitive sense of jealousy on the part of the Futurists was inherent in their situation. Being Italians they were painfully self-conscious about their national heritage. The cultural past that all of Europe was in process of discarding or transforming was largely an Italian tradition, described in one of their Manifestoes as 'a huge Pompeii white with graves'. Cubism was to bridge the gulf between their ambition for a modern Italian art and its realisation. With Marinetti as their sponsor and Severini as their guide, Boccioni, Carra and Russolo visited Paris in October, 1911. Their only previous knowledge of Cubist painting was from illustrated articles and verbal description. Through Se-

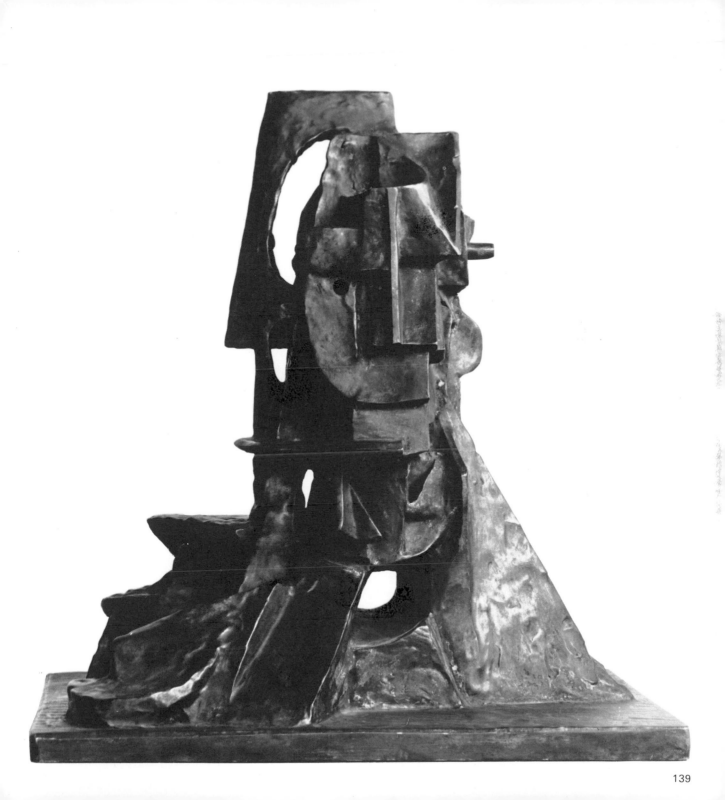

148. *Ardengo Soffici,
typographical design from a
collection of futurist poems
BIF & ZF + 18, Simultaneità
e Chimismi Lirici
Florence 1915*

verini's friendship with Braque and Marinetti's with
Apollinaire they were now able to visit most of the
Cubists in their studios.

Boccioni's first comments were typically patronising
(Writings p. 131), but in the next three months the
Futurists drastically modified their art in the light of
Cubism. In February 1912 they returned to Paris with
an exhibition of restyled Futurist painting. Cubism was
a challenge they were only too willing to accept: it
provided the raw material for their art of the future.

They were already working in terms of a post-
Impressionist Divisionism: in many ways Futurism was
an extension of Impressionism. Their subjects are im-
pressions of modern urban life: Boccioni's *The Laugh*
is a Renoir motif brought up to date. The gaiety and
vitality of city life is expressed in terms of shifting
lights and fractured images. Boccioni still assembled
a multiplicity of impressions and presented them
simultaneously, but they cohere not into a single
moment of experience, but into an idea of total,
environmental experience. The more complex fractur-
ing of Cubist painting lent itself perfectly to the
Futurists' vision of mechanical speed and flux, the in-
teractions of light, bodies and space, colours, noises
and even smells that for them constituted the modern
world. In *Swifts* (1913), inspired like Duchamp's *Nude*
paintings by a study of sequential photography, Balla
pursued the passage of forms through time and space

with an objective discipline. In Boccioni's *Forces of a
Street* the romantic Futurist idea of simultaneity be-
came the explicit subject-matter. In intellectualising
the Futurist vision of urban dynamics into terms of
abstract energies, Boccioni came closer to the inter-
national aftermath of Cubism. Through their contact
with Cubism the Futurists could now envisage the
concept of simultaneity in purely pictorial forms, com-
parable to the simultaneous formal contrasts of Léger
or the simultaneous colour contrasts of Delaunay. By
1914/15 at least two of the Futurist painters— Severini
and Balla—were painting non-figurative compositions,
based like Delaunay's discs on the opposition of purely
formal values.

If Boccioni never lost his commitment to the motif,
he certainly underwent a conversion through Cubism
from philosophical to aesthetic considerations. His
Manifesto of Futurist Sculpture (Writings p. 131–2)
was for its date, April 1912, the clearest statement yet
of Cubism's ideas for sculpture. Its proposed abolition
of closed forms and widening of the range of materials
pinpointed Cubism's importance. The statement was
more important and probably more influential than
his sculpture, most of which was made immediately
after the manifesto was written, 1912/13. In its pursuit
of Cubist spatial concepts Boccioni's work anticipated
and surpassed all the French Cubist sculptors; he went
straight from painting into sculpture, as if its dimen-
sions offered the real, even the inevitable expression
of current ideas.

The plaster *Abstract Voids and Solids of a Head*
(1912) translates the principles of Cubist painting
into three dimensions with an almost naive lack of
compromise. The cumbersome medium of plaster is
brilliantly manipulated to produce a sequence of soft
shadows, gentle transitions and hard lights. More
subtly than Picasso's 1909 *Head*, more elusively even
than Gris' 1912 painting of his mother that this so
much resembles, Boccioni creates a real opportunity
for sculpture to say that matter and space are inter-
changeable. In *Unique Forms of Continuity in Space*
(1912-13), of which the title alone reveals Boccioni's
attitude to sculpture, he takes this a stage further.
Treating the traditional theme of a free-standing figure,
he breaks down the sanctity of mass and closed con-
tours. In human terms it is an idealisation of the dy-
namic energy of the body. *The Evolution of a Bottle in
Space* makes the same denial of mass and volume.
More succinctly than Picasso's *Absinthe Glass* of two
years later the bottle's volume is cut open. Like the
plaster head or the bronze figure, this still-life is about
the relationship of the subject with its environment.

In traditional sculpture, time and movement were
frozen: its massive volumes, inviolable in space, ex-
press a unique situation, fixed for eternity. In Boc-

149. *Umberto Boccioni*
The Laugh
1911, oil on canvas
43.4 × 57.25 in.
(123 × 143 cm.)
Museum of Modern Art,
New York (Gift of Herbert
and Nannette Rothschild)

150. *Pierre-Auguste Renoir*
Le Moulin de la Galette
1876, oil on canvas
30.75 × 45 in.
(78 × 114 cm.)
Louvre, Paris

151 *Giacomo Balla*
Swifts: Paths of Movement
and Dynamic Sequences
1913, oil on canvas,
38.1 × 47.25 in.
(97 × 120 cm.)
Museum of Modern Art,
New York

152. *Umberto Boccioni*
Horses and Houses: Dynamic
Construction of a Gallop
1912–13, wood, metal and
cardboard
h. 28 in. (71 cm.)
Collection of
Benedetta Marinetti, Rome

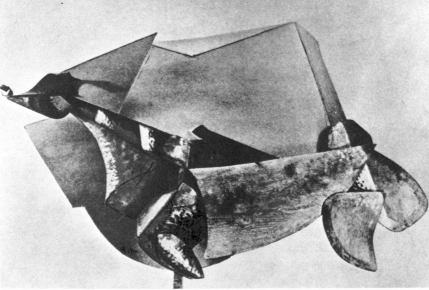

153. *Umberto Boccioni*
States of Mind II:
Those who go
1911, oil on canvas
27.9 × 37.75 in.
(70.8 × 96 cm.)
Private Collection, New York

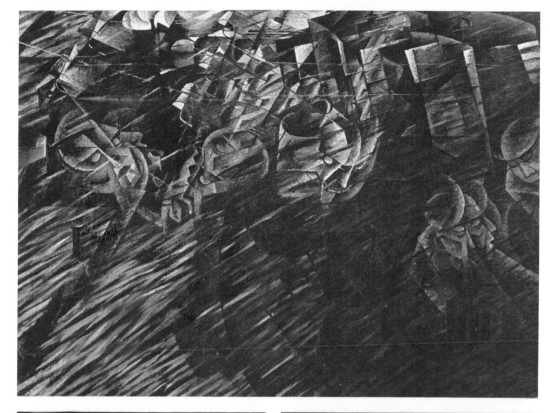

154. *Umberto Boccioni*
Abstract Voids and Solids of
a Head
1912, plaster
now destroyed

155. *Juan Gris*
Portrait of his Mother
1912, oil on canvas
21.75 × 18 in.
(55 × 45.5 cm.)
Private Collection, London

154

155

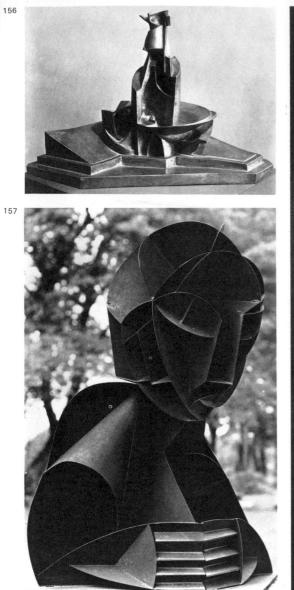

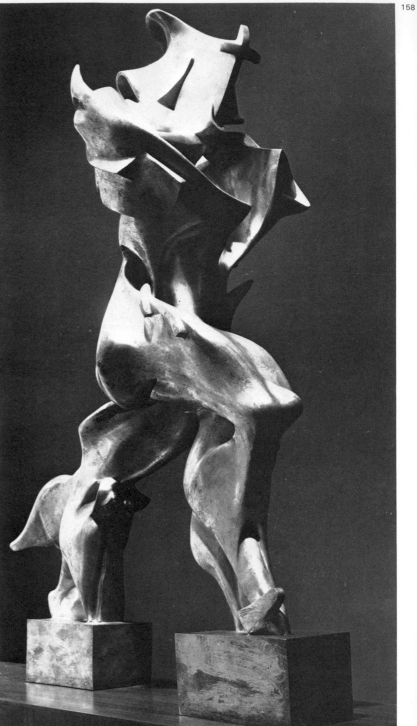

156. *Umberto Boccioni*
Evolution of a Bottle
in Space
1912, bronze
h. 15 in. (38 cm.)
Museum of Modern Art,
New York
(Aristide Maillol Fund)

157. *Naum Gabo*
Constructed Head No. 2
1916, metal
h. 17.75 in. (45 cm.)
Artist's Collection

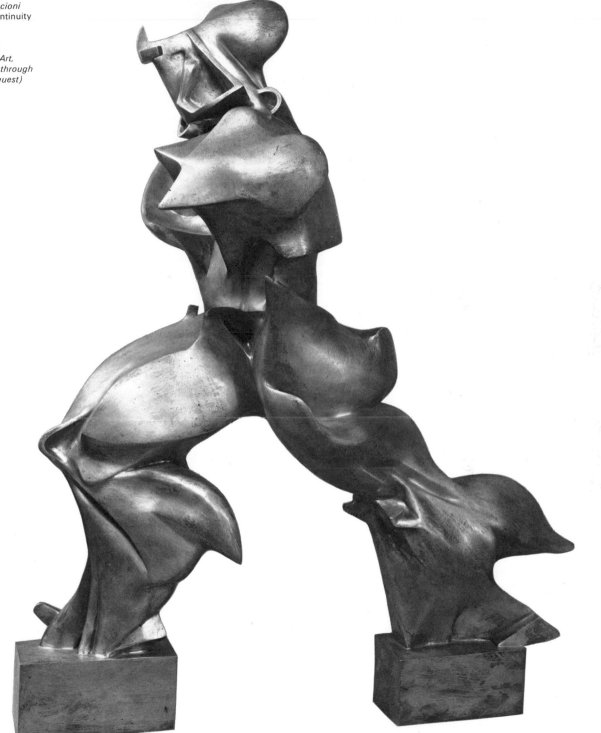

158/9. *Umberto Boccioni*
Unique Forms of Continuity
in Space
1913, bronze
h. 43.5 in. (110 cm.)
Museum of Modern Art,
New York (acquired through
the Lillie P. Bliss Bequest)

160. *Antoine Pevsner*
Head of a Woman ·
1922—23, wood and plastic
14.75 × 9.5 × 9.5 in.
(37.5 × 24 × 24 cm.)
Collection of André Lefèvre,
Paris

161. *Wyndham Lewis*
Composition
1913, pencil, pen and
ink, watercolour
13.5 × 10.5 in.
(34.3 × 26.7 cm.)
Tatle Gallery, London

162. *John Marin*
Movement, Fifth Avenue
1912, watercolour
16.6 × 13.5 in.
(42 × 34.2 cm.)
Art Institute of Chicago
(Alfred Stieglitz Collection)

cioni's sculpture the introduction of a time element and the destruction of mass were inseparable. His own work may now look very dated, but his themes of continuity through space and evolution in space dominate 20th-century sculpture. The Russian constructivists Tatlin, Gabo and Pevsner, aware equally of Cubism and Futurism, took up the space theme without Cubist sculptors' inhibitions and without Futurism's specific overtones. Gabo and Pevsner could condemn the 'logical anarchy' of the Cubists and the 'provincial tags' of the Futurists (Writings p. 132) but their precedent was the seed of Constructivism.

157 Gabo's *Constructed Head No. 2* (1916) by abandoning the sensual modelling of Boccioni's figures evades mass completely. In the 1920s when transparent plastics were available, Pevsner made a series

160 of images whose subtle sequence of planes in space recall the translucent crystal of Analytical Cubism. In the long term the Constructivists were dissatisfied with Cubism for the banal level of its reality. Picasso's *objets trouvés* are thoroughly out of place in the context of Gabo's and Pevsner's visionary writing about the speed of light in the firmament: similarly Boccioni's locomotives seem naive beside their 'hurrying trains of galaxies'. From Cubism Gabo drew a method of structure and a recognition of new materials, free of old-fashioned sensuality and literary romanticism, that

could express his 20th-century vision of space. What for the Futurists was the language of the Machine Age, became for Gabo a scaffolding of relationships from which to observe and interpret the universe.

Futurism was one channel of communicating Cubist ideas to Russia, a role it filled elsewhere as well. The manifestoes were translated and widely circulated and Marinetti undertook several lecture tours. A more direct example of Futurism in this role was its influence on England. The short-lived Vorticist movement was a response to Cubism via Futurism. Wyndham Lewis, Nevinson, Etchells, Epstein and others were infected by the romantic spirit of modernism and Lewis's writing in the Vorticist magazine *Blast* was in emulation of Marinetti's anti-establishment anarchy. In Lewis's work the fractured Cubist structure was given a Futurist sense of dynamism. One consequence of the Vorticist movement was the production of the first non-figurative painting in Britain—Lewis, Bomberg and others.

161
121

The first response to Cubism in America was also akin to Futurism. (Joseph Stella, made contact with Futurism on a visit to Italy 1910–11.) In motifs drawn from American city life, Marin, Weber and Stella adopted 162 Cubist fragmentation and simultaneity as an expression of their environment. Cubism arrived in force in America with the enormous 1913 Armory Exhibition, but the stir it created was brief. The presence in New

York of Duchamp and Picabia emphasised a Dadaist tendency in the immediate aftermath of the Armory Show. In a longer term, however, Cubism can be seen as the backbone of modern American painting, even of the severe realism between the wars.

CUBISM BETWEEN THE WARS

A common heritage

After the 1914-18 war Cubism as a style virtually disappeared from progressive art, but passed in a debased form into more conservative art. By the 1920s it was even beginning to appear in popular and commercial design: a leading French fashion magazine of 1920 displayed on its cover a dress fabric design un-

165 ashamedly composed of stylised Cubist still-life motifs. The freedoms of Cubist dislocation and montage were also rapidly adopted by leading graphic designers such

163 as McKnight Kauffer and Cassandre.

164 In the art world of the 1920s, Cubism appeared to fall between two stools. Not yet accepted in its original form by the public, it was still attacked in the Parisian popular press. Yet to the progressive artists, Cubism was very much part of history and as such was almost certain to be condemned by successive, avant-grade movements. The faults found in Cubism compose a catalogue of contradictions: too apolitical, not pure enough; too figurative, too abstract; too disorderly, too mathematical; and so on. The heat of all these accusations demonstrates at least the universal consciousness of Cubism and the equally universal obligation to formulate some response to it. The ambiguity of the responses acknowledges how wide an application Cubism's values could find among widely divergent languages and philosophies.

After Futurism, the relevance of Cubism to modern architectural and design theory found its most immediate expression in Purism in France. The dependence of most Abstract Art between the wars on Cubism is equally explicit. In the field of figurative art —dominated by the Surrealist movement in the 1920s and '30s—Cubism's influence is perhaps less immediately obvious, but in fact no less pervasive. The arts of construction and assemblage, overlapping both figurative and non-figurative art, form together the outstanding manifestation of Cubism's influence on between-the-wars art.

Cubism and Modern Design—Purism

At a superficial level, the geometry of Cubism seems like an anticipation of all modern design. The rectangular grid structure of Analytical Cubist paintings with their subtle manipulation of space stand at the head of this tradition, but not alone. The unornamented and structure-conscious designs of post-*Art Nouveau* architects like Mackintosh and Adolph Loos have al-

13,14 ready been mentioned. On the strength of this, Cubism's prophesy of modern design may seem no

163. Edward McKnight Kauffer Advertisement c. 1920

164. Adolphe Mouron ('Cassandre') Poster, 1935

165. Textile design reproduced on the cover of Art, Goût et Beauté, *1920—21 Collection of Edward Wright, London*

more than one expression of a 20th-century spirit. There were few direct links between Cubist art and more functional design at the time. Two architects, Perret and Mare, were associated with Cubist circles, but the only concrete evidence of such interest to emerge from the Cubist movement was Raymond Duchamp-Villon's banal *Maison Cubiste*, a model 167

R 12484½ CRÊPE de CHINE IMPRIMÉ
A·G·B

exhibited in the *Salon d'Automne* of 1912. The first real application of Cubist ideas to architectural thinking came through Futurism. The writings and drawings of Sant'Elia proposed a brave-new-world architecture, relieved of inhibiting traditions and based on the interpenetration of levels and spaces, that was clearly related to the Cubist aesthetic. In the same general terms many of the characteristics of Le Corbusier's architecture may be equated with Cubism: breaking down of conventional space-divisions, use of transparent walls and free-standing supports, absence of decoration and the pervading sense of inventive variations within a disciplined and economic framework.

166

The movements that were to exert most pressure on the formal and theoretical evolution of an 'International Style' of modern architecture and design—Futurism in Italy, Constructivism and Suprematism in Russia, De Stijl in Holland and Purism in France—were all heavily in debt to Cubism as a catalyst. Through the convenience of history, we may see the critical meeting of these currents at the Bauhaus during the '20s as the refined crystallisation of a primitive Cubist aesthetic. (The vast majority of painters active at the Bauhaus were clearly committed to Cubism). Most of these post-1914 movements saw their role as embracing art and architecture. One of them—like the Bauhaus itself—saw architecture as the principal concern, while art and design were areas that related and contributed to

architecture. This was Purism, whose founders were the painter Amédée Ozenfant and the painter-architect Charles-Edouard Jeanneret (Le Corbusier).

In many ways Purism was a direct response to Cubism, to its implicit values and what they saw as its deficiencies. A large part of their writings was devoted to a critique of Cubism (Writings p. 132).

The first general criticism that Le Corbusier and Ozenfant levelled against post-war Cubism in Paris was its decline into a decorative art. Ozenfant saw 1914 as the turning point in Picasso's art from a grand manner into mere 'intriguing mannerisms', and the **182** Cubist concern with colour was also seen as a degenerate, decorative tendency, with its roots in Cézanne. More particularly they criticised all Cubist painting for its disorderliness. The random relationships and eccentric details that were so absorbing for Picasso and Gris were eliminated by the Purists as impure trivialities. Furthermore, whereas Gris had claimed that the bottle in his painting was his own and 'unlike any other bottle', for the Purists the reverse was true: the only true bottle in Purist art was a universal, standardised, typical bottle. This principle meant first of all that the objects depicted carried no subject-matter overtones of their own. The *objet-type* was possessed of an inevitable modern beauty, almost a machine-age truth to nature. Le Corbusier's own paintings of the twenties exemplify the hygenic stand-

166. *Charles-Edouard Jeanneret (Le Corbusier) Villa Savoye at Poissy 1929—30*

167. *Fernand Leger*
The City
1919, oil on canvas
91 × 117.75 in.
(231 × 297 cm.)
Philadelphia Museum of Art

168. *Raymond Duchamp-Villon Maison Cubiste*
1912, plaster maquette
present whereabouts
unknown

ardisation that the Purists wished to impose on **181** Cubism. His *Still-Life with Many Objects* (1923) is a monument of late, conservative Cubism: impassive, regular and undemanding. Of the Cubists, only Léger bore obvious affinities with Purism. His apocalyptic vision of a gun-barrel during the war (Writings p. 130) and his subsequent attitude to contemporary subject-matter took him within reach of their philosophy. In **168** *The City* of 1919 Léger's forms are regularised as if acknowledging an ideal of beauty that springs from utility. He incorporates the standardised printed letter, the simple elements of concrete architecture, the functional geometry of modern engineering. The figure too is reduced to an elemental norm. Other works of the 1920s transferred the pastorale of the 18th and 19th centuries into its 20th-century context. Olympias of the machine-aesthetic exemplify a *'figure-type'*. Their formal context, related to abstract art, modern architecture and utilitarian reality, brings together all the main thoughts behind Purist theory. The ideal is inclusive and generalised, the language universal.

Purism, like Futurism, belongs with Cubism. Understandably, later generations were to see them as only slight variations within a single aesthetic. The other leading reactions to Cubism were not. They involved radical transformations of the language and the theory.

Cubism and Abstract Art

The work and statements of the Cubists leave little doubt that complete abstraction was never their goal. Nor was the *idea* of complete abstraction a result of Cubism: the main theoretical sources of Abstract Art came from earlier art.

Kandinsky's attitude towards Cubism—his admiration of Picasso's daring, but his puzzlement that Picasso 'seems to wish to preserve the appearance of materiality' (*Concerning the Spiritual in Art*, 1912) — is typical of abstract artists' criticism of Cubism, but also points to Cubism's importance as a transition towards abstraction. Picasso later defended Cubism against the charge that it was an art of transition (Writings p. 128), but in its relationship to Abstract Art it was precisely that.

Kandinsky had been able to draw his conclusion that the motif was no longer crucial to art from Monet as early as the 1890s. In this light he was bound to see the figurative element in Cubism as conservative and obstructive. However for other pioneers of Abstract Art —Mondrian, Malevich, Gabo and the Cubist Delaunay —it was only through their experience of Cubism that they drew Kandinsky's conclusions. For them Cubism and not Impressionism was the critical transition, but the similarity between Cubism's importance to them and Impressionism's importance to Kandinsky is very significant. Impressionism (in colour) and Cubism (in form) were the most revolutionary manifestations of a modern French tradition of 'Divisionism'. It is this whole tradition, concerned ostensibly with the disassembly of the object into smaller units or particles which were then free to become the basis of a new structure, that underlies most forms of 20th-century abstract art. As a result of Impressionism's absorption with a divisionism of colour, its direct influence was limited to painting. Cubism on the other hand, being principally concerned with the division of formal elements and involved too in more radical technical revolutions, bore wider applications.

Delaunay described the transitional role of Cubism as the turning point between Impressionism and Abstract Art. In his own work and that of his followers the
183 American 'Synchromists' (Stanton McDonald Wright and Morgan Russell) both the transition to abstraction and the ultimate origins in post-Impressionist colour
114 theory are explicit. In 1912/13 Picabia was reaching a similar standpoint. Outside France several artists who had clear sympathies with Impressionist and Post-Impressionist art moved through Cubism towards an abandonment of figuration. The abstract paintings of
169 Balla and Severini reflect their former devotion to Seurat's Neo-Impressionism and to the idea of simultaneous contrast. The 'Rayonism' of the Russian
170 painter Larionov, while clearly indebted to the analy-

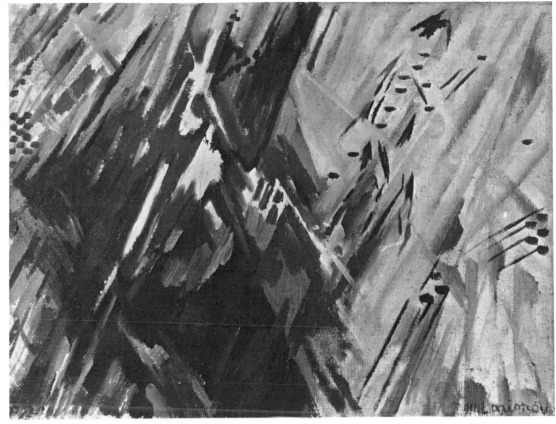

tical processes of Cubism and to Futurist lines-of-force, still ultimately derives from the Impressionist painting of light.

For many of these painters, as for others like Léger and Bomberg, abstract art was a temporary excursion prompted by Cubism. For Malevich, Mondrian and Gabo, the transition of Cubism led to a position that was absolute, that completely severed all ties with pre-Cubist traditions. To them Cubism was a valuable but inadequate compromise: it showed a way that it was unable itself to follow. Gabo's dissatisfaction with Cubism had already been mentioned in the context of Futurism. Once he had moved through a short transitional phase of abstracted figuration his constructivism was concerned with the relationships of the material elements he was using and not with any other sort of representation.

171

Malevich's break with these traditions was almost gestural. Faced like all Central and East European painters, with the full scale of modern revolutions, his decision to paint simply a black square on a square white canvas (c. 1913-14) was like a desperate and symbolic reaching out for purity and sanity. When he

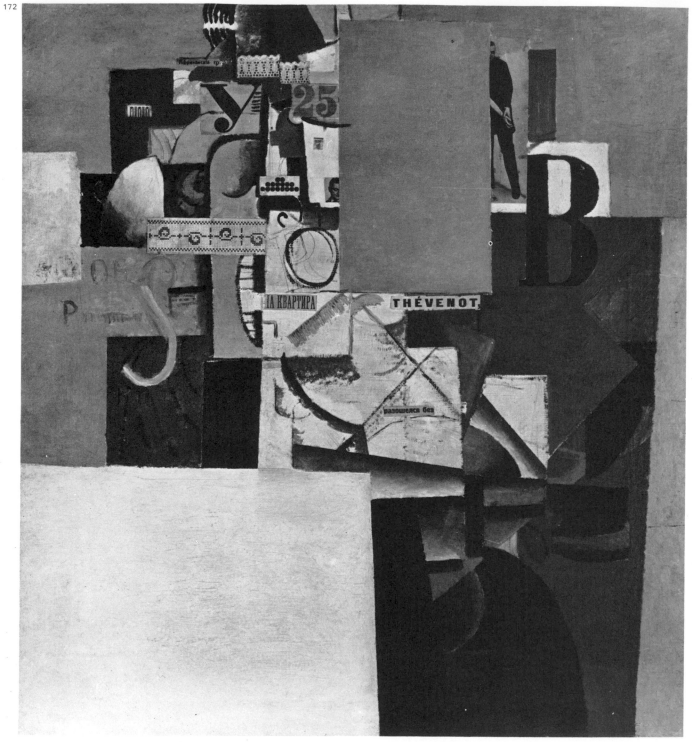

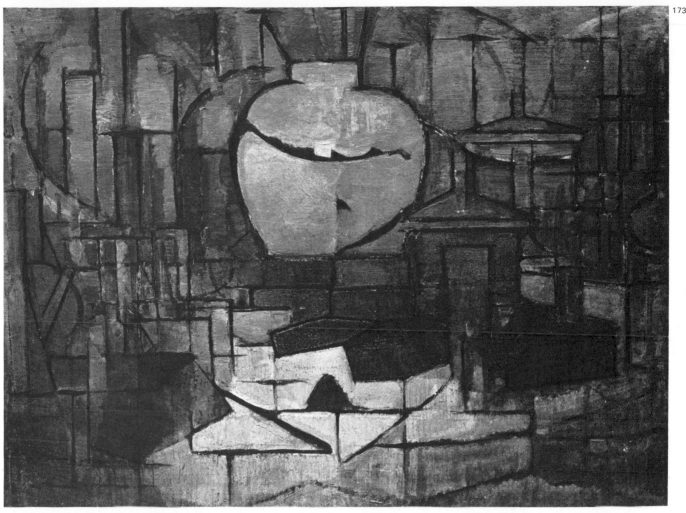

came to evaluate and define his position and its origins in essays after 1915 the constructive value to him of Cubism was paramount (Writings p. 132). His Cubist paintings were heavy and simple, reflecting perhaps
184 his admiration of Léger. The *Large Cubist Rose* (sometimes called *Cubist Head*) is a compressed arrangement of modelled volumes, consistently monochromatic in colour and with no explicit meaning except as volumes. The elements in his collage *Lady at the Ad-*
172 *vertising Pillar,* on the other hand, carry very clear external references. These were the terms within which Malevich saw Cubism. From these two extremes—an ostensibly non-figurative art treating forms consistently in terms of space and scale and, secondly, an art of figurative elements arranged with no consistence of space or scale—he drew his extreme conclusions. Painting was about formal oppositions alone. He attri-

buted directly to Cubism the fact that 'the millstone around the neck of painting is beginning to crack.' Suprematism, as he called his new art, was founded on his post-Cubist freedom from any vestige of naturalism.

Mondrian took Cubism to a similar conclusion without gesture or declamatory revolution. Living and working in Paris from 1911-14 and more than once exhibiting with the Cubists, his evaluation of Cubism was inseparable from the considered evolution of his own art.

His early expressionist landscapes had been related more to Munch and Van Gogh than to Cézanne and Seurat. The objective discipline of Cubist analysis and the geometry of its language transformed the appearance of his art. In the landscapes and still-lifes of 1911-12 he employed Cubism's linear system to sim- **173**

172. *Kasımır Malevich*
Lady at the Advertising Pillar
1914, oil on canvas with papier collé and lace
28 × 25.25 in.
(71 × 64 cm.)
Gemeentemusea, Amsterdam

173. *Piet Mondrian*
Still-Life with Ginger Pot II
1911-12, oil on canvas
36 × 47.25 in.
(91.5 × 120 cm.)
Gemeentemuseum,
The Hague
(Loan of S.B. Slijper)

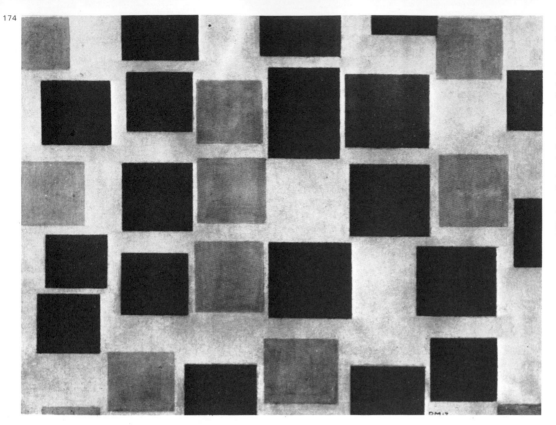

174. *Piet Mondrian*
Composition with
Colour Planes
1917, oil on canvas
18.9 × 24.2 in.
(48 × 61.5 cm.)
Boymans Museum,
Rotterdam

175. *Ben Nicholson*
Prince and Princess
1932, oil and pencil on board
Collection of
Sir John Summerson, London

176. *Ben Nicholson*
White Relief,
1935, oil on carved mahogany
39 × 65 in.
(99 × 165 cm.)
Tate Gallery, London

175

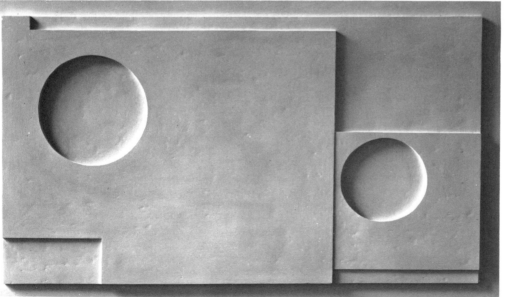

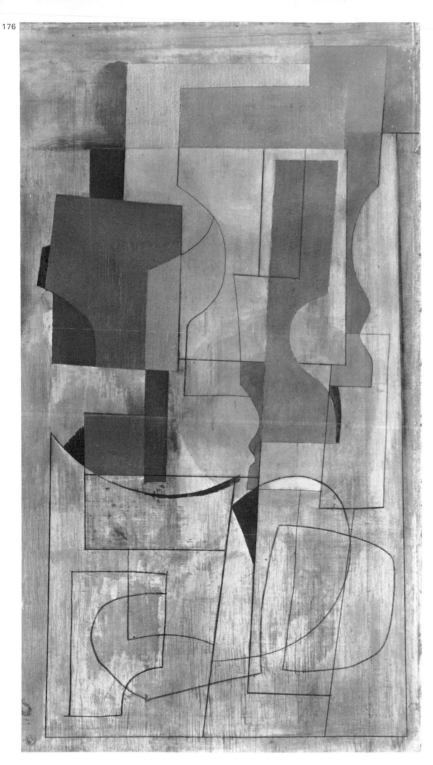

plify and regularise the motif into a pictorial order. 'Nature gives us everything,' he wrote later, 'but to represent her gives us nothing.' His assessment of Cubism may have been identical to that of Gabo or Malevich, but Mondrian's ultimate demands were more exacting, more fanatically extreme in their search through Cubism's randomness for a perfect universal order.

If we compare Mondrian's *Oval Composition,* **187** *Tableau III* (1914) with a typical Cubist painting of 1911—the year Mondrian arrived in Paris—the similarities and differences are equally evident. Mondrian has taken the linear grid of Picasso's *Toreador Playing* **55** *Guitar* and spread it right out to the edges. The lines which in Picasso' painting hovered somewhere between independence and the representation of forms are freed in the Mondrian. They only exist as part of a grid, a rectilinear mesh that spreads right across the surface. Tonal contrasts, crucial in the Picasso, are almost eliminated. Picasso's succulent broken impasto is also abandoned. The combined effect of all these modifications was to develop the Cubist emphasis on the picture plane into an absolute all-over equality of surface.

In Mondrian's mature work the absoluteness of the surface is left in no doubt. In 1917 in paintings like *Composition with colour planes* the Cubist separation **174** of elements is extreme. His term Neo-Plasticism was a vindication of the implicit Cubist thesis that painting's plastic values were autonomous. Cubism was an art of representation; Neo-Plasticism was not. Mondrian was intolerant of the ambiguity between the image and the process of painting that was the essence of Cubism.

Such a finite and exclusive interpretation of Cubism was extreme and, although in itself Mondrian's art was to condition later interpretations of Cubism, his position between the wars was an isolated one In the 1920s and '30s Ben Nicholson, successively discovering Cubism and Neo-Plasticism, could assimilate a great deal from both concepts and not find them incompatible. Many of his paintings like *Prince and Princess* of 1932 explore precisely those areas of the pro- **175** cess of painting—mottled colours, rough textures, the casual encounters and overlaps of lines, tones and forms—to which Mondrian had been so hostile in Cubism. Even in one of the great still-lifes of the '30s, **192** where the tight linear discipline more nearly approaches Mondrian's asceticism, there are soft diffusions of colour fading into the grain of the canvas. More significantly both of these paintings are representational. Whether the fragments are fluid and informal like the profiles of *Prince and Princess* or tightly geometric like the section and silhouettes of

the 1929—35 *Still-Life*, it is their associative meaning and their spatial connotations that animate the paintings' formal structures. In these works Nicholson was at the heart of Cubism. When under the influence of his meetings with Mondrian (1934—35) he made his first 176 carved wood reliefs, painted white and composed of wholly abstract geometric forms, he foresook the central concern of Cubism. But it was only a temporary departure. Total abstraction has not subsequently been his absolute criterion. As he said in 1948, 'Whether or not his visual, "musical" relationship is slightly more or slightly less abstract is for me beside the point.'

Clearly the pursuit of total abstraction involved the abandonment of many of the qualities and effects that had constituted Cubism. Inasmuch as Cubism contributed to the rise of Abstract Art between the wars, it was contributing to its own demise. But these very qualities of Cubism that were anathema to Kandinsky, Malevich or Mondrian proved of vital consequence to other artists.

Cubism and figurative painting: new realities

One of the major figurative painters between the wars, Max Beckmann wrote: 'It is not the subject which matters but the translation of the subject into the abstraction of the surface by means of painting. Therefore I hardly need to abstract things, for each object is unreal enough already, so unreal that I can only make it real by means of painting.' (*On My Painting*, 1938). This recognition that objects represented in a painting were necessarily an unreal abstraction and that the only reality in art lay in the fixed actuality of pictorial forms shows a complete understanding of Cubism. It is the key to almost all post-Cubist figurative art.

Beckmann's paintings endorse his affinity with Cu-177 bism. In *The Dream* (1921) the objects are clearly defined and the figures bear very precise relationships to each other, but only in terms of painting's reality. The method of compiling the elements is that of Synthetic Cubism. The only significant difference between this painting and a Picasso of 1914—15 is that *all* of Beckmann's elements are overtly figurative. The effect is haunting and disturbed. Other German Expression-194 ists like Grosz used the same Cubist idiom for a more explicit social satire, and even the social-realist murals of Diego Rivera bear formal echoes of his early years as a minor member of the Cubist movement in Paris, *c.* 1910—14.

Comparatively little painting between the wars was so apparently committed to social comment. The wider effect of Cubism was its liberation of the artist's 195 scope and means. For Chagall and Klee, whose most direct affinity with Cubism was through the Orphist circles of Delaunay and Apollinaire, the fragmenting

177

of structure and of imagery was a release into lyrical improvisation. The Cubist reality lay in both structure *and* image: in Cubist painting neither was more or less real. In the paintings of Chagall there is a pronounced emphasis on imagery, a personal mythology that made literary use of dislocations and unexpected juxtapositions. Klee's imagery was often less explicit and emerged much more from the process of painting. The loosely rectangular planes of his *Vocal Fabric of the Singer Rosa Silber* (1926), reminiscent of Delaunay's 193 *City* paintings, undulate gently on and above the picture surface. In technique the majority of Klee's paintings and drawings comply with Gris' definition

178

of Synthetic Cubism. From the subtle adjustment of relationships between relatively random abstract de vices a new image crystallises. Cubism's destruction of naturalism as the basis of art made Klee's intuitive poetry possible.

Even Matisse, whose standing at the head of the Parisian avant-garde had declined in proportion to the rise of Picasso and of Cubism, and who on the face of it might seem the least sympathetic to Cubism, responded to this liberation. After the progressive flattening of surface into clearly defined colour areas, 1907–10, his work became more varied in technique again, more sombre and tonal in construction. He

emerged from this experimental phase around 1916 with pictures like *The Moroccans*. The elements are far **178** more abstract than before and the composition is not of evenly saturated colour planes, but of a balance between colours and tones. Matisse was obviously very aware of Cubism and during the early months of World War I he had long conversations with Gris, whom he had befriended and helped in times of financial hardship. He became less doctrinaire about the rigidity of the picture surface and more expansive in his methods of construction, seeing tonal values as a valuable complement to colour and not as an undesirable alien.

179. *Pablo Picasso*
Pipes of Pan
1923, oil on canvas
80.5 × 68.6 in.
(204.5 × 174 cm.)
Artist's Collection

180. *Pablo Picasso*
The Three Dancers
1925, oil on canvas
84.6 × 56.25 in.
(215 × 140 cm.)
Artist's Collection

The paintings of Beckmann, Chagall, Klee and Matisse all endorse Picasso's denial that Cubism was an art of transition. Most painters between the wars worked within its terms, not away from them. Picasso himself, working in a widely and even erratically diverse range of idioms has continued to demonstrate the flexibility of those terms. The massive 'Neo-Classical' paintings of the 1920s are as much a product

of Synthetic Cubism as the *Three Musicians* of 1921. 84 The figures in *The Pipes of Pan* (1923), echoing his 179 portraits of 1906 in their stylisation, are colossally sculptural, but calmly fixed on the surface. The serenity of these Classical motifs, inspired by his visits to Rome and Naples to work with Diaghilev, disappeared abruptly in the mid-1920s. The *Three Dancers* (1925) 180 may also have been inspired by his contact with the theatre—seeing figures transformed by masks and costumes and by the artificiality of extravagant stage sets. But this dance is a return to the savage ritual quality of his 1907 primitive figures. The double-heads of the two outside dancers appear not as witty improvisation, but as stark surrealist hallucination.

The Surrealist movement was founded in 1924 and Picasso was very quickly recognised as a pioneer of the surreal in painting. The uncertainties, evasiveness, contradictions—all the qualities of Cubism that pioneers of Abstract Art had sought to destroy—were critical stimuli for Surrealism. The incoherent images of Picasso's collages and Synthetic Cubist paintings became the principal means by which Surrealist figurative painters expressed the random, irrational imagery of the subconscious. The disjointed assembly of elements in paintings like Picasso's great *Green Still-Life* (1914) (which Ozenfant rejected as trivial deco- 182 ration) was recognised by the Surrealists as a glimpse of a magical, inner reality, uncontrolled by the conscious intellect.

To De Chirico, founder of the *'Scuola Metafisica'* and another acclaimed pioneer of Surrealism, Cubism played the same sort of role as it had for Matisse. His philosophy was already clearly formed; Cubism enriched the means of its expression. After 1915 he began to assemble figures, still-lifes and interiors out 188 of tightly-packed, often incongruous elements. Some of them are recognisable objects, others more abstract. Often it is the contrast between the forced reality of the dramatic perspective setting and the art-conscious Synthetic Cubist construction of the figure that creates the picture's Surrealist content. The relationship of the structures to Picasso's 1915 paintings is clear enough. 185 The easy transition of de Chirico's disciple Carlo Carrà from Futurist collages to Surrealist juxtapositions serves to cement the relationship.

Magritte's Surrealism was a skilful if limited edifice built entirely around the play between art's artifice and the varying levels of reality that Cubism had thrown open. *Personal Values* (1952) is a conversation be- 186 tween reality and the process of painting. The objects are everyday domestic articles like the elements of a Cubist still-life but by a heightened and very literal interpretation of Cubist freedoms of assemblage they achieve this new compulsive reality.

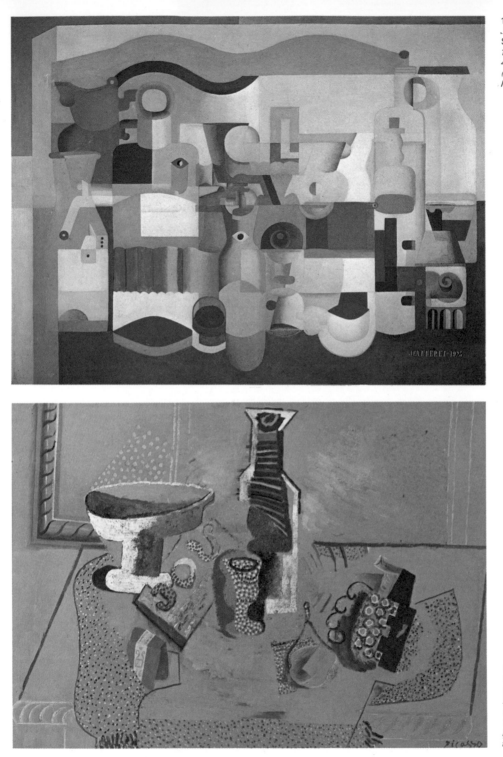

181. *Charles-Edouard*
Jeanneret (Le Corbusier)
Still-Life with Many Objects
1923, oil on canvas
44.75 × 57.5 in.
(114.5 × 146 cm.)
Musée d'Art Moderne, Paris

182. *Pablo Picasso*
Green Still-Life
1914, oil on canvas
23.5 × 31.25 in.
(59.7 × 79.4 cm.)
Museum of Modern Art,
New York (acquired through
the Lillie P. Bliss Collection)

183. *Stanton McDonald*
'Oriental'.
Synchromy in Blue and Green
1918, oil on canvas
36 × 50 in.
(91.5 × 127 cm.)
John Hay Whitney Museum
of American Art, New York

184. *Kasimir Malevich*
Large Cubist Rose
1912, oil on canvas
31.5 × 37.4 in.
(80 × 95 cm.)
Stedelijk Museum,
Amsterdam

185. *Pablo Picasso*
Man with a Guitar
*1915, gouache and
watercolour on paper
12.2 × 9.4 in
(31 × 24 cm)
Collection of
Dr Ingeborg Pudelko*

186. *Renè Magritte*
Personal Values
1952, oil
32 × 40 in.
(81.3 × 101.6 cm.)
Private Collection,
New York

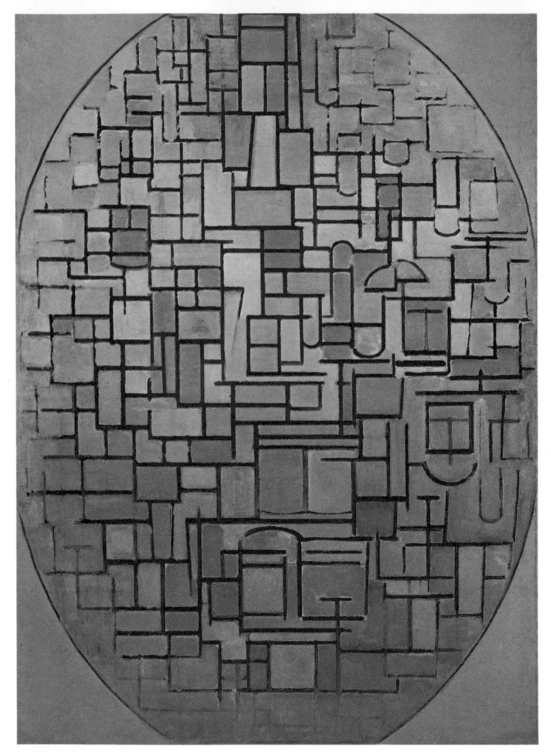

187. *Piet Mondrian*
Oval Composition III
1914, oil on canvas
55.3 × 40.1 in.
(40.5 × 102 cm.)
Stedelijk Museum,
Amsterdam

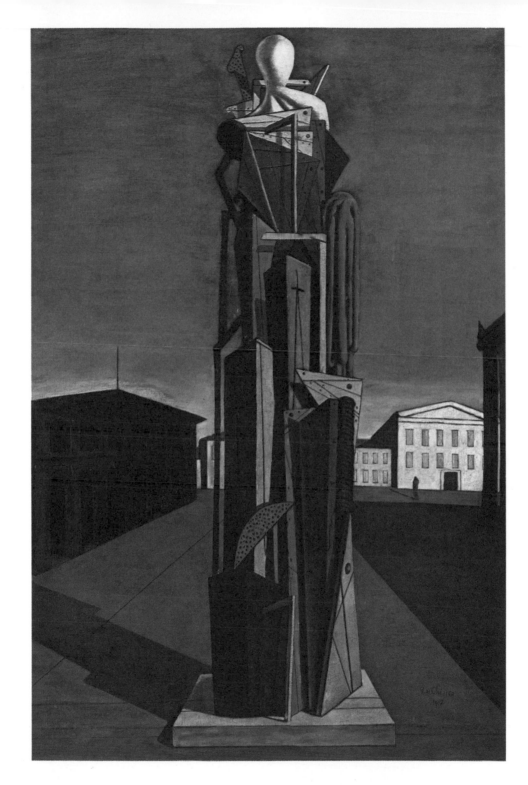

188. *Giorgio de Chirico*
The Great Metaphysician
1917, oil on canvas
41.1 × 26.5 in.
(104 × 68.5 cm.)
Museum of Modern Art,
New York (Philip
L. Goodwin Collection)

Collage, construction and assemblage

The idea of construction and assemblage that is implicit in all Cubist art was as influential for non-figurative as for figurative art. This depended simply on whether the 'parts' were abstract elements (as they were for Malevich, Mondrian, Gabo, etc.) or explicit fragments of figuration (as they were for Chagall, Beckmann, Le Corbusier and some Surrealists). For a number of artists such as Klee and Nicholson it was relatively unimportant whether the components were more or less figurative. What was common to all these artists was that art had, in Apollinaire's words, 'renounced the cult of appearances'. In their very different ways all started from the Cubists' penetration of surface imitation towards an inner reality of one sort or another.

The relationship of Russian Constructivism to Cubism has already been mentioned. The early work 189 of Tatlin, Gabo and the others was inspired partly by the planear construction of Cubist painting and partly by the introduction of new materials through collage. As an independent area of artistic activity, bearing close affinities with modern architecture, Constructivism has filled a major role in 20th-century abstract art.

For Dada and Surrealism the effect of collage has been no less dramatic. Its impact on Surrealist painting was dealt with in the preceding section. As Marcel Duchamp had already demonstrated, the assembly of actual objects into a work of art (realised more by the artist's thought than by his touch) was probably the most effective equivalent in art to the Surrealist writer's methods of assembling random thoughts. Arp's series of collages, *Squares arranged according to the Laws* 190 *of Chance*, looking suitably like life-worn Mondrians, are directly comparable to Tzara's Dada poems composed of words and phrases drawn at random from a bag. Dada was intent on reducing the gap between art and life. Nevertheless, most Dada collages were a conversation between art and the informality of life such as Picasso had already conducted. Kurt Schwit- 191 ters used the same pavement-scrap range of materials and the same punning with fragments of typography. Ernst too improvised with found images, found materials and art until all were transformed by their new situation. Almost all the Surrealist artists benefited

196 from the new freedom of media: Arp, Ernst and Miró all 197 moved freely between painting, sculpture, collage, various graphic media and assemblage. Whether the object was depicted in paint, stuck on a surface or assembled in three dimensions was relatively unimportant.

Assemblage, like Constructivism, has become accepted in modern art's terminology as a new genre, between painting and sculpture. Its roots are clearly

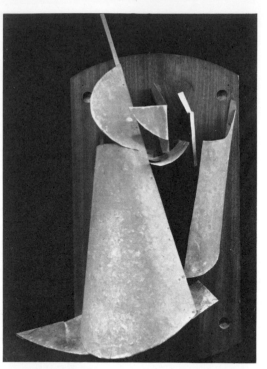

189. *Vladimir Tatlin*
Relief
1917, wood, zinc and iron
39.5 × 25.25 in.
(100 × 64 cm.)
Tretyakov Gallery, Moscow

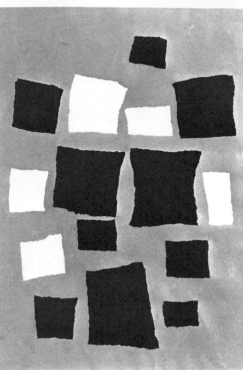

190. *Jean (Hans) Arp*
Collage with Squares
arranged according to the
Laws of Chance,
1916-17
collage of coloured papers
19.1 × 13.6 in.
(48.5 × 34.5 cm.)
Museum of Modern Art,
New York

191. *Kurt Schwitters*
Cherry Picture
1921, collage of coloured
papers, fabrics, pieces of
wood etc. on cardboard
36.1 × 27.75 in.
(91.7 × 70.8 cm.)
Museum of Modern Art,
New York (Mr and Mrs
J. Atwater Kent Jr. Fund)

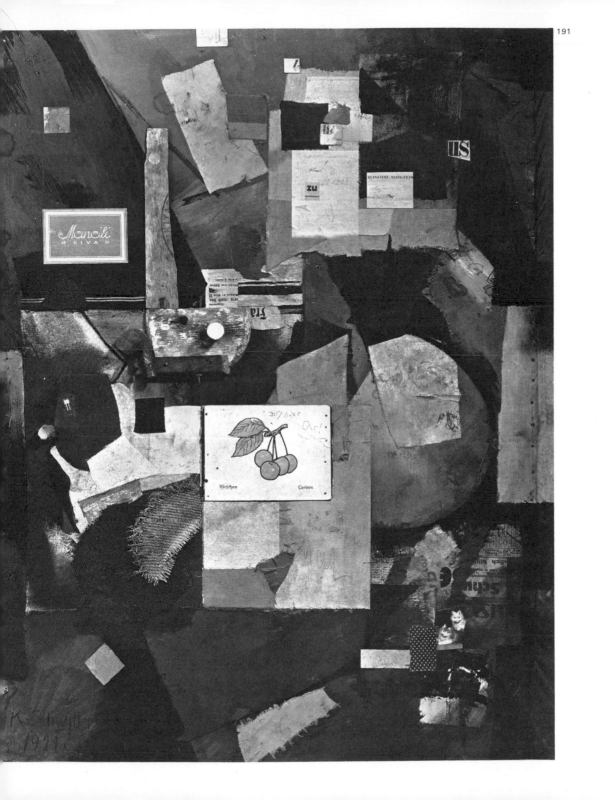

192. *Ben Nicholson*
Still-Life, *1929—35*
pencil and oil on canvas
26 × 32 in.
(66 × 81.3 cm.)
Collection of C. Reddihough,
Ilkley, Yorkshire

193. *Paul Klee*
Vocal Fabric of the Singer,
Rosa Silber
1926, gouache and gesso
on canvas
20.25 × 16.4 in.
(52 × 42 cm.)
Museum of Modern Art,
New York (Gift of
Mr and Mrs Stanley Reson)

194. *George Grosz*
Metropolis
1917, oil on cardboard
26.75 × 18.75 in.
(68 × 48 cm.)
Museum of Modern Art,
New York

195. *Marc Chagall*
Homage to Apollinaire
1911—13
81.75 × 77.9 in.
(207.5 × 197.8 cm.)
Stedelijk Van Abbemuseum,
Eindhoven

196. *Max Ernst*
Loplop introduces the
Members of the Surrealist
Group, *1930*
pencil and collage on paper
19.75 × 13.25 in.
(50.2 × 33.7 cm.)
Museum of Modern Art,
New York

in collage and in the general Cubist pursuit of object-quality in painting. Whereas Constructivism was to free the Cubist object of any element of fetishism, a 198 Surrealist assemblage like Miró's *Objet Poétique* sought out and emphasised this ritualistic fantasy. Unlike even Duchamp's ready-mades which had discovered a new surreal situation for banal, functional objects, the Surrealist object, in Dali's words,

> 'is one that is absolutely useless from the practical and rational point of view, created wholly for the purpose of materialising in a fetishistic way, with the maximum of tangible reality, ideas and fantasies having a delirious character.'

(*The Secret Life of Salvador Dali,* 1942).

In 1926 Picasso made one such object with the minimum of means and the maximum of tangible reality. Only a step away from a Cubist collage, his 199 *Guitar* concentrates all the emotion of the *Three Dancers* into a simple but primitively aggressive opposition.

CUBISM SINCE 1945

Attitudes to Cubism in the last twenty-five years have been conditioned partly by the big inter-war developments and partly by new reactions against 'history' in which Cubism is now very deeply embedded. The 202 three major Cubists, Picasso, Braque and Léger were still active after the war. Their presence was felt strongly both as direct stimulus and as oppressive competi-

tion. There was a renewed sense of obligation, conscious or subconscious, to measure oneself against their standards. Most art of the 1940s and '50s was conditioned by its relationship to the Cubist tradition. Since then this self-consciousness has diminished. The increasing preoccupation of post-war painting with colour, accounting for the meteoric rise in reputation of Matisse, has in itself qualified the immediate relevance of Cubism.

Strangely, although Picasso and Braque had remained in France during the war and Léger was soon to return there, European artists seemed the least inhibited by Cubism. The relationship of De Stael, Poliakoff and early Vasarely to the surface treatment of Synthetic Cubism is clear enough, but it was Klee and Kandinsky who exerted the most direct discernible influence on European art. Within the School of Paris the most significant challenge to a Cubist basis of painting came first through the more painterly techniques of Wols, Hartung and Mathieu and secondly through the anti-painterly constructions of Vasarely and the *Group de Recherche d'Art Visuel*. Even here the sequential unit-construction of much of Vasarely's work is still descended from the space-grid of Cubism and Mondrian.

The effect of the Second World War on European art had been no less disruptive than the first. The final decline of Paris as the dominant centre of avant-garde activity was a direct result of that situation. Since 1945 Paris' role has been usurped first by New York (which prospered culturally from the war situation) and subsequently by London as well.

The competitive awareness of Cubism has been most apparent in America. Since the elated experiment surrounding the Armory Show of 1913, American art had in general withdrawn from progressive tendencies. Now, relatively undisturbed by the war context, it was suddenly confronted again by the major 20th-century developments in Europe. Torn between this confrontation and more national impulses, the American avant-garde experienced an extraordinarily heightened consciousness of conflicting traditions that had long since disappeared in Europe.

In the 1920s and '30s Stuart Davis and Gorky had 203 been almost alone in evolving a more than superficial understanding of Cubism, Gorky leaning on Picasso, Davis more on Léger whom he described as 'the most American painter working'. Léger's presence in America during the early 1940s further enhanced his standing there. Gris' reputation in America seems negligible.

The contact with progressive European art was established in the later '30s and early '40s by the arrival in America of leading European artists. This *émigré* avant-garde represented both of the main-

199

197. *Max Ernst*
Fruit of a Long Experience
1919
Painted wood and metal
18 × 15 in.
(45 × 38 cm.)
Private Collection, France

198. *Joan Miró*
Poetic Object, *1936*
stuffed parrot, wood, hat, etc.
h. 33.25 in. (84.5 cm.)
Pierre Matisse Gallery,
New York

199. *Pablo Picasso*
Guitar
1926, string, paper,
floorcloth and nails
38.25 × 51.25 in.
(97 × 130 cm.)
Artist's Collection

streams of post-Cubist art: the Constructivist-Abstract Art pioneers (Gabo, Moholy-Nagy, Mondrian, Albers, Hofmann) as well as leading Surrealists (Ernst, Tanguy, Masson, Matta, Lam). Archipenko, Ozenfant, Léger (all active as teachers), Lipchitz and Feininger were also in America. With the important exceptions of Klee and Kandinsky, almost the whole European avant-garde was reconstituted. Collectively it laid new emphasis on the foundation-role of Cubism and in the event it was the direct influence of Picasso's more Surrealist Synthetic Cubism of the '20s and '30s that prompted crucial turning points in modern American art. This applies as much to the sculpture of David Smith as to the painting of Pollock and De Kooning.

In England too it was Picasso's influence that dominated the first phase of post-World War II art. During the war British art had renounced the progressive

200. *Willem de Kooning*
Gotham News
1955–6, oil, enamel and
charcoal on canvas
69.5 × 79.75 in.
(176.5 × 202.5 cm.)
Albright Knox Art Gallery,
Buffalo, N.Y.

201. *Jasper Johns*
Numbers in Colour
1959, encaustic and
collage on canvas
66.5 × 49.5 in.
(169 × 125.7 cm.)
Albright Knox Art Gallery,
Buffalo, N.Y.
(Gift of Seymour H. Knox)

175

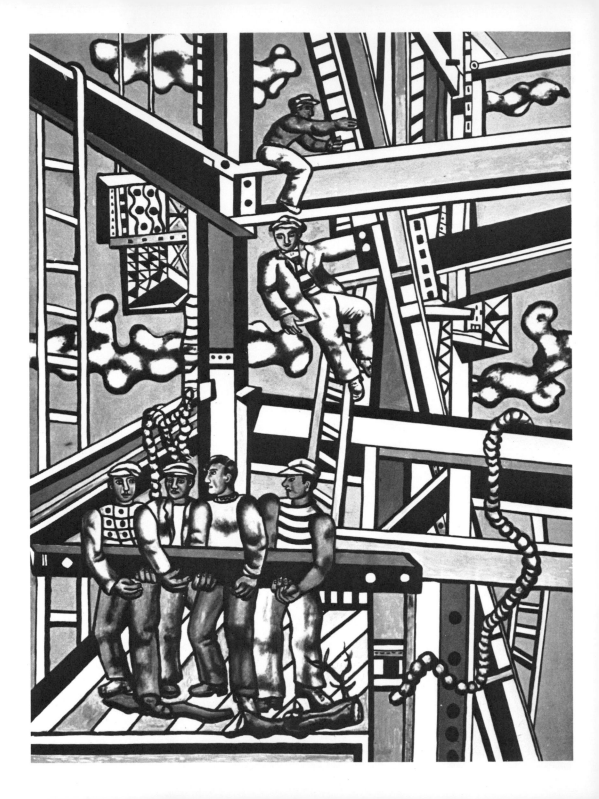

202. *Fernand Léger*
The Builders
1950, oil on canvas
118.1 × 78.75 in.
(299.7 × 198.1 cm.)
Musée Léger, Biot

tendencies of the later 1930s, centred around Nash, Nicholson, Piper and Hepworth and strengthened by Europeans like Gabo, Moholy-Nagy, Gropius, Breuer and (briefly) Mondrian, which had laid the foundations of an Abstract Art movement in Britain. English wartime art withdrew, in a mood of committed Samuel Palmer-ish romanticism.

A large exhibition of recent work by Matisse and Picasso at the Victoria and Albert Museum, 1946, marked a renewal of contact with European art. While Matisse went almost unnoticed at this stage, Picasso's late Cubism made its mark widely. There was even a revival of Cubism as a style in the work of Colquhoun, MacBryde, De Maistre and others. More significantly the example of Cubism was of paramount importance for Victor Pasmore and British Constructivists in the late 1940s and early '50s and, to a lesser extent for the more painterly near-abstraction of the landscape painters associated with St Ives (Heron, Lanyon, Frost, Hilton). The complete abandonment of figurative art was obligatory for the Constructivists, but their formal repertoire and their ultimate decision were both stimulated by their respect of Cubism, particularly of Picasso and Gris. During the 1950s they progressively abandoned painting as a medium in favour of reliefs and free-standing constructions, some of them mobile.

204

205

203. *Stuart Davis*
Eggbeater No. 2
1927, oil
29.1 × 36 in.
(74 × 91.5 cm.)
John Hay Whitney Museum
of American Art, New York

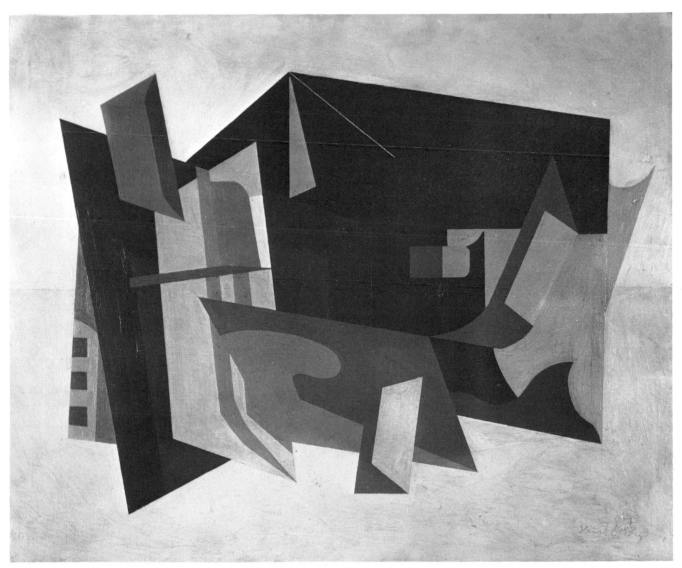

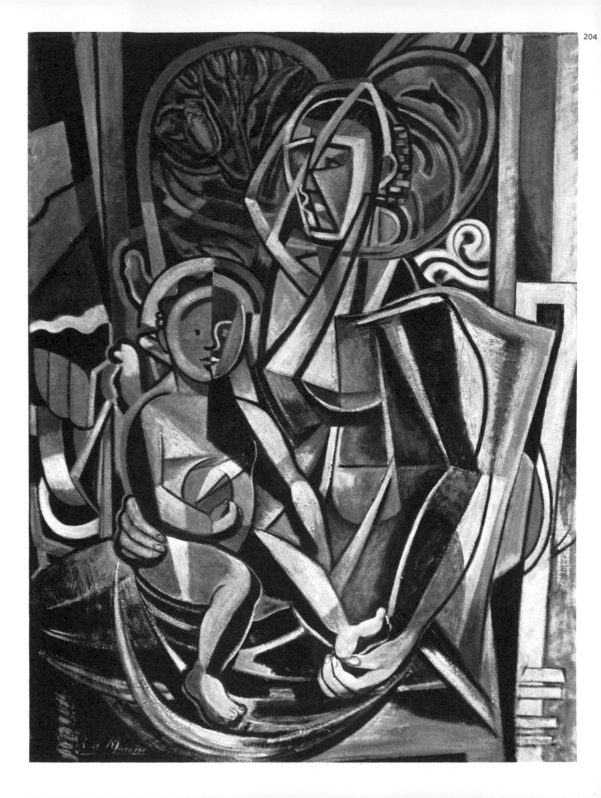

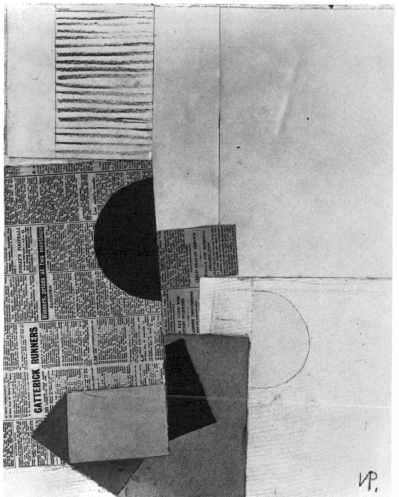

204. *Roy de Maistre*
Veiled Madonna
1946, oil on canvas
48 × 38 in.
(122 × 96.5 cm.)
Collection of
Mrs. H.R. Broadbent,
Maidstone

205. *Victor Pasmore*
Abstract in Grey,
White and Ochre
1949, pencil, coloured papers
and newspaper on canvas
20 × 16 in.
(51 × 40.2 cm.)
Tate Gallery, London

respected in England. The first wave of British post-war sculpture (Chadwick, Butler, etc), more or less figurative but closer to Hepworth than Moore, was an art of spatial construction, standing in the same general post-Cubist, post-Picasso tradition as Smith in America.

The break with Cubism was inherent in the concepts of the Constructivists but elsewhere the first significant change of direction came from contact during the later 1950s with American art.

The general formal characteristic of what is called Cubist in post-war art is its planear structure, as described by Hofmann (Writings, p. 133). It is a relationship of elements more or less definable as planes, that in painting are clearly on the surface, which creates spatial effects through oppositions and harmonies of colour, tone or form. In a painter like De Kooning all **200** three sorts of contrast and analogy are set to work against each other, pushing backwards and forwards in space and creating in toto something very like the ambiguous surface grid of Cubist painting. In sculpture and assemblage there is a comparable tradition of composition by relationships—relationships of form-space and of image.

De Kooning is perhaps slightly uncharacteristic of his age in his explicit and continued endorsement of the Cubist aesthetic as a completely adequate working environment. (Writings, p. 133). Several developments since the early 1950s have amounted to a progressive rejection of that aesthetic: all of them most clearly definable in American art. Barnett Newman's statement (Writings, p. 133) voices a not uncommon feeling that the Cubist aesthetic was an undesirable constraint from the past that must be severed.

Jackson Pollock, after his early rather morbid expressionism, had first come to terms with modern painting through a Picasso-based Synthetic Cubism. **206** From the start his execution was looser and more painterly than Picasso and this developed in the late 1940s 'Action Painting' into a form of painting whose links with Cubism were more tenuous. Although the canvas was still articulated by relationships, they were spread, like Mondrian's, all across the surface with no centralised focus. Although the final form was an image of the autonomous process of painting (hence the term Action Painting), the inseparable traces of dripped and thrown paint broke away from the identifiable planear basis of construction to an elusive, open curvilinearity.

The other and perhaps most finite break with Cubism was a dramatic increase in the scale of paintings. Cubist painting (using the term in its widest sense) was on a scale conceived and perceivable by artist and spectator within a single human focus of vision. In saying that 'if I stretch my arms. . .and

The formal, constructive aspect of collage was of direct influence in this development. Pasmore, Hill and the Martins employed real elements for their physical integrity more than for the dual role of form *and* symbol that had absorbed the Cubists. Cubism for them was a critical transition (Writings p. 133). Through his influence as a teacher in the 1950s, Pasmore transmitted this interpretation of Cubism to another generation.

Other British artists have remained closer to the Cubist thesis and closer to the medium of painting. Patrick Heron wrote of Braque as 'the greatest living painter' in the 1950s and manifested this sentiment in his painting. Hilton, Heath and Frost reflected the Synthetic Cubist adjustment of planear relationships on the surface in a more general way, not dissimilar from the paintings of Poliakoff, who was known and

206. *Jackson Pollock*
Guardians of the Secret
1943, oil on canvas
48 × 76 in.
(123.8 × 191 cm.)
San Francisco Museum of Art

wonder where my fingers are—that is all the space I need as a painter', De Kooning remains within the graspable scale of Cubism. The massive engulfing scale that Pollock, Rothko, Newman and others adopted around 1950 was not identifiable in this sense.

This change of scale has had a lasting effect both inside and outside America. It was sustained in the strictly non-painterly aftermath of Abstract Expressionism, an aftermath which also saw a reduction in Cubism's ambivalent relationships—what De Kooning called 'that wonderful unsure atmosphere of reflection'. The painterly looseness of Action Painting was supplanted by simple clean-edged colour areas, more akin to Synthetic Cubist planes but seldom overlapped. A degree of ambivalence remains but within a much tighter sense of surface.

In recent sculpture, the Cubist construction of planes or elements into a spatial relationship, which has constituted the vast majority of post-war sculpture, has been qualified by the thesis of 'Minimal Sculpture'. In its most extreme form this thesis has proposed to reduce the work of art to an ultimate state that does not depend on internal relationships at all. The implicit antipathy to Cubist unit-composition here

is comparable to Newman's demand for 'an art of no-geometry'. In a sense, that area of 'Pop' or 'Neo-Dada' art which is concerned with the selection of a single motif from reality and its enlargement to a new scale (Lichtenstein, Oldenburg) also subscribes to a Minimalist doctrine, a minimalism sired by Duchamp's ready-mades.

The vast majority of 1950s and 1960s artists who fall within or near this category of figurative art—British and American —retain strong affinities with the Cubist tradition. The preoccupation with motifs from everyday reality and the adoption of commercial art techniques are sometimes more directly inspired by Duchamp or Dada but still ultimately derive from collage and Synthetic Cubism. This applies equally to assemblage and painting. Rauschenberg's term 'combine paintings' is a new name for what are in essence Cubist collage-constructions. His description of his work as 207 'an oscillation' or 'a tacking' between the image from reality and the process of painting comes very close to the knife-edge poise that characterised the greatest Cubist works of Picasso. In his *Numbers* paintings, 201 Jasper Johns was more obviously teasing the nerve of that Cubist balance, hovering on and near the pic-

207. *Robert Rauschenberg*
Gloria, 1956
combine painting on canvas
66.5 × 63.25 in.
(169 × 161.3 cm.)
Leo Castelli Gallery,
New York

ture surface, and between paint and image. His concept of reality—applying as much to each brushstroke, colour or mark as to the readably or touchably real objects in paintings—is the Cubist reality. In figurative art of the 1960s this has remained the dominant concept.

Cubism has been justly described as another Renaissance, with Picasso as its figurehead, prolifically fertile in ideas about art's new potential. More than half a century of subsequent art history has demonstrated the creative liberating influence, both of Picasso and of the movement. Several phases of competitive post-Cubist mannerism have passed. First-hand influence of the movement in its original context has been modified by the stature of subsequent artists

and movements. Direct contact is now more often in the intimate form of allegiance to a particular aspect of Cubism or affection for a particular Cubist painting. The overall effect of subsequent movements has been to enrich rather than to deny the bases of Cubism. At its simplest level, Cubism made it possible for Rauschenberg to say that 'painting is the juxtaposition of one element against another element'. Art since Cubism has realised how wide is the application of this fertile proposition.

Cubism was much more than a revolution in artistic style; it expressed new senses of reality in art. In giving such totally new meaning to the real in art, it infected most other fields of visual experience.

181

Reading List

The major books on the Cubist movement:

Guillaume Apollinaire: *The Cubist Painters*. Paris, 1913. English edition, New York, 1944.

Alfred H. Barr: *Cubism and Abstract Art*. New York, 1936.

Edward Fry: *Cubism*. London, 1966.

John Golding. *Cubism, a History and Analysis, 1907–1914*. London, 1959, revised, 1968.

Christopher Grey: *Cubist Aesthetic Theories*. Baltimore, 1953.

D.H. Kahnweiler: *The Rise of Cubism*. Munich, 1920. English edition, New York, 1949.

A short selection of books on the leading artists:

Alfred H. Barr: *Picasso, 50 Years of his Art*. New York, 1946.

John Berger: *The Success and Failure of Picasso*. London, 1964.

Georges Braque: *Cahier 1917–1947*. Paris, 1948.

Douglas Cooper: Introduction and notes, catalogue to the exhibition *G. Braque*. Edinburgh and London, 1956.

Douglas Cooper: *Fernand Léger et le Nouvel Espace*. Geneva, 1949.

D.H. Kahnweiler: *Juan Gris, his life and work*. London and Paris, 1947, new edition, London, 1969.

G. Vriesen & M. Imdahl: *Robert Delaunay, Light and Colour*. New York, 1969.

Index

Acknowledgements

Illustrations

Numbers in italics refer to colour illustrations.

Albright Knox Art Gallery, Buffalo, New York *111*, *200, 201*; Architectural Record, London 7, 42; Art Institute of Chicago *31*, 54 (Grift of Mrs Gilbert W. Chapman), 60 (Gift of Mr and Mrs Leigh Block), 162 (Alfred Stieglitz Collection); Arts Council, London 40, 41, 95, 179, 186; Barnes Foundation, Merion, Pa. 27; Collection Mr and Mrs Armand P. Bartos, New York 61; Collection Clive Bell, Sussex 41; Collection G. Beron, Garches 19; Photo Ivan Bettex, Pully, Switzerland 10; Collection E.G. Bührle, Zurich 56; Boymans Museum, Rotterdam 174; British Museum, London, 39; Brompton Studio, London 177; Collection Mrs H. R. Broadbent, Maidstone 204; Gelett Burgess 7; Leo Castelli Gallery, New York, 207; Cinémathèque Française, Paris 128; Walter P. Chrysler, Jr, New York, 40; Courtauld Institute Galleries, London 9, 16; Denver Art Museum, Colorado 136; Madame Cuttoli, Paris *37*, Madame Duchamp, New York 127; Naum Gabo, Middlebury, Conn. 157, 171; Galerie Beyeler, Basle 101; Galerie Louise Leiris, Paris; 75, 89, 91; Galerie Pierre, Paris 88; Keith Gibson, Keighley, Yorkshire 13, *192*; Gemeetsmusea, Amsterdam 172; Gemeentemuseum, The Hague (Loan of S. B. Slijper) 123, 173 ; Giraudon, Paris, 15, *25*, 19, 20, 33, 46, 47, 50, *77*, 150; John Golding, London 58; Solomon R. Guggenheim Museum, New York, *105*, 107, *116*, 141; Collection Mr and Mrs Walter A. Haas, San Francisco 12; Collection Dr Paul Hänggi, Basle *120*; Collection of the late R.A. Harari, London 11; Hans Hinz, Basle 98, *120*; Hermitage, Leningrad, 46, 47, 53; Lucien Hervé, Paris, 166; Institute of Contemporary Arts, London 1; Collection D.H. Kahnweiler, Paris *29*; Germain Krull, Boston 6; Kunsthalle, Hamburg *108*; Kunsthaus, Zurich *104*; Kunstmuseum, Basle, *44*, *67*, 81, *103*, 143; Kunstmuseum, Berne (Herman and Margrit Rupf Collection) 2, 48, 62; Kunstsammlung Nordrhein-Westfalen, Düsseldorf 57, *79*, 144; Collection Larionov, Paris 170; Collection André Lefèvre, Paris 86, 160; Louvre, Paris *25*, 150; Executors of Roy de Maistre, Maidstone, Kent 204; Collection Mr and Mrs Barnet Malbin, Birmingham, Michigan (The Lydia and Harry Lewis Winston Collection) 169; H. Mardyks, Paris 33; Marlborough Fine Art (London) Ltd., 17 64, 121; Collection of Benedetta Marinetti, Rome 152; Pierre Matisse Gallery 198; Mr and Mrs Morton D. May, St Louis 177; Metropolitan Museum, New York 22, 23, 99 Minneapolis Institute of Arts 124; Musée d'Art Moderne, Paris 18, 20, *73*, 93, 112, *114*, 118, 122, 126, *181*; Musée de l'Homme, Paris 131; Musée des Beaux-Arts, Rouen Musée Léger, Biot 202; Municipal Museum, The Hague 123, 173; Museum of Fine Arts, Boston *24*; Museum of Modern Art, New York 23 (Gift of G. David Thompson), the following *35*, *66*, *71*, *72*, *83*, 97, 158, 159 and *182* (acquired through the Lillie P. Bliss Bequest), 51 (Gift of Mrs Simon Guggenheim), 101 (Sidney and Harriet Janis Collection), *115* (Gift of Mrs Louise Smith), 129, 130, 135, both 137 and 140 (Van Gogh Purchase Fund), 142 (Gift of the Henry Pearlman Foundation), 149 (Gift of Herbert and Nannette Rothschild), 151, 156 (Aristide Maillol Fund), 178 (Gift of Mr and Mrs Samuel A. Marx), *188* (Philip L. Goodwin Collection), 190, 191 (Mr and Mrs J. Atwater Kent Jr Fund), *193* (Gift of Mr and Mrs Stanley Reson), *194*, 196; National Gallery, Prague 55, 85, 145, 146, 147; Nationalmuseum, Stockholm 68; Collection of the Vicomtesse de Noailles, Paris 76; Philadelphia Museum of Art, the following *30*, *43*, 65, *84* and 87 (A.E. Gallatin Collection), *110* and 125 (Louise and Walter Arensberg Collection), 167; Phillips Collection, Washington (Gift of Katherine Drier) 92; Collection Pablo Picasso, Cannes 33, *77*, 133, 179, 180, 199; Private collections *38*, *82*, 96, *117*; Private collections, France 21, 50, 69, 74, 75, 80, 91, 98, 113, 197; Private collections, London *45*, 64, 155· Private collections, New York *28*, 139, 153, 186; Collection Dr Ingeborg Pudelko, (formerly) 94, 185; Pushkin Museum, Moscow 53, 63; Collection C. Reddihough, Ilkley, Yorkshire *192*; Rijksmuseum Kröller-Müller, Otterlo 100, 106; Collection Raoul la Roche, Paris 90; Roger-Viollet, Paris 112; Royal Museum of Fine Arts, Copenhagen (Rump Collection) 32; Collection of Georges Salles, Paris *78*; San Francisco Museum of Art, Permanent Collection 206; Scala, Florence *117*; Mr and Mrs Taft Schreiber, Beverley Hills *36*, Snark International, Paris, 11, *37*; State Tretyakov Gallery, Moscow 189; Stedelijk Museum, Amsterdam *184*, *187*; Stedelijk van Abbemuseum, Eindhoven, Holland 195, Studio Maywald, Paris 8; Collection Sir John Summerson, London 175; Trustees of the Tate Gallery, London 52, 132, 161, 176, 180, 205; Mr and Mrs Burton G. Tremaine Jr, Connecticut *109*; Collection J. Tucker, St Louis 134; University of Glasgow (Mackintosh Collection), 13; Verlag Otto Walter AG, Otten 148, 163, 164; Nicholas Wadley, London 165; Wallraf-Richartz Museum, Cologne *119*; Collection Richard S. Weil, St Louis 102; Whitney Museum of American Art, New York *183*, 203; Collection of Edward Wright, London 165; Yale University Art Gallery, New Haven, Conn. (Gift of Collection Société Anonyme) 138; Editions Zodiaque, Saint-Léger-Vauban France 80.

Text
Grateful acknowledgement is made below for permission to reprint translations and quotations in the chapter entitled *Writings*:

p. 128 Statement by Picasso: 1923. From Picasso: *Fifty Years of His Art* by Alfred H. Barr, Jr. copyright 1946 The Museum of Modern Art, New York, and reprinted by permission of the publisher. The 'Statement by Picasso: 1923' was made in Spanish to Marius de Zayas. Picasso approved de Zayas' manuscript before it was translated into English and published, originally, in *The Arts*, New York, May 1923, under the title 'Picasso Speaks.'

pp. 128–9 Statement by Picasso: 1935. From Picasso: *Fifty Years of His Art* by Alfred H. Barr, Jr., copyright 1946 The Museum of Modern Art, New York, and reprinted by permission of the publisher. Christian Zervos put down these remarks of Picasso immediately after a conversation with him at Boisgeloup in 1935. They were first published under the title 'Conversation avec Picasso' in *Cahiers d'art*, 1935, volume 10, number 10. The translation is based on one by Myfanwy Evans.

p. 129 Statement by Braque. Translation from the Arts Council of Great Britain catalogue to the Braque exhibition held at the Tate Gallery, London in 1956.

pp. 129–30 Gris quotations. Translations from D.H. Kahnweiler, *Juan Gris, his Life and Work*, translated by Douglas Cooper, new enlarged edition, 1969, Thames and Hudson, London/Harry N. Abrams Inc., New York.

p. 130 Léger quotation beginning 'During those four war years...' From Douglas Cooper, *Fernand Léger et le Nouvel Espace*, 1949, Editions des Trois Collines, Geneva.

pp. 130–1 Léger quotations beginning 'The realistic value...' and 'If pictorial expression...' and Metzinger quotation beginning 'Because they use...' from *Du Cubisme*. Translations from Edward Fry, *Cubism*, 1966, Thames and Hudson, London/ McGraw-Hill Book Company, New York.

p. 130 and p. 132 Statements by Gleizes and Metzinger and by Le Corbusier and Ozenfant on *Purism*. Translations from Robert L. Herbert, Ed., *Modern Artists on Art:* Ten Unabridged Essays, © 1964, Prentice-Hall Inc., Englewood Cliffs, New Jersey.

pp. 130–1 Futurism. Boccioni quotation. Translation from Reyner Banham *Theory and Design in the First Machine Age*, 1960, The Architectural Press Ltd., London.

p. 132 Ozenfant on Picasso after 1914. Translation from *Foundations of Modern Art*, paperback edition, 1952, Dover Publications Inc., New York.

p. 132 Naum Gabo and Antoine Pevsner on Constructivism. Translation from Robert Goldwater and Marco Treves *Artists on Art*, Pantheon Books Inc., New York.

pp. 132–3 Mondrian quotations. Translations from *Plastic Art and Pure Plastic Art, 1937 and other essays (1914–43)* published by Wittenborn-Schultz Inc. in 1945, reprinted in this book by courtesy of Harry Holtzmann.

p. 132 'Since 1945' Pasmore quotation from *What is Abstract Art* by courtesy of Victor Pasmore.

p. 132 Statement by Willem de Kooning: 1951. From *What Abstract Art Means to Me*, Bulletin of The Museum of Modern Art, New York, Volume XVIII, No. 3, Spring 1951, and reprinted by permission of the publisher.

p. 132 Statement by Barnet Newman: 1958. From *The New American Painting*, 1959. All rights reserved by The Museum of Modern Art, New York and reprinted by permission of the publisher.